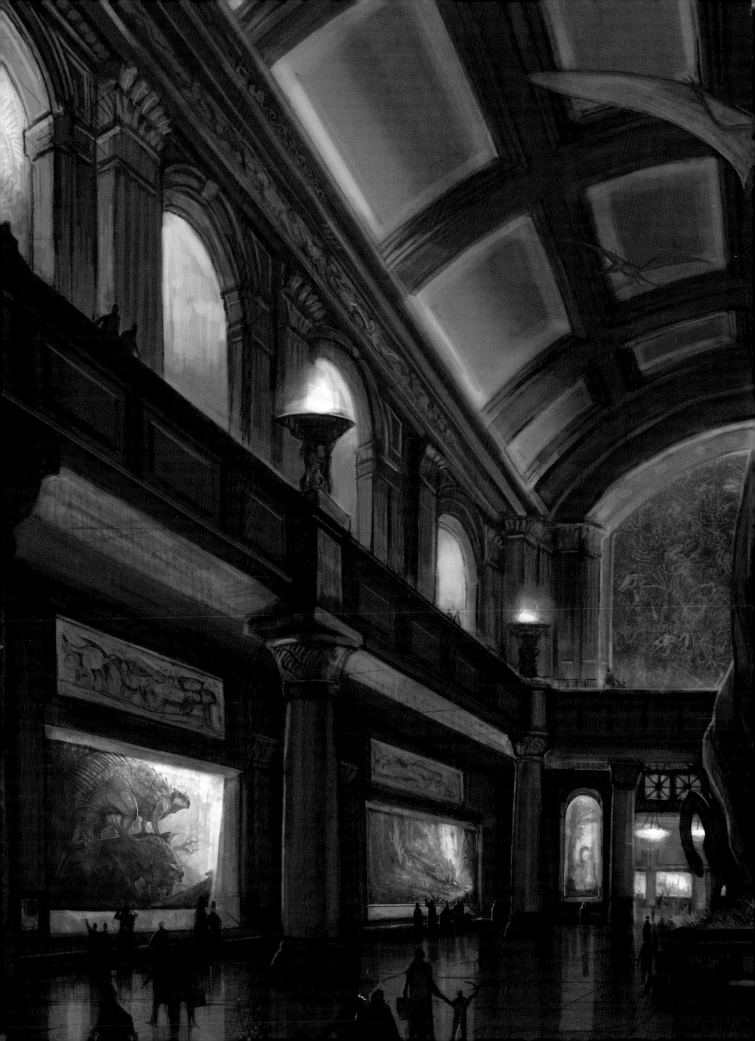

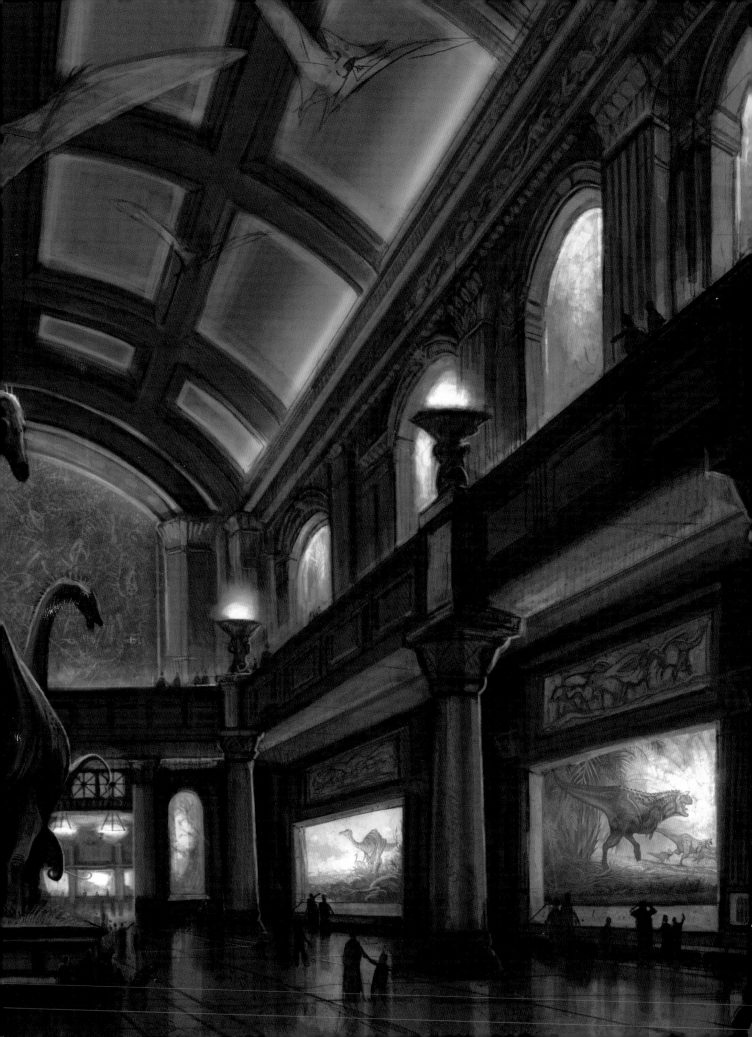

CONTENTS

10
ANKYLOSAURUS

18
APATOSAURUS

26
ARCHAEOPTERYX

36
CARNOTAURUS

44
DIMETRODON

52
GALLIMIMUS

60
KRONOSAURUS

70
PACHYCEPHALOSAURUS

80 PARASAUROLOPHUS

90 PLATEOSAURUS

98 PROTOCERATOPS

108 PTERANODON

118 STEGOSAURUS

126 TRICERATOPS

136 TYRANNOSAURUS

146 VELOCIRAPTOR

INTRODUCTION

WELCOME TO THE HALL OF DINOSAURS! This year, the American Institute of Natural Sciences is proud to unveil the most astounding display of dinosaurs in the world! Larger than a football field, this new Hall of Dinosaurs has been conceived as a natural continuation of other astounding halls of animals in the Institute. The amazing dioramas within combine both science and art into a unique learning environment.

The American Institute endeavours to present and display dinosaurs with the same natural beauty as the animals in the other halls of the museum. So much of Hollywood and popular culture has turned dinosaurs into terrifying nightmares—we can easily forget that they were living, breathing creatures with the same grace, beauty and complexity as the animals that we study in the world today. Through a combination of paleontology, science, art and imagination, the Hall of Dinosaurs hopes to bring these magnificent creatures back to life.

DINOSAURS: THE TERRIBLE LIZARD

Dinosaurs are considered one of the most successful groups of creatures to ever roam the planet. The word *dinosaur* directly translates to "terrible lizard." For almost 200 million years this huge class of animals consisting of thousands of documented species ranging from tiny swift hunters to massive lumbering grazers evolved to dominate the planet. Their popularity remains in equal measure to their superlatives as the biggest, fiercest and fastest.

PALEOART AND HOW TO USE THIS BOOK

As many readers may be aware by reading my other IMPACT works, I place a lot of importance on morphology. This is a fancy word that simply means an animal's design. Why does T-rex have small forelimbs? Why does stegosaurus have a spiked tail? Why do sauropods

have long necks? Over time, we've discovered that all species in the dinosauria class had a similar morphology: a common pelvic structure similar to birds (making them ancestors), an endothermic metabolism that differentiates them from reptiles (also known as warm blooded), and the ability to lay eggs.

Paleoart is a branch of art and illustration that brings to life prehistoric creatures based upon contemporary paleontological studies of these animals. In its strictest sense, paleoart concentrates on the anatomical and scientific accuracy of paleontology. In this book we are not limited to contemporary paleo science. We can use our imaginations to not just learn about dinosaurs, but also to dream of worlds and scenes that may have existed millions of years ago, and animals we have never seen before.

Please note that there may be scenes in this book that depict dinosaurs of different regions or even different eras in the same scene. This has been done with the intent of creating imaginative and engaging images.

CREATING NATURAL 3-D ENVIRONMENTS

There are three basic elements to creating believable nature scenes of paleoart: the background, the subject and the foreground. In each of the demonstrations in this book these three key aspects are used to create believable images, depth and the illusion of the space. All of the images are from "human perspective." The horizon line and point of view are roughly the same as if you were standing there observing the dinosaurs in their habitat.

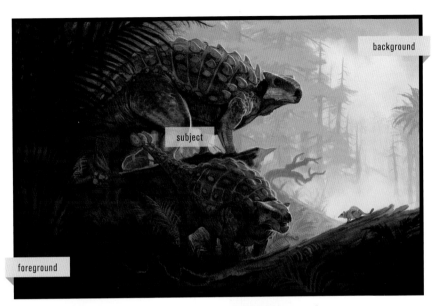

background

subject

foreground

Element 1: The Background

The background landscape should illustrate a broad environmental ecosystem that the dinosaur would live in, whether mountains, forest, desert, jungle or seashore. The background should establish the weather, lighting, time of day and overall world in which each dinosaur lived. Search online for visual reference of landscapes, or even better, explore nature to take your own photos. Drawing en plein air will also give you a better sense of the natural environment.

Element 2: The Subject

The subject of each diorama is the dinosaur itself, whether alone or in a group, and is the focal point of your nature scene. For this element, you will need to gather a great deal of dinosaur anatomy reference. The dinosaur does not belong in the center of the design, but should be central in the overall composition. Placement of the dinosaur is crucial. Try to position the dinosaur so that it is interacting with its environment, whether looking off into the background or moving into the foreground. This will help enhance the illusion of space and depth.

Element 3: The Foreground

The placement of a foreground element in the design helps frame the composition. Including rocks, plants and small animals in the foreground adds believable detail and helps scale the drawing. This framing technique also helps set the dinosaur more naturally into the landscape. Try to carry the details of the background into the foreground. For instance, if there are palm trees in the background, litter the foreground with fallen dried palm fronds.

Visit impact-books.com/hall-of-dinosaurs to download free bonus materials.

7

TRADITIONAL DRAWING TOOLS

Imagination and a pencil are all you need to bring to life the ancient creatures of the Mesozoic Era. All of the drawings in this book can be completed using nothing more than a simple no. 2 pencil and some paper. What is commonly referred to as a no. 2 pencil actually contains HB lead. This is a perfect balance of softness for dark marks and blending, and it has good hardness to hold a point for detail. I like to keep several sharp pencils on hand so I don't have to keep going back to the sharpener.

I like to use a medium weight drawing paper sized about 14" × 18" (36cm × 46cm) such as bristol board. This paper is heavy enough to endure fairly rugged erasing and can handle a variety of expressive texture and tight detail work. The size is not too big to be cumbersome, while not so small that it hinders detail work. This size also fits nicely on the flatbed scanner in my studio so I can bring my drawings into the computer for painting and enhancement. Here are a few examples of some of the more common drawing techniques I use throughout this book.

Lines
Directional lines add contour and form to your work.

Light Shading
Shading with the side of the pencil adds value and shadows to your drawings.

Crosshatching
Crosshatching adds texture and form.

Dark Shading
Use more pressure to create darker shading.

DIGITAL PAINTING

For the majority of paintings in this book I've used Photoshop and a digital tablet. However, there are dozens of digital drawing and painting apps and programs available today. I have designed the demonstrations and techniques in this book so they may be applied universally to any software or traditional painting methods. I encourage you to experiment with different tools, materials and programs to find out what you like best.

Normal Mode, 100% Opacity

BRUSHES

Whatever software or medium you choose, a variety of brushes is fundamental to painting. In digital painting, it is quick and easy to create a menu of custom brushes with an infinite variety of textures for a myriad of uses. Below are a few of my favorites that I've created in Adobe Photoshop.

PAINTING MODES AND OPACITY

The second most important aspects of digital painting are modes and opacities. Combining a variety of opacities in your brushwork will add depth to the painting and allow the underpainting and layers of brushstrokes to show through.

Normal Mode, 50% Opacity

Multiply Mode, 100% Opacity

Multiply Mode, 50% Opacity

Some of My Custom Brushes

These custom brushes were made using a variety of filters, textures, splatter effects and other modifiers available on most brush software. Some I've made to look like scumbled paint, others like pencil lines or even splattered and stippled paint. Try using a combination of brushes together in the same painting or drawing to add depth and character to your work. Throughout this book's demonstrations I will identify the particular brushes that I'm using to get certain effects.

Understanding Opacity

Each layer has an opacity setting. Here are two brushstrokes shown in a variety of opacities and modes to demonstrate how they interact.

Visit impact-books.com/hall-of-dinosaurs to download free bonus materials.

9

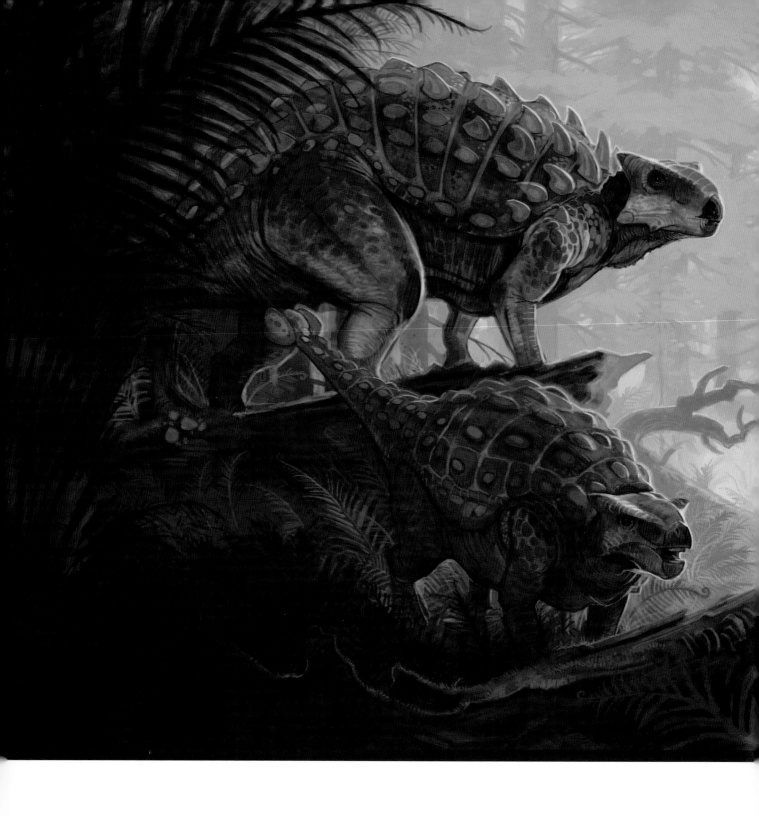

ANKYLOSAURUS

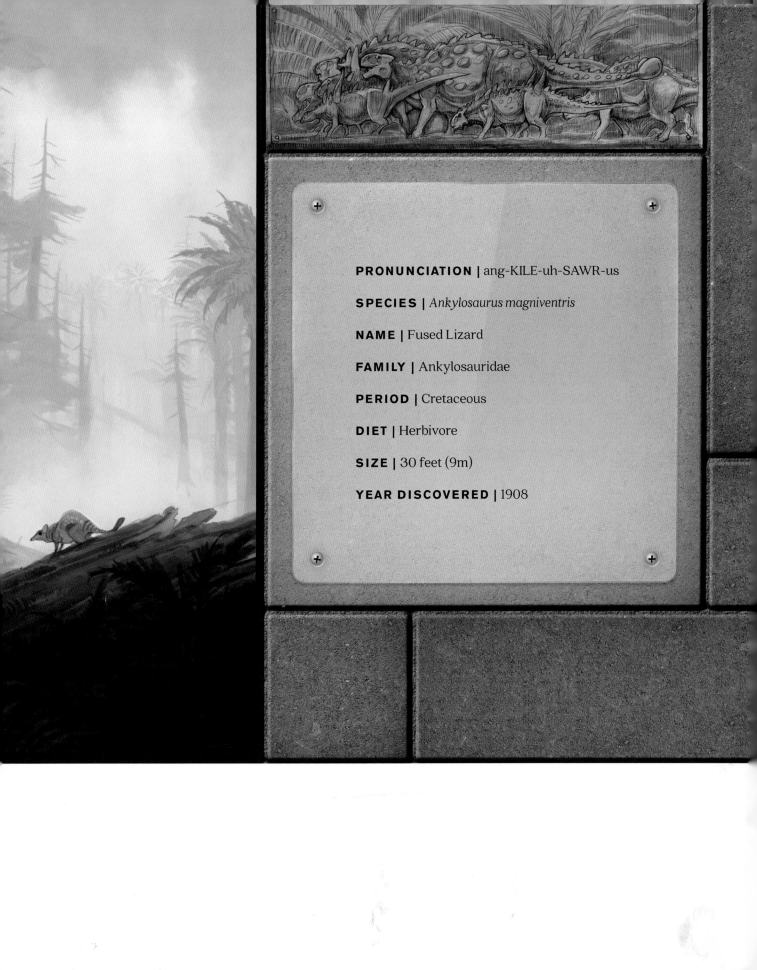

PRONUNCIATION | ang-KILE-uh-SAWR-us

SPECIES | *Ankylosaurus magniventris*

NAME | Fused Lizard

FAMILY | Ankylosauridae

PERIOD | Cretaceous

DIET | Herbivore

SIZE | 30 feet (9m)

YEAR DISCOVERED | 1908

DESCRIPTION AND BIOLOGY

Ankylosaurus were the tanks of the dinosaur world and a member of the much larger Ankylosauridae family that included similar armored dinosaurs like euoplocephalus and talarurus. Armored with thick bony plates and a heavy clubbed tail (some with protruding spikes), ankylosaurus was a slow and gentle but powerful giant.

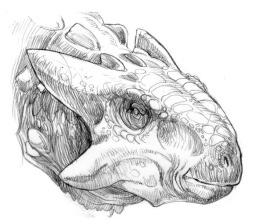

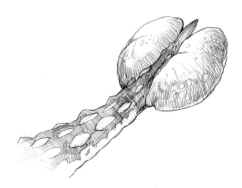

Head

Because the ankylosaurus lived low to the ground in deep forest, its eyes were small but its nose was powerful. Its nose would sweep the ground for tasty morsels, much like hogs, while also taking note of danger in the woods.

Tail

The heavy bone clubbed tail was an effective defense against predators of the Cretaceous forest. One strong hit with this formidable weapon could shatter the bones of a tyrannosaurus. Like with modern porcupines or armadillos, most predators simply left ankylosaurus alone.

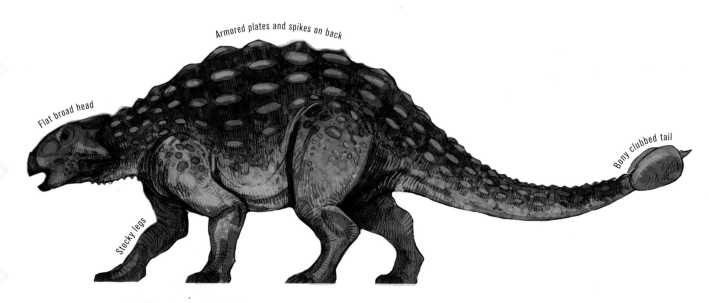

Armored plates and spikes on back

Flat broad head

Bony clubbed tail

Stocky legs

Ankylosaurus Side View

Though ankylosaurus is believed to have had poor vision, a keen sense of smell would have served it well in the Cretaceous landscape. The top speed of ankylosaurus is thought to be about 6mph (10km).

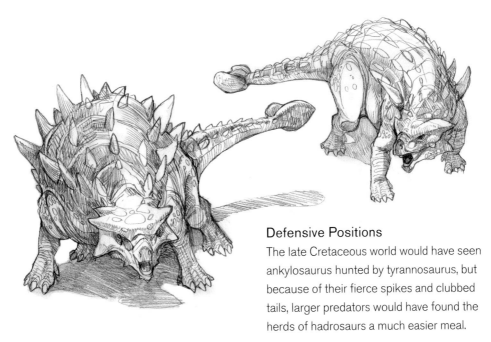

Defensive Positions

The late Cretaceous world would have seen ankylosaurus hunted by tyrannosaurus, but because of their fierce spikes and clubbed tails, larger predators would have found the herds of hadrosaurs a much easier meal.

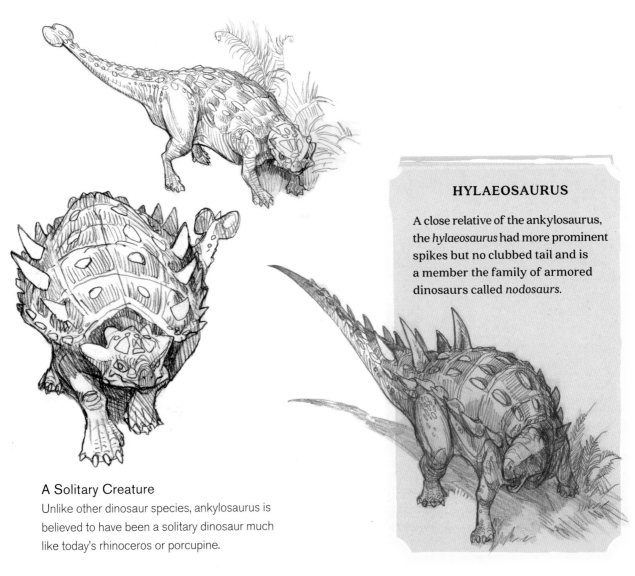

HYLAEOSAURUS

A close relative of the ankylosaurus, the *hylaeosaurus* had more prominent spikes but no clubbed tail and is a member the family of armored dinosaurs called *nodosaurs*.

A Solitary Creature

Unlike other dinosaur species, ankylosaurus is believed to have been a solitary dinosaur much like today's rhinoceros or porcupine.

Visit impact-books.com/hall-of-dinosaurs to download free bonus materials.

13

ANKYLOSAURUS

The *ankylosaur hylaeosaurus*, one of the first dinosaurs discovered, was described and named "Forest Lizard" in 1832. Although paleontology did not exist at the time and scientists did not understand these creatures, the name inspired generations. Envision a big ankylosaurus foraging through the Cretaceous forests, grazing the carpet of cycads and ferns or perhaps rooting and scratching for tubers and roots like many contemporary forest animals such as wild pigs.

Even though later paleontological discoveries of ankylosaurus demonstrate that they were loners, it is possible that during their early development the young armored dinosaurs may have stayed near their mothers until their spikes and clubs could develop enough to defend themselves.

The scene in this demonstration depicts a mother stepping out onto a rise to survey an open glade for danger as morning burns off the woodland mist. Her young charge aims its attention at the curious little mammal that has poked up from a nearby log to see what all the noise is about.

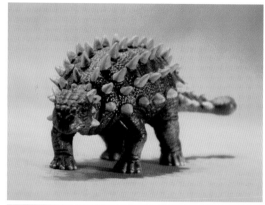

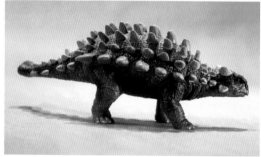

References
Models of the ankylosaurus are useful to visualize anatomy and foreshortening.

1 PRELIMINARY THUMBNAIL SKETCHES
Sketch out a few sample thumbnails to find a setting that works best. I chose the composition on the right for this demonstration.

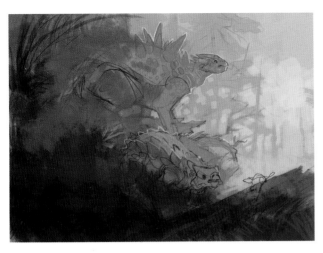
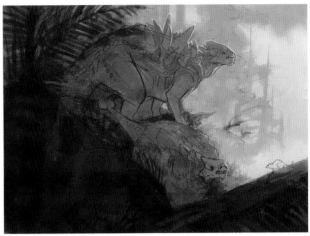

2 ROUGHING IN THE INITIAL SHAPES

Begin the painting with a digital sketch of broad, general shapes. Sometimes you have to make several different sketches before a usable image emerges. With digital sketching these changes can be made right in the picture. Don't be afraid to make mistakes. My initial sketches illustrated a more generic ankylosaurus of no specific species.

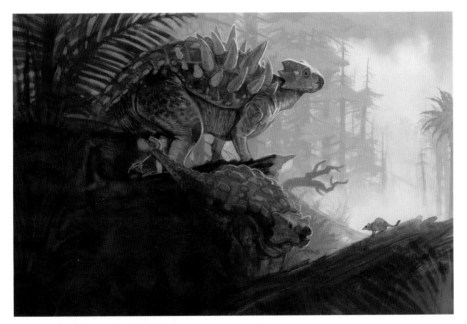

3 COMPLETING THE UNDERPAINTING

Establish the underpainting and basic color scheme. Use broad loose brushstrokes to give the overall image tone, lighting and color. The goal of my color scheme here is to portray the time of day. Here, I have the background roughly detailed for the final painting.

Color Palette

Visit impact-books.com/hall-of-dinosaurs to download free bonus materials.

15

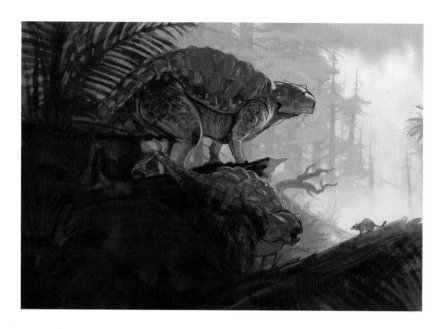

4 REFINING THE SUBJECT

Revisit your paleo reference and refine the animal's anatomy to more accurately represent an ankylosaurus and not one of its many cousins. At this stage, I've made big changes to the shape of the head and body armor such as reducing the height of the spikes.

TUTORIAL | Ankylosaurus Sketch

Start the sketch of the ankylosaurus with large round shapes to establish its silhouette. The internal structure is roughed out with approximations of femurs, joints and the central spinal column. See page 12 for the finished colored drawing.

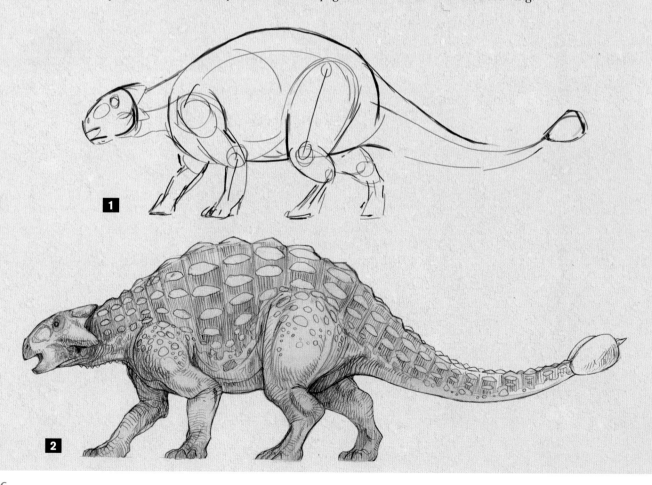

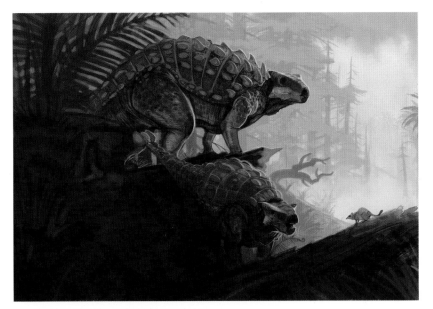

5 COMPLETING THE MIDDLE GROUND

Once the anatomy has been corrected, move on to the surrounding environment and refine the details of the ankylosaurus in the focal area of the image.

6 FOREGROUND AND FINISHING DETAILS

Add details to the framing foreground element. I don't want these details to compete with my subject so they remain in the shadows and loosely rendered. Only the little rodent is given any real detail, including tiny whiskers.

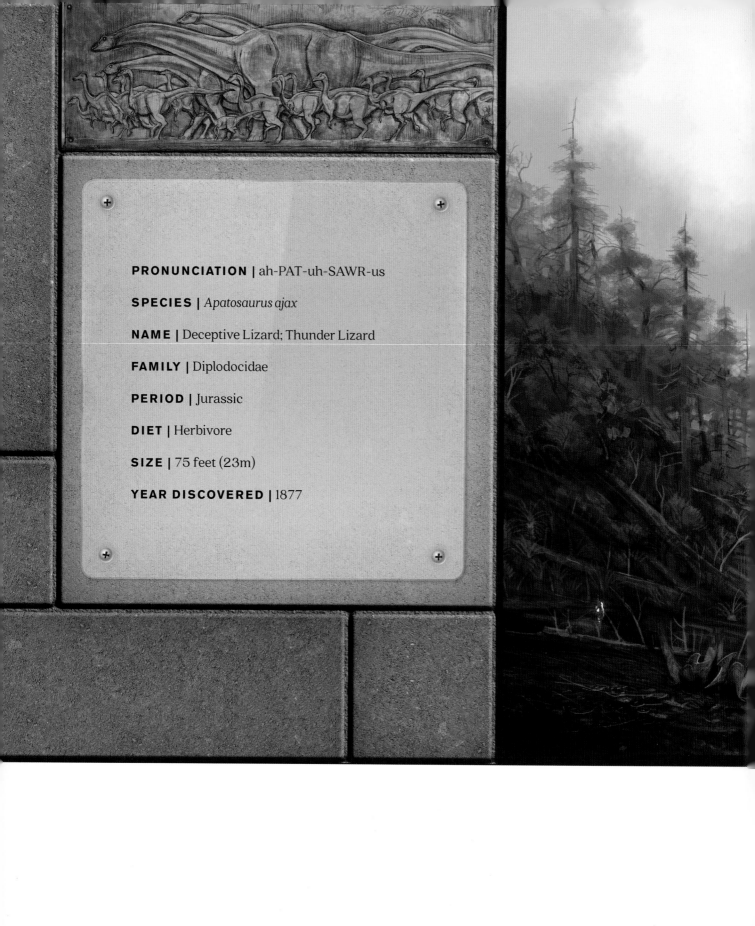

PRONUNCIATION | ah-PAT-uh-SAWR-us

SPECIES | *Apatosaurus ajax*

NAME | Deceptive Lizard; Thunder Lizard

FAMILY | Diplodocidae

PERIOD | Jurassic

DIET | Herbivore

SIZE | 75 feet (23m)

YEAR DISCOVERED | 1877

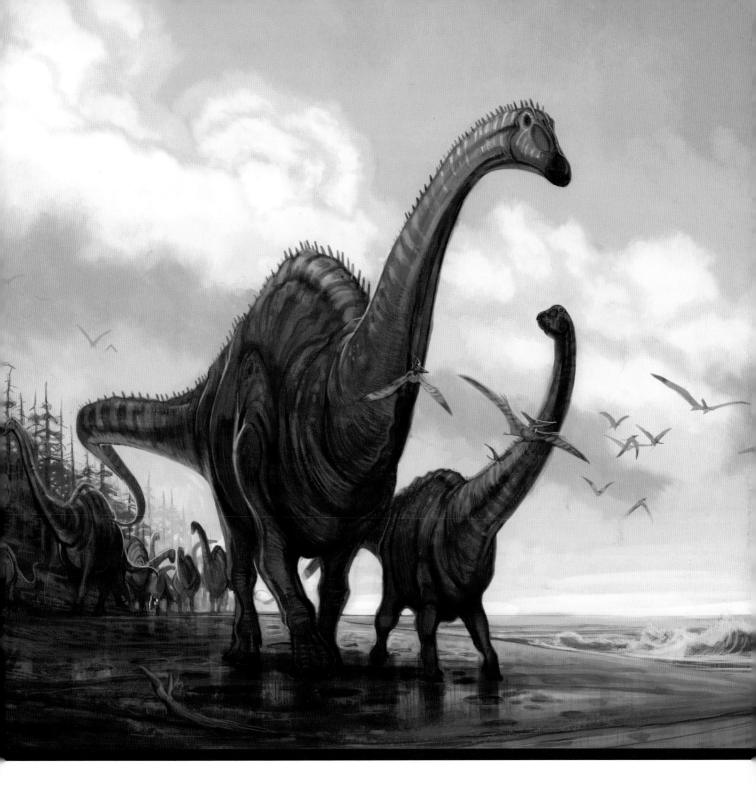

APATOSAURUS

DESCRIPTION AND BIOLOGY

As one of the biggest land animals that ever lived, the *apatosaurus* is staggering to comprehend. Many different species of sauropod, such as diplodocus and brachiosaurus, roamed the Mesozoic Era, but the apatosaurus (or brontosaurus) is the most recognizable.

Apatosaurus Head

It's hard to imagine that such a tiny head provided all necessary food and oxygen for such a massive animal. It's believed that sauropods such as the apatosaurus would have spent their entire lives grazing to consume the tons of vegetation needed every day to sustain their bodies. Its small peglike teeth acted like hedge trimmers mowing down whole forests of trees. Muscles in its gizzard, plus intentionally swallowed grinding stones, may have helped aid plant digestion.

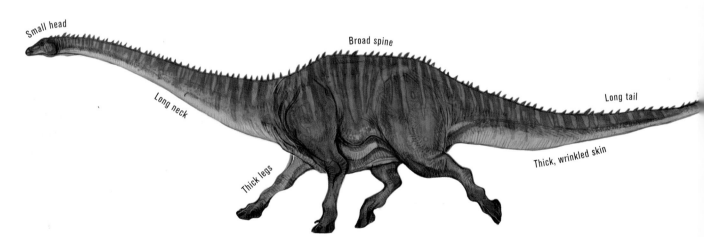

Small head

Broad *spine*

Long neck

Long tail

Thick, wrinkled skin

Thick legs

Apatosaurus Side View

Paleoartists originally depicted apatosaurus as either slow, lumbering behemoths with tails dragging, or as hippos floating in a swamp, though these interpretations have evolved over the decades. Today it is understood that the spine of the apatosaurus would have acted much like a truss bridge, with the ligaments and muscles holding out the tail and neck like long counterbalanced cantilevers. Much like a 75-foot-long (23m) backhoe digger.

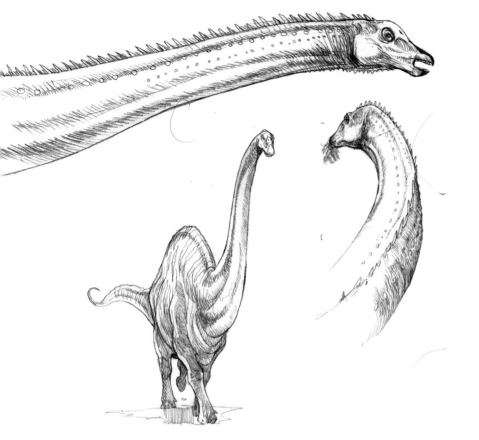

Sketches of Apatosaurus

It is now understood that these animals may have been fairly agile to move their massive frames with enough dexterity to pick the leaves off a branch of a tall tree. Like giraffes today, they may also have been capable of sprinting short distances in the case of a stampede or danger. Modern elephants can reach almost 20mph (32km) and giraffes can sprint at over 30mph (48km). It stands to reason that the apatosaurus could likewise reach similar speeds at a fast trot, giving literal meaning to the name "Thunder Lizard."

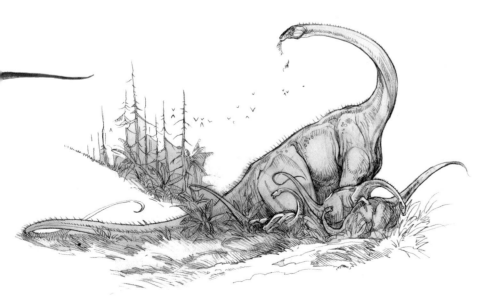

A Social Creature?

Paleontologists debate over the social behavior of dinosaurs, though as an artist, I prefer to take my cues from modern animals like birds and mammals, which are extremely social. Even reptiles like lizards and amphibians such as frogs gather in groups for safety and breeding. This creative freedom is an important aspect of paleoart. Speculation of whether or not apatosaurus could sit down to sleep is also open to debate. Some paleontologists suggest their massive weight would prevent them from rising again, or even breathe in the prone position. For me I find it difficult to imagine evolution creating an animal that couldn't sit down.

Visit impact-books.com/hall-of-dinosaurs to download free bonus materials.

21

APATOSAURUS

My first thought for depicting the apatosaurus was to show its massive size and its herding behavior. Many sauropod prints have been fossilized in the mud along water so I felt this a good place to start.

Some paleontologists over the years have suggested that sauropods were semiaquatic in order to buoy their massive weight. Although this is an interesting idea, and although sauropods like apatosaurus would indeed have spent some time in the water to cool off (much like elephants), the need to consume massive amounts of vegetation would have likely kept them perpetually moving. Dense forests would be impractical and dry deserts would not provide enough food for a whole herd. Following along the shore of the Panthalassic ocean was probably the safest route for these titanic herds as they migrated from winter to summer feeding and breeding grounds throughout Pangaea. The wet packed sand of the beach would be as solid as concrete under their immense weight. Seaweed along with scrub pine and cycads would provide enough food, while the seaside would provide a safe haven for the herd's young so they could not be attacked by predators.

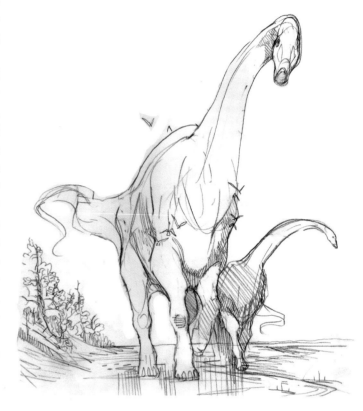

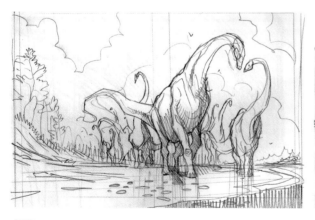

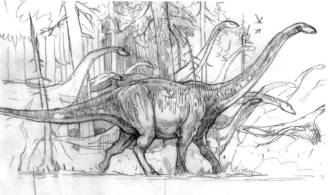

1 PRELIMINARY THUMBNAIL SKETCHES

Before starting the final painting, visualize the composition by working out a few sketches. For an apatosaurus, it is best to start with the spine. The long fluid backbone of the sauropod is central to its design. Next flesh out the muscle masses, then add details such as flesh, back-spines, wrinkles and markings to complete the animal.

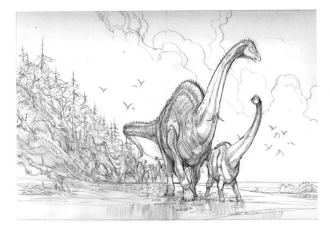

2 SKETCHING THE FINAL DRAWING

The most important aspect of drawing an apatosaurus is scale so they look truly massive. Since there were no cars or people in the Mesozoic Era, I've placed some pterosaurs pecking for shellfish in the foreground, and an eroded bank of pine trees in the background to help the viewer judge the size and scale of the dinosaurs.

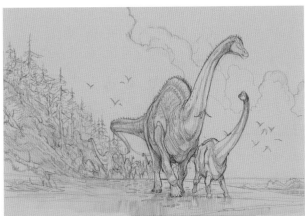

3 SCANNING THE DRAWING

I like to use a 11" × 17" (28cm × 43cm) flatbed scanner set to 300dpi grayscale to import my drawings. The advantage of a flatbed scanner is that if your drawing is bigger than the scanning bed you can scan it in several pieces then stitch it together in photo editing software. For really large drawings or paintings you can also use a digital camera to photograph your work. Some smartphones and tablet cameras also work for this application.

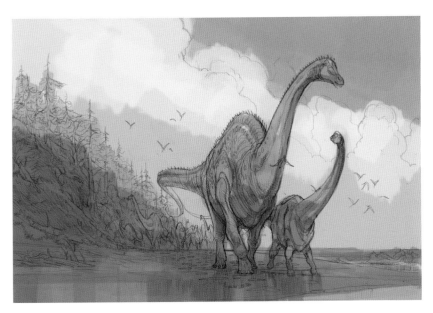

4 ESTABLISHING THE UNDERPAINTING

Using the color palette, establish broad shapes of color and shadow. It's at this stage that I envision the heads of the apatosaurus rising out of the shadows of the dune and into the low sunshine.

Color Palette and Key Brushes

Visit impact-books.com/hall-of-dinosaurs to download free bonus materials.

23

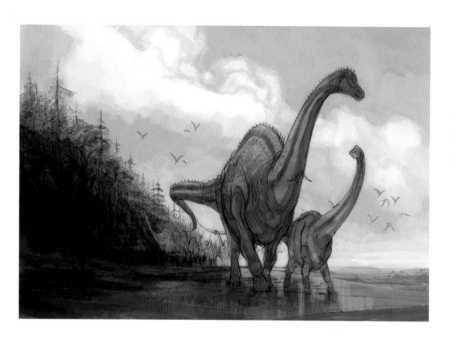

5 **REFINING THE BACKGROUND DETAILS**

Refine the sky, clouds, trees and water to establish the background. Deepen the shadows throughout and reflect a bit of the sky tones on the sand to indicate that the beach is wet.

TUTORIAL | Apatosaurus Sketch

The most important design element of the apatosaurus is the spinal column. The center line sweeps gracefully from the head to the tail like the arch of a suspension bridge. Rough in the rib cage, pelvic joints and muscles around the central column then add the details of skin. See page 20 for the finished colored drawing.

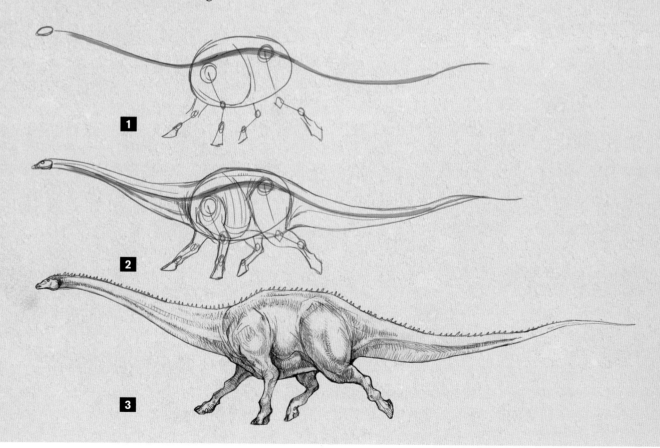

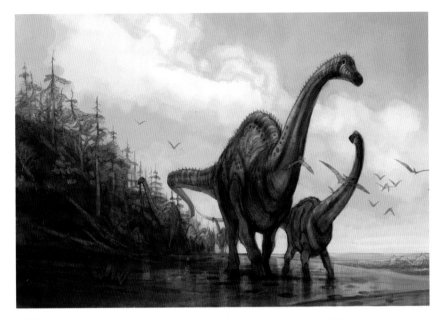

6 COMPLETING THE MIDDLE GROUND AND SUBJECT

Reference the three elements guideline on page 7 and review your painting. Once the underpainting and background have been established, complete the middle ground and subject. Here I added the apatosaurus skin patterns, wrinkles and colored facial markings.

Tree Line

Detail of the tree line with the underpainting applied using texture brushes. At this stage, you can still see the sketch beneath.

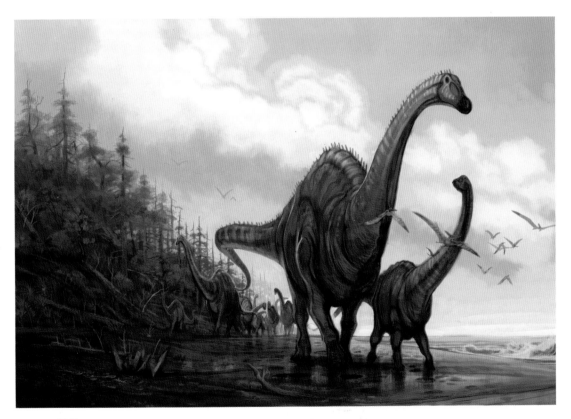

7 FOREGROUND AND FINISHING DETAILS

Add final details to help frame the image. The log in the foreground, the tidal pool and the small pterosaurs help the image appear more dimensional.

Visit impact-books.com/hall-of-dinosaurs to download free bonus materials.

25

PRONUNCIATION | AR-kee-OP-tur-icks

SPECIES | *Archaeopteryx lithographica*

NAME | Ancient Wing

FAMILY | Archaeopterygidae

PERIOD | Jurassic

DIET | Herbivore

SIZE | 2 feet (61cm)

YEAR DISCOVERED | 1861

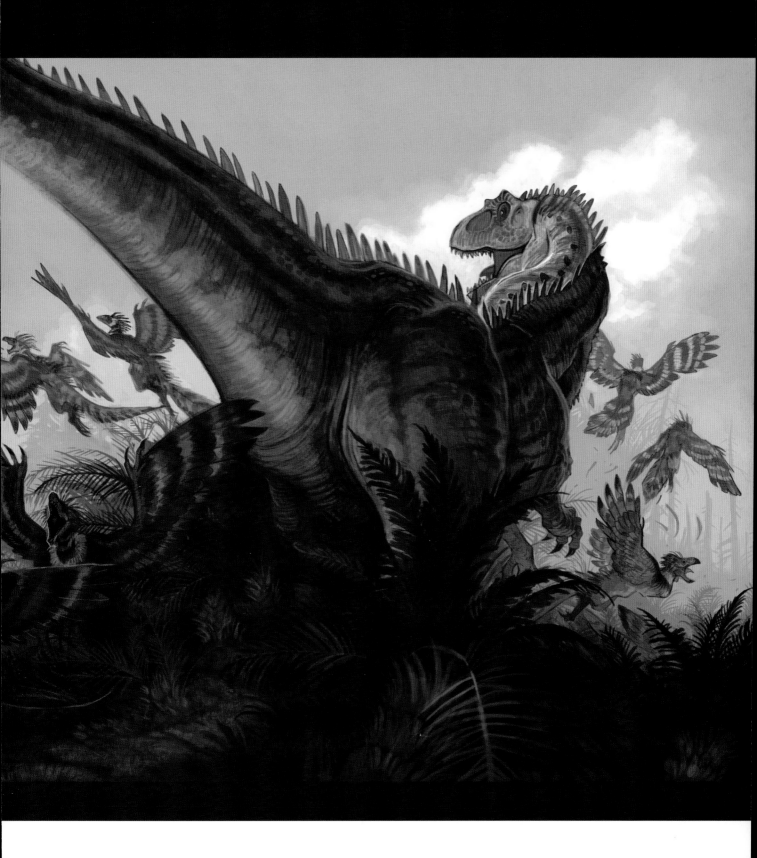

ARCHAEOPTERYX

DESCRIPTION AND BIOLOGY

Archaeopteryx is commonly thought of as the missing link that ties dinosaurs to birds, and although only about the size of a modern crow, this small winged creature has had a huge influence on our understanding of the evolution of both dinosaurs and birds.

Of the many functions of modern bird feathers such as plumage displays, insulation in harsh weather and flight, the archaeopteryx is thought to be one of the earliest specimens to possess all of said elements.

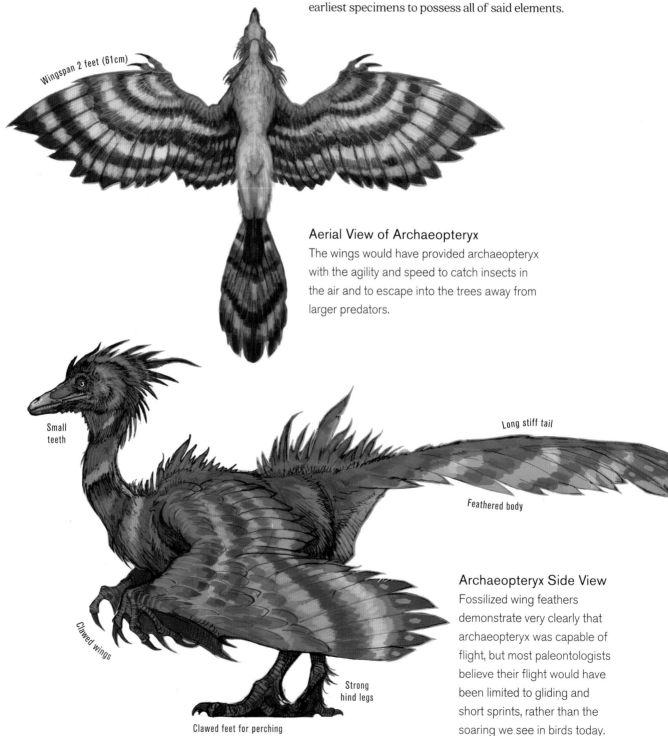

Wingspan 2 feet (61cm)

Small teeth

Clawed wings

Clawed feet for perching

Strong hind legs

Long stiff tail

Feathered body

Aerial View of Archaeopteryx
The wings would have provided archaeopteryx with the agility and speed to catch insects in the air and to escape into the trees away from larger predators.

Archaeopteryx Side View
Fossilized wing feathers demonstrate very clearly that archaeopteryx was capable of flight, but most paleontologists believe their flight would have been limited to gliding and short sprints, rather than the soaring we see in birds today.

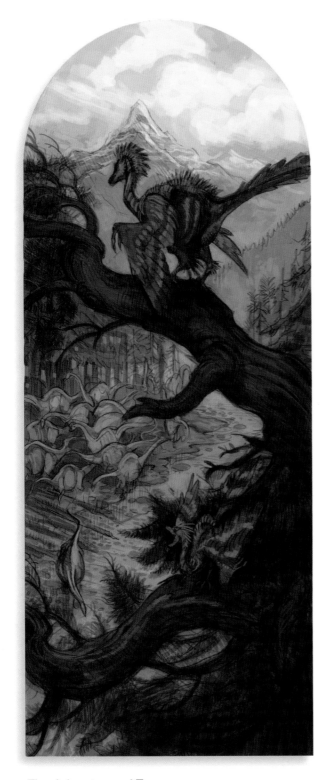

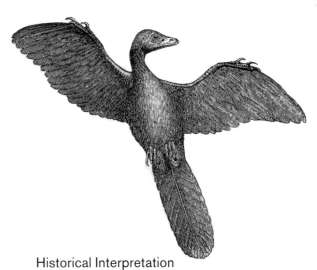

Historical Interpretation
A nineteenth-century reconstruction of archaeopteryx.

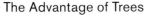

Archaeopteryx Sketch Study

The Advantage of Trees
The archaeopteryx possessed the ability to use the trees as shelter. Small creatures living in the canopy provided a food source. Although it is unknown whether they nested in trees, trees did provide archaeopteryx a safe perch and the ability to migrate over a larger range.

Visit impact-books.com/hall-of-dinosaurs to download free bonus materials.

29

ARCHAEOPTERYX

When designing the image of the archaeopteryx, I wanted to illustrate some of the characteristic behavior we often see in modern birds. My goal of this painting was to illustrate some scale since the archaeopteryx is so small compared to many other dinosaurs of its day. Since paleontologists believe it to be capable of only short flight, I imagined a rookery of animals nesting together on the ground like modern pheasant or quail in a thicket of cycads.

In paleoart, it is common for artists to depict big monster combat scenes among large dinosaurs, which is cool, but probably not always accurate. Here, I chose to have the archaeopteryx nests raided by a large carnivore theropod. I imagined the archaeopteryx taking flight and attempting to attack the predator like when a smaller birds' nest is attacked by a modern-day hawk or raptor. Unless its choice of prey is old or injured, or the carnivore is working in a pack, it seems more likely that a large carnivore would attack smaller animals to avoid injury. An allosaurus would probably want to attack an adult stegosaurus no more than a modern lion would attack a rhinoceros, but perhaps an archaeopteryx would make a nice snack.

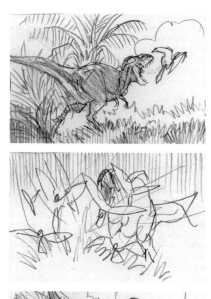

1 PRELIMINARY THUMBNAIL SKETCHES

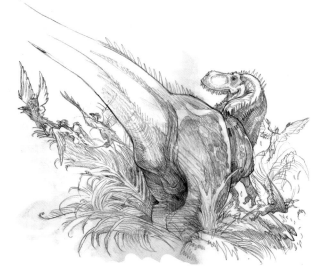

2 SKETCHING THE FINAL DRAWING

Use your thumbnail sketches to establish the composition of the carnivore flushing out the nest of birds. Rendering several archaeopteryx in a variety of positions gives the scene a 3-D effect and establishes a sense of motion.

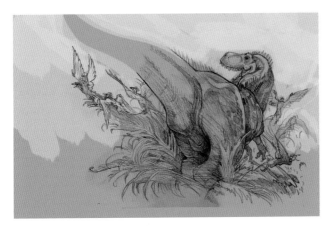

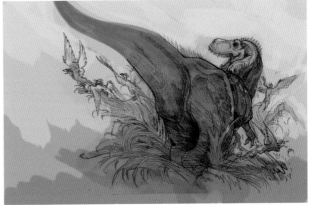

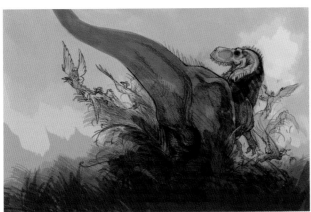

Color Palette

3 ESTABLISHING THE UNDERPAINTING

With such an unusual composition, strong lighting is necessary to define the shapes. A bright light-blue background with a saturated dark-green warm foreground helps add depth to the design. I used broad brushes to define the scene with shapes of light and color.

ALLOSAURUS

The *allosaurus* was a large, agile apex predator of the Jurassic Era able to sprint up to 20mph (32km). Juvenile allosaurus presented more danger to smaller ground-dwelling prey, giving the flying archaeopteryx a great advantage at survival.

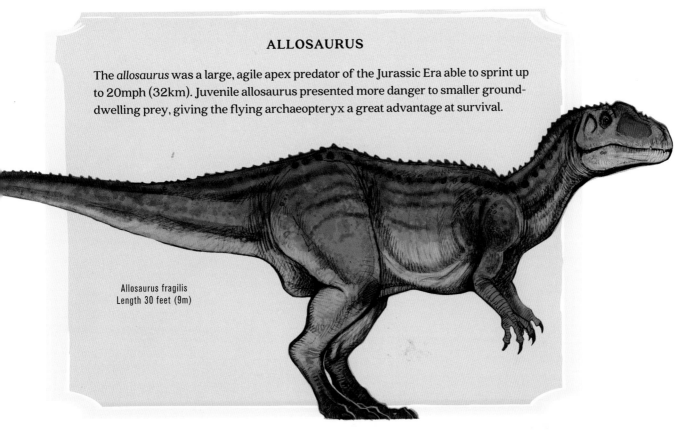

Allosaurus fragilis
Length 30 feet (9m)

Visit impact-books.com/hall-of-dinosaurs to download free bonus materials.

31

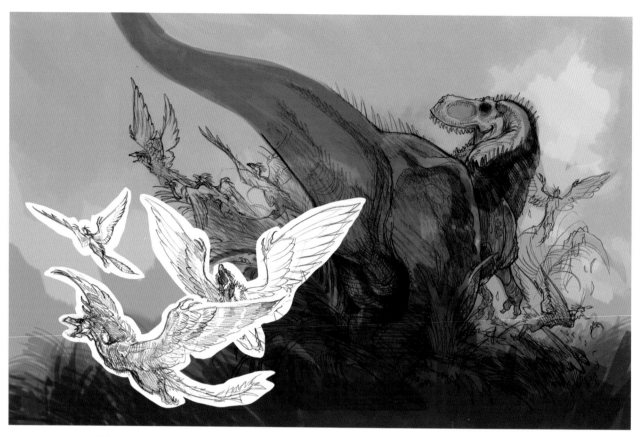

4 IMPROVING THE COMPOSITION

Making alterations to an image is fairly simple when using a computer, but is also normal when working traditionally. At this point in the illustration I felt there needed to be more archaeopteryx in the foreground so the animal could be seen in better detail. Here I digitally imported three sketches directly into my painting, then scaled, rotated and positioned them until I was happy with their size and location.

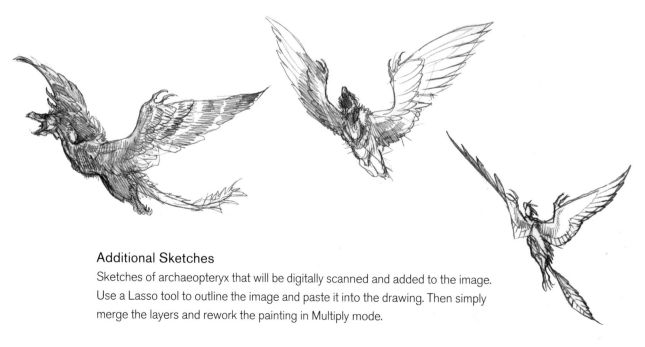

Additional Sketches

Sketches of archaeopteryx that will be digitally scanned and added to the image. Use a Lasso tool to outline the image and paste it into the drawing. Then simply merge the layers and rework the painting in Multiply mode.

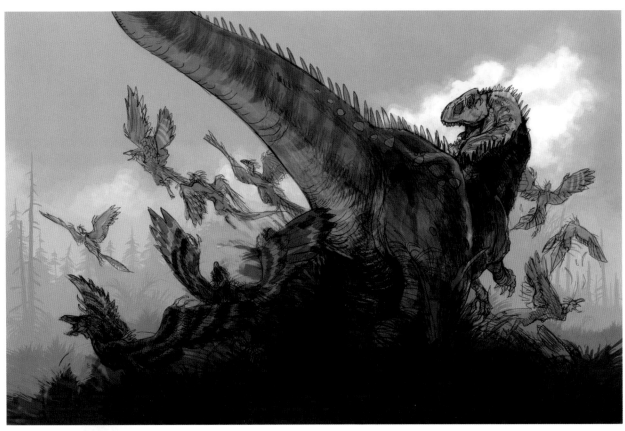

5 COMPLETING THE MIDDLE GROUND AND SUBJECT

Alterations to the head and arms of the carnosaur are made to turn it from a T-rex into a young allosaurus. T-rex was not alive in the Jurassic period and is too big to be in this scale.

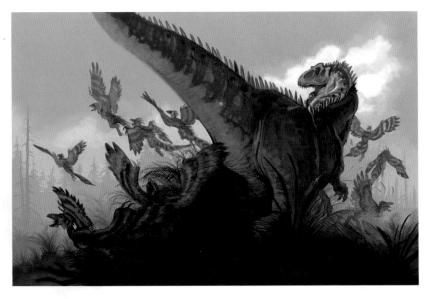

6 ADDING DETAILS TO THE FOREGROUND

The foreground elements in this image are fairly extensive, with a total of ten archaeopteryx depicted in the picture. The animals in the foreground are more detailed than in the background, adding to the sense of depth.

Visit impact-books.com/hall-of-dinosaurs to download free bonus materials.

33

TUTORIAL | Archaeopteryx Head

When you start your drawing, sketch with general forms so you can make alterations regarding proportion and anatomy early on, rather than later when the drawing is almost finished. Slowly define the details such as the tongue, teeth and feathers, then move on to the shadows. Once the drawing is complete, color it in with the medium of your choice.

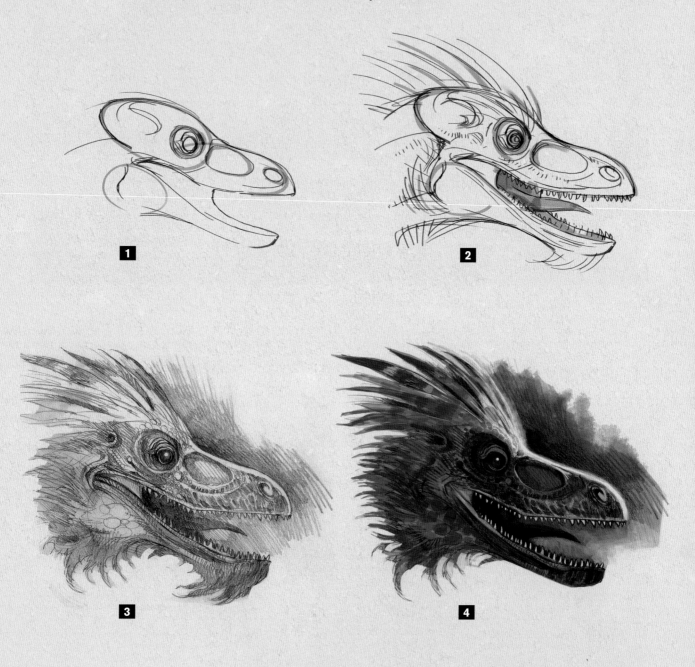

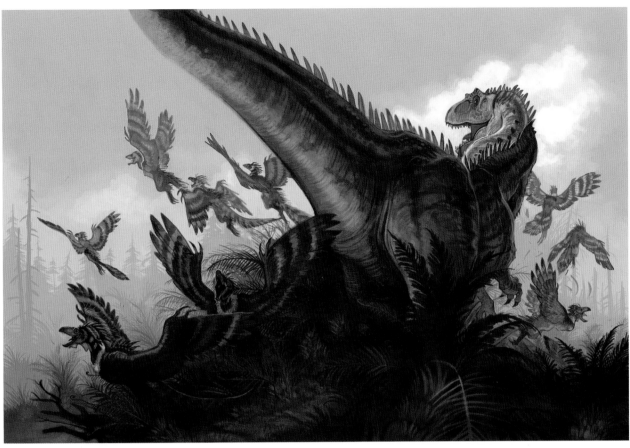

7 FOREGROUND AND FINISHING DETAILS

Add the final details to the scene. Since there is no way to know the exact color of the feathered plumage on an archaeopteryx, this is where the artist's imagination is important. For this painting, I based the colors on a blue jay since they are a large and aggressive insectivore, much like archaeopteryx would have been. Cycad plants in the extreme foreground help create depth in the picture.

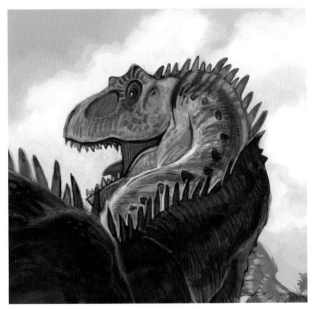

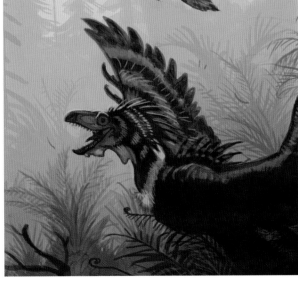

Details of Allosaurus and Archaeopteryx Heads

PRONUNCIATION | KAR-no-TAWR-us

SPECIES | *Carnotaurus sastrei*

NAME | Meat-eating Bull

FAMILY | Abelisauridae

PERIOD | Cretaceous

DIET | Herbivore

SIZE | 25 feet (8m)

YEAR DISCOVERED | 1985

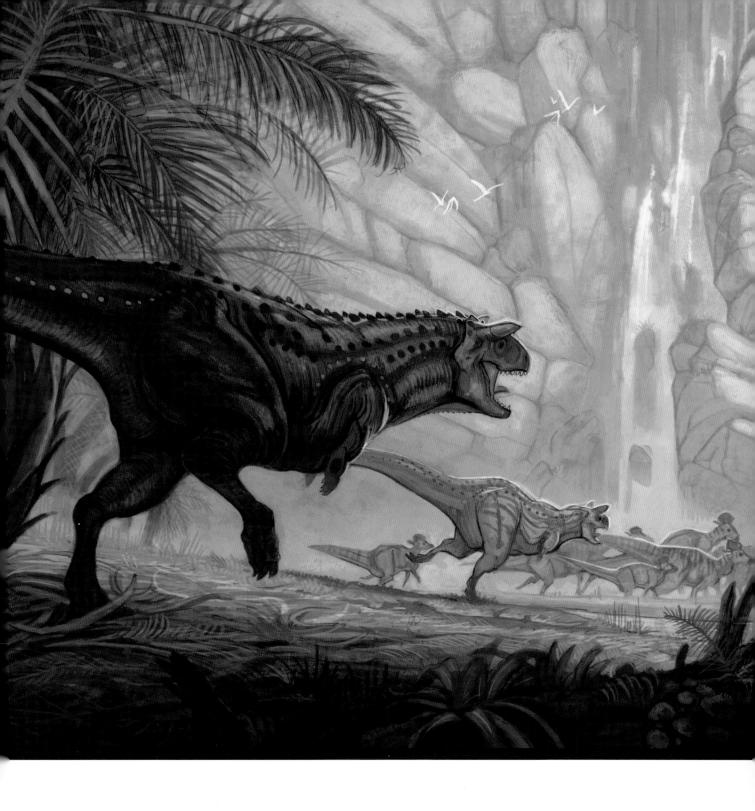

CARNOTAURUS

DESCRIPTION AND BIOLOGY

Carnotaurus was the Cretaceous land shark. Fast, agile, ferocious and covered in spikes, this bipedal carnivore gives T-rex a run for title of King of the Cretaceous. Carnotaurus was a unique and dangerous predator with its distinctive blunt-nosed face, formidable brow horns and bristling hide. Discovered fairly recently, the carnotaurus is known from only a limited source of fossils.

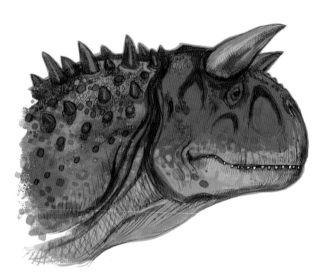

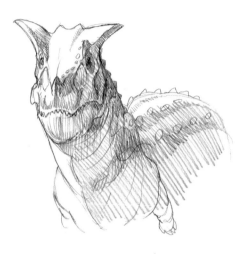

Carnotaurus Profile

Its short muzzle and thin snout with small teeth would allow the carnotaurus to strip meat close to the bone. Thick bull-like horns and spikes might have been used like modern bulls for sparring among rivals.

Horns Served Important Roles

The horns of the carnotaurus may have been for rutting males or to protect the eyes during attacks.

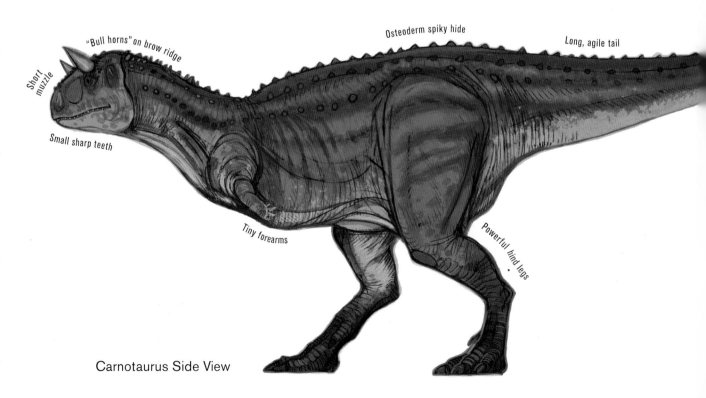

"Bull horns" on brow ridge

Short muzzle

Small sharp teeth

Tiny forearms

Osteoderm spiky hide

Long, agile tail

Powerful hind legs

Carnotaurus Side View

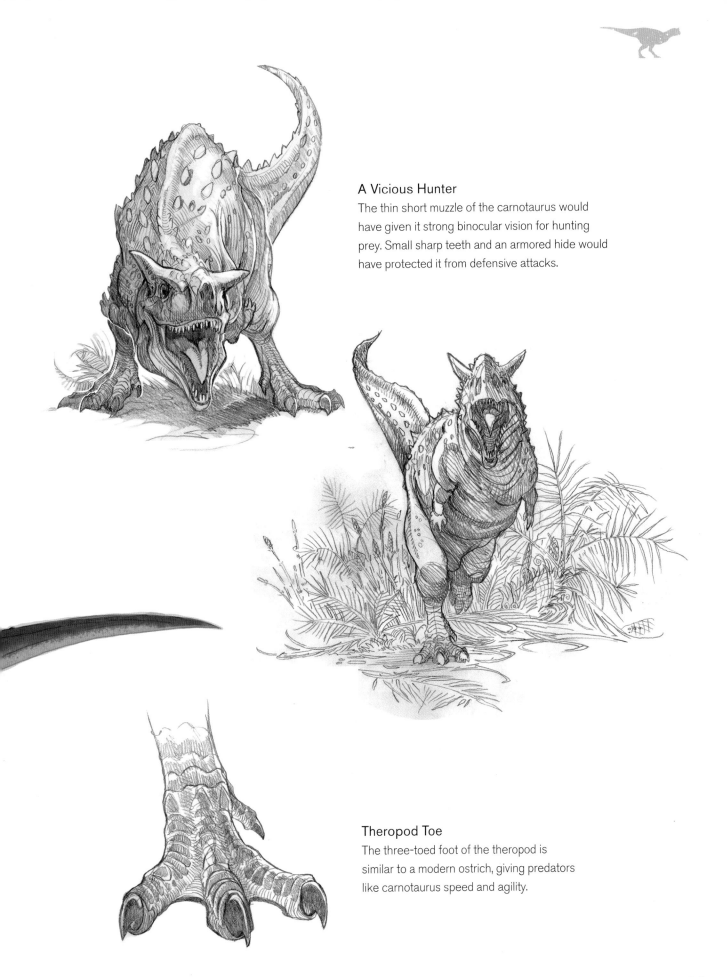

A Vicious Hunter

The thin short muzzle of the carnotaurus would have given it strong binocular vision for hunting prey. Small sharp teeth and an armored hide would have protected it from defensive attacks.

Theropod Toe

The three-toed foot of the theropod is similar to a modern ostrich, giving predators like carnotaurus speed and agility.

Demonstration

CARNOTAURUS

For this demonstration, my goal was to convey the great speed of the carnotaurus. For a predator of its size it would have been impressively quick and nimble on the hunt. Where T-rex is speculated to have been a lone scavenger, I wanted the carnotaurus to seem more social, hunting in a pair. Here, one carnotaurus flushes out a herd of lambeosaurus (see page 87), while the second races out from the grove of cycads to outflank the group.

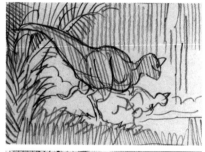

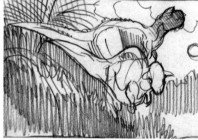

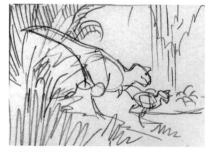

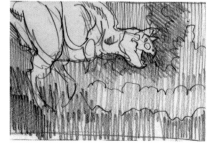

1 **PRELIMINARY THUMBNAIL SKETCHES**
Small postage stamp-sized thumbnail sketches are quickly hashed out to try to come up with a composition for the carnotaurus design.

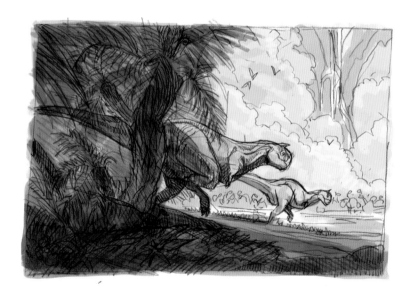

2 **SIMPLE COLOR STUDY**
Producing a quick color composition of the sketch will help you decide how to approach the lighting. Here, my initial concept is to set the scene against a brilliant forest of ginkgo trees turned golden in the sun. This will contrast perfectly with the purple tones I've selected for the carnotaurus.

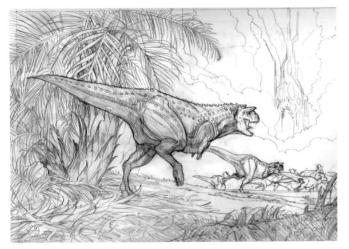

3 SKETCHING THE FINAL DRAWING

Using your thumbnail sketches and reference material, render the detailed sketch with pencil on paper.

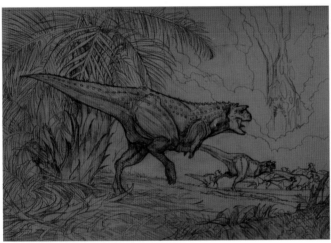

4 SCANNING THE DRAWING

Whether working digitally or traditionally, the process of blocking in the local color remains the same. I know that I want my painting to have an overall purple hue such as in the shadows, so I start by importing the scanned drawing into the computer and adjusting the color balance to purple.

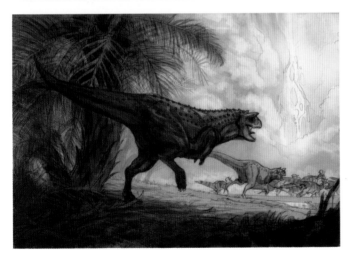

5 ESTABLISHING THE UNDERPAINTING

Create a new layer over the sketch, and fill the layer with purple to tint the canvas. Work with a variety of stipple and splatter brushes to loosely block in the local colors from the planned color scheme.

Color Palette and Key Brush

This is the basic color palette that I used for the painting. Purple against yellow creates a striking contrast.

Visit impact-books.com/hall-of-dinosaurs to download free bonus materials.

41

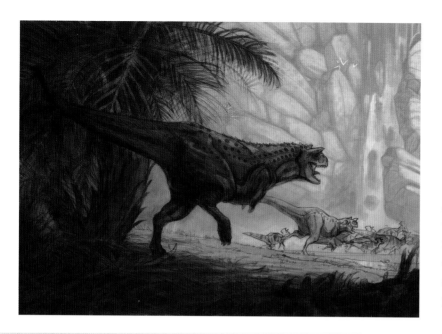

6 COMPLETING THE BACKGROUND

In the background, what I had originally conceived as a stand of trees is transformed into a wall of stone. This supports the narrative of the hadrosaurs being herded by the carnotaurus into a killing zone. To enhance the sense of scale, I added a second carnotaurus in the background to force perspective and create the illusion of space. This technique is a common artist's tool. If you have two of the same elements at different sizes, place the smaller one farther away.

TUTORIAL | Carnotaurus Sketch

Begin the carnotaurus sketch with a simple skeletal frame. Once the basic anatomical features have been established, render the dino's flesh, spikes and facial details. See page 38 for the finished colored drawing.

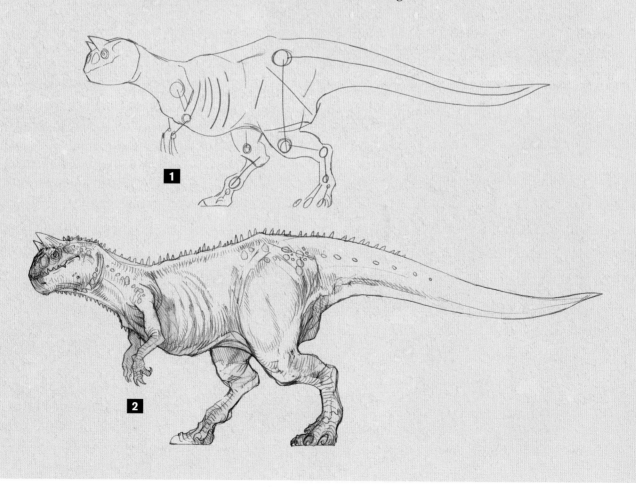

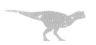

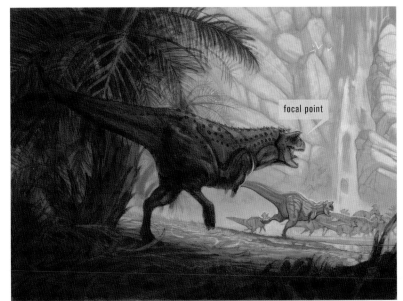

7 COMPLETING THE MIDDLE GROUND AND SUBJECT

Render the details of the central carnotaurus to bring it into sharper relief as the focal point. Add teeth, facial markings and spikes to further draw the viewer's attention into the composition.

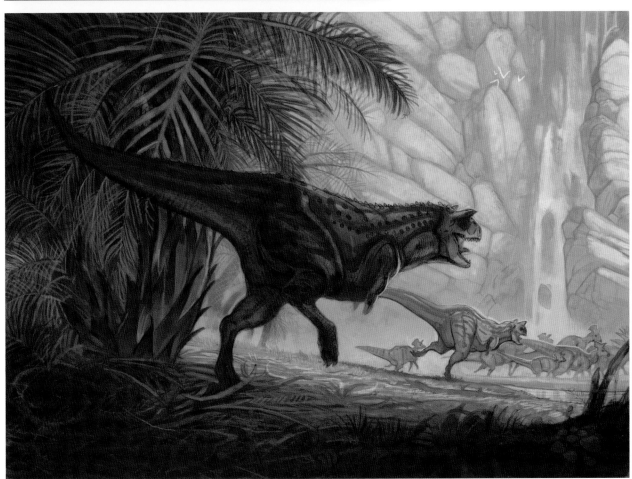

8 FOREGROUND AND FINISHING DETAILS

Once the central subject has been rendered, finalize the foreground framing element. The palm fronds, mushrooms and fallen logs helps push the illusion of depth by creating a strong frame. Use textured brushes and more opaque paint with more saturated colors to flesh out the details.

Visit impact-books.com/hall-of-dinosaurs to download free bonus materials.

43

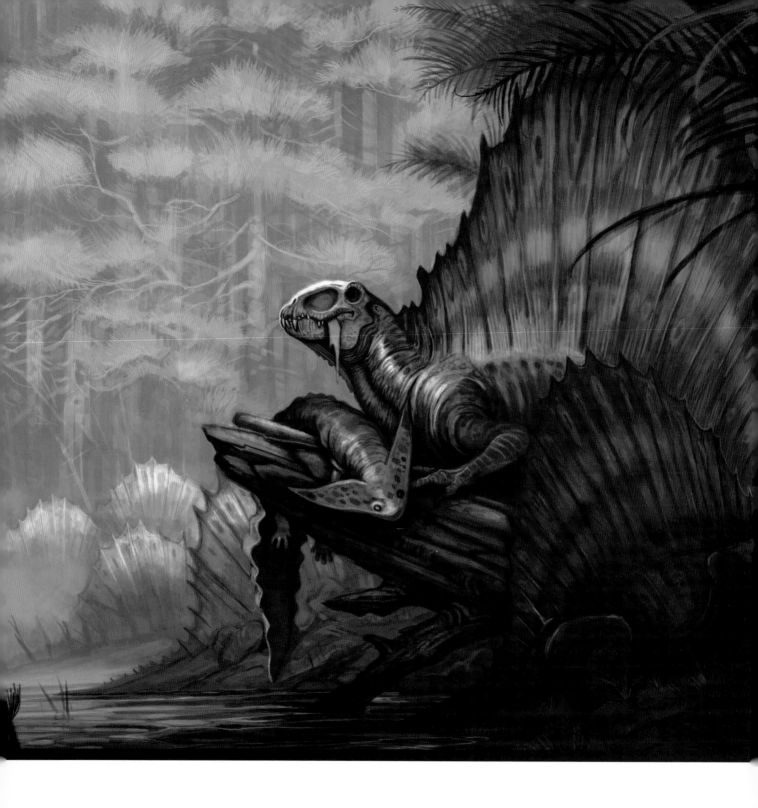

DIMETRODON

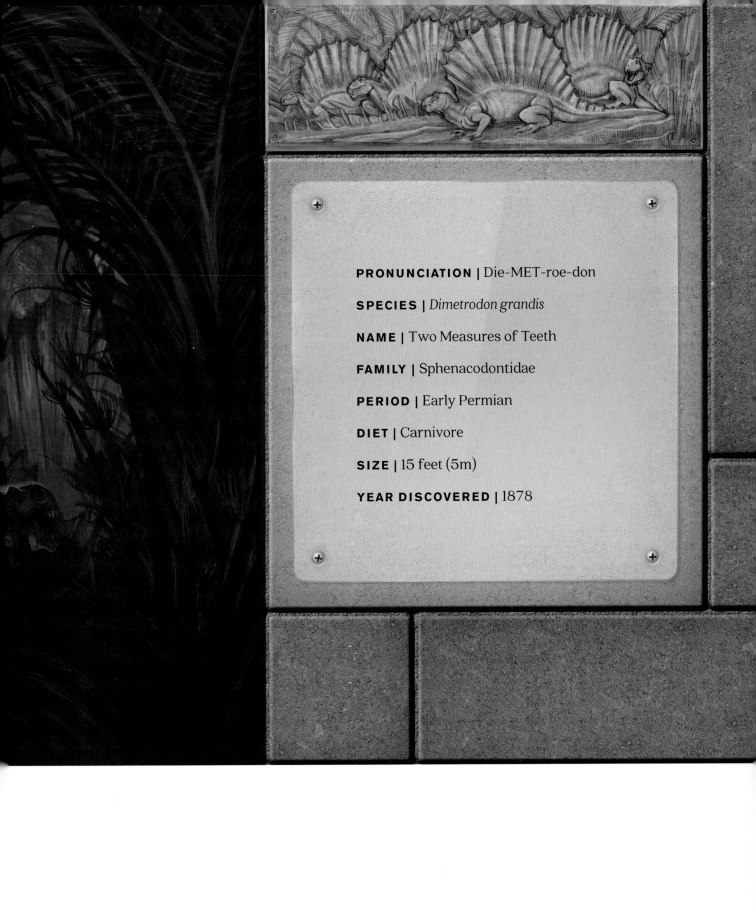

PRONUNCIATION | Die-MET-roe-don

SPECIES | *Dimetrodon grandis*

NAME | Two Measures of Teeth

FAMILY | Sphenacodontidae

PERIOD | Early Permian

DIET | Carnivore

SIZE | 15 feet (5m)

YEAR DISCOVERED | 1878

Dimetrodon is perhaps the most famous dinosaur that is not actually a dinosaur—it went extinct 40 million years before the first appearance of dinosaurs. It is in the synapsids group and is more closely related to mammals than dinosaurs. These meat-eating mammal-like reptiles were the apex predators of the time before dinosaurs. Their name "Two Measures of Teeth" refers to the combination of large biting fangs at the front of the mouth and the grinding canines in the rear, not dissimilar from a cat or dog of today.

Dimetrodon Gait

With a wide reptilian stance, dimetrodon would have had a whiplike gait and run much like a crocodile or Komodo dragon. It was possibly capable of short bursts of speed.

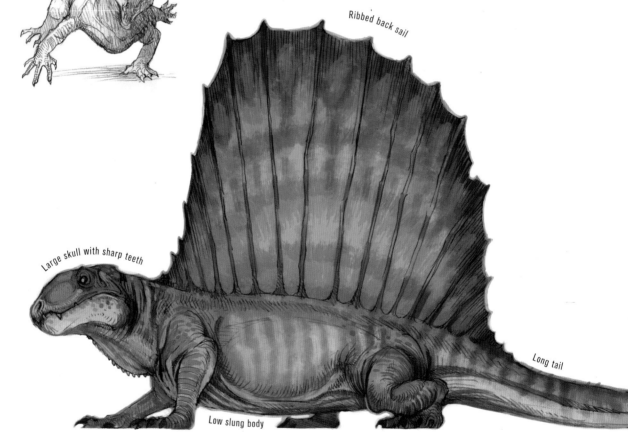

Ribbed back sail

Large skull with sharp teeth

Low slung body

Long tail

Dimetrodon Side View

The dimetrodon is most famous for the large sail along its spine used for regulating temperature. This blood-filled sail might have also been capable of changing colors, such as brightening in danger to ward off a threat or to attract a mate, not unlike a peacock's tail. Various other species in dimetrodon's Sphenacodontidae family ranged in size from large crocodiles to medium-sized lizards.

Head in Profile

Dimetrodon was a carnivore. Its massive bull-like head was filled with large teeth similar to that of an alligator. The small eyes perched high on its head and large nasal cavity suggest the dimetrodon was a lurking hunter that possibly waded in shallow water, locating its prey by smell.

DIPLOCAULUS

A common prey of dimetrodon, the *diplocaulus* was a large amphibian with a boomerang-shaped head. This salamander-like creature would have been common throughout the swamps and waterways of the Permian period feeding on small fish and giant insects. Its large, flat body would allow it to glide through muddy shallows.

Diplocaulus magnicornus
Length 3 feet (1m)

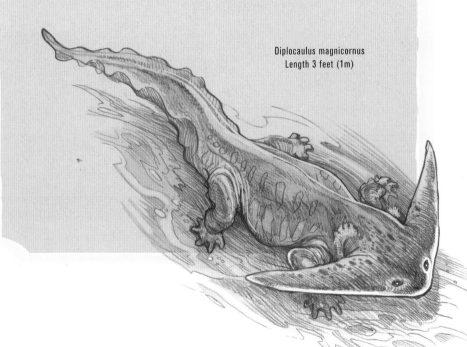

Visit impact-books.com/hall-of-dinosaurs to download free bonus materials.

47

DIMETRODON

To begin the dimetrodon painting, my first idea was to illustrate a primeval riverbank of the Permian period, the last part of the Paleozoic Era, with a pack of dimetrodon gathered in groups like crocodiles or marine iguanas. Like sunbathing crocs, they would be sluggish on the banks of the river while the sails of their backs soaked in the warming rays. My goal is to illustrate different sizes of dimetrodon, the young being considerable smaller than older specimens.

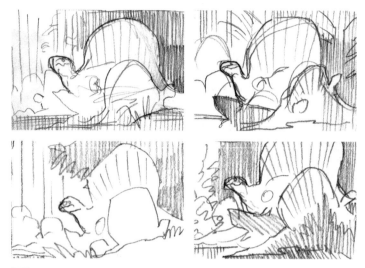

1 PRELIMINARY THUMBNAIL SKETCHES

Loosely sketch a series of quick thumbnail designs to compose the final image.

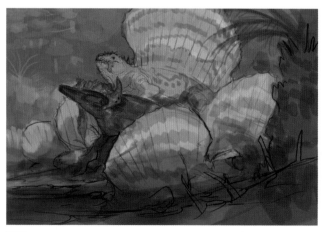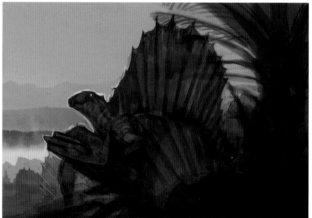

2 SIMPLE COLOR STUDIES

The desert scene on the left incorporates paleontological studies that place dimetrodon in scrubby, arid terrain, so I experimented with a morning desert scene. The shaded design on the right illustrates how the sun might fall upon the dimetrodon sails in the cool shade of a Permian glade along the river.

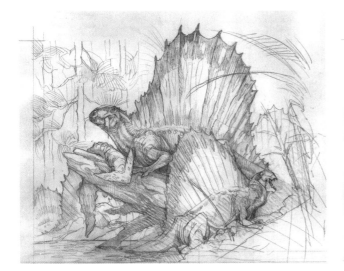

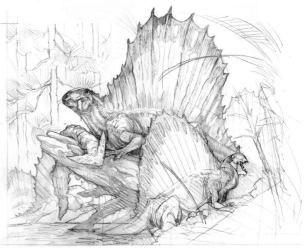

3 SKETCHING THE FINAL DRAWING

After gathering reference and choosing a composition, sketch the scene in full using a pencil or the medium of your choice.

4 SCANNING THE DRAWING

Bring the drawing into the computer and resize the image to fit a horizontal design format. Adjust the contrast levels as needed.

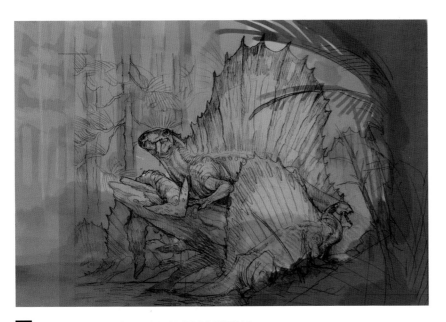

Color Palette

5 ESTABLISHING THE UNDERPAINTING

Block in broad areas of the composition with a cool color palette to indicate the wet, muddy riverbank and glade. Don't worry about details at this point; instead, loosely paint shapes of color and light to establish the design.

Visit impact-books.com/hall-of-dinosaurs to download free bonus materials.

49

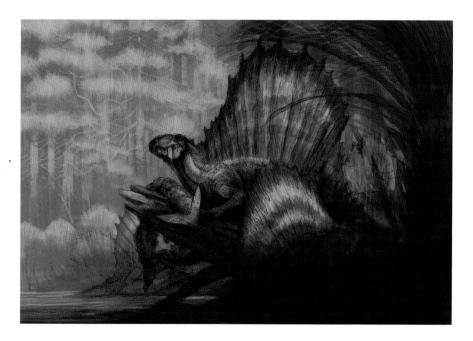

6 REFINING THE BACKGROUND DETAILS

Once the overall light, shadow and color has been established in the blocking-in stage, render the smaller details with small brushes and saturated colors.

TUTORIAL | Dimetrodon Sketch

To draw a dimetrodon, start sketching the loose outline of the profile silhouette using basic anatomical placement of the joints and spinal column. Add details over this structure and render the skin texture last. Photo reference of monitor lizards is helpful to visualize the anatomy. See page 46 for the finished color drawing.

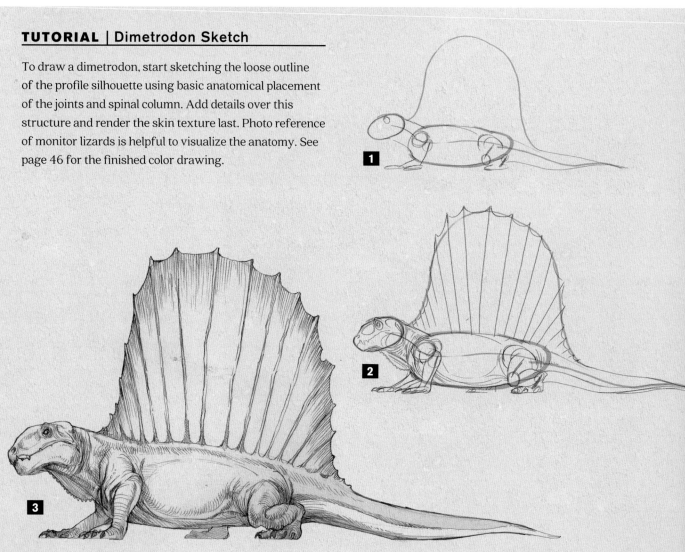

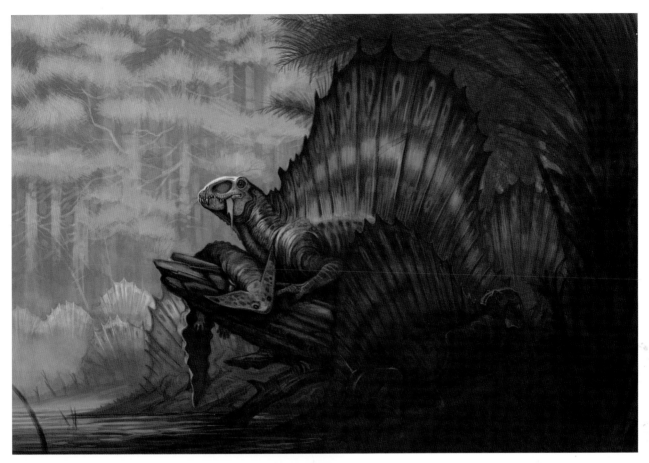

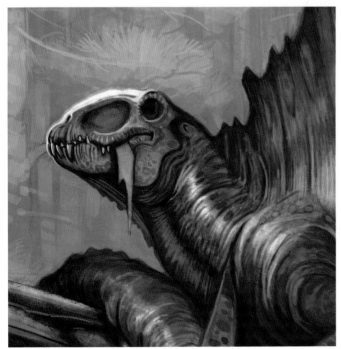

Detail of Dimetrodon Head

7 FOREGROUND AND FINISHING DETAILS

Rendering details like the large palm tree on the right and some horsetail swamp grass in the lower-right foreground will frame the image and create a natural looking environment. The details are purposefully dark and subtle to help the viewer focus on the central element of the dimetrodon head. I like to think of creating an image like designing a stage. The spotlight is on the action, but the sidelines are just as important.

Visit impact-books.com/hall-of-dinosaurs to download free bonus materials.

51

PRONUNCIATION | GAL-ee-MIME-us

SPECIES | *Gallimimus bullatus*

NAME | Chicken Mimics

FAMILY | Ornithomimidae

PERIOD | Cretaceous

DIET | Omnivore

SIZE | 20 feet (6m)

YEAR DISCOVERED | 1972

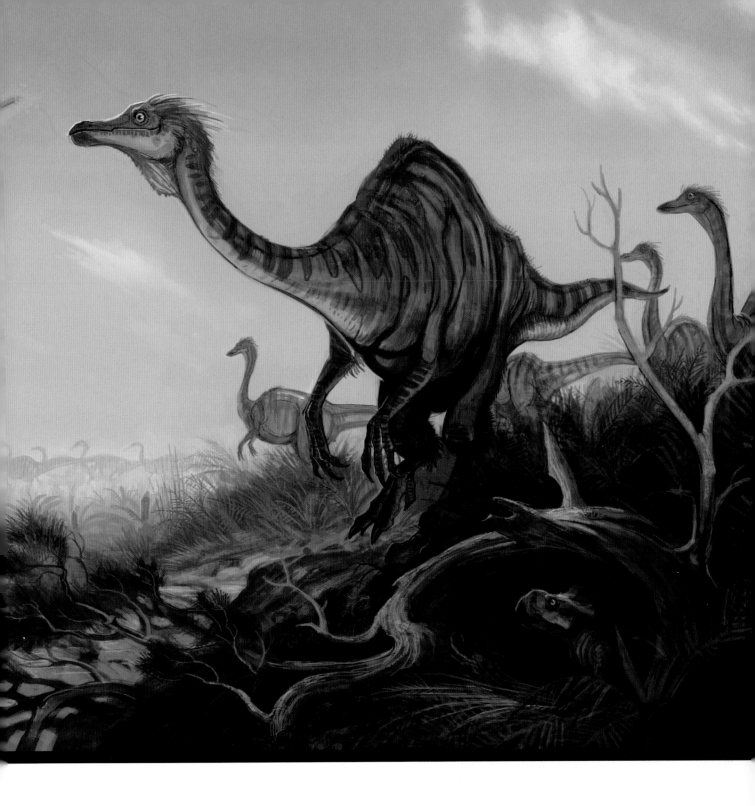

GALLIMIMUS

DESCRIPTION AND BIOLOGY

The long-limbed *gallimimus* is one of the more recent dinosaur discoveries that has led paleontologists to relate dinosaurs to birds. The similarity in morphology between birds and this dinosaur inspired the scientists to name it "Chicken Mimic." At almost exactly the same size and proportion as an ostrich, it is easy to see the linked ancestry to the gallimimus. With their hollow bones, large eyes and toothless beaks, it is believed that all species of the Ornithomimidae family were direct relatives of modern birds.

Head in Profile

With a small birdlike head and beak gallimimus would have fed on a variety of food such as insects and perhaps even small animals. Its large eyes would cast a wide arc and see well even in dim light.

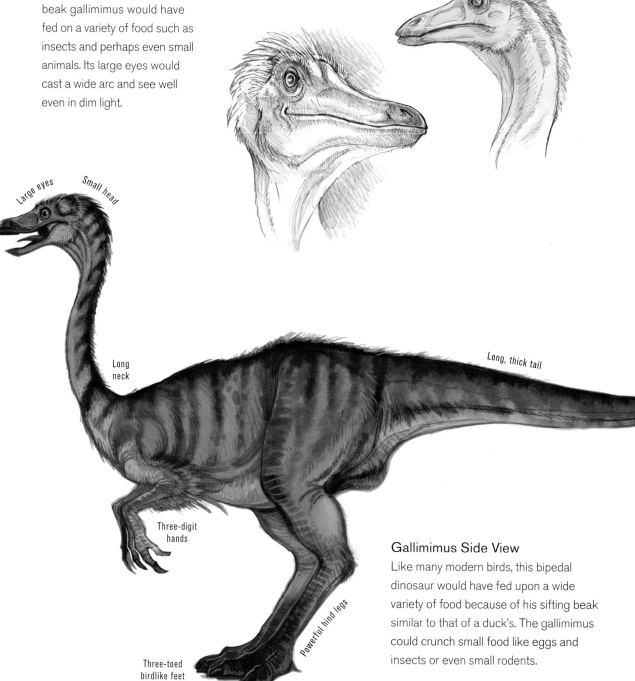

Large eyes

Small head

Long neck

Long, thick tail

Three-digit hands

Powerful hind legs

Three-toed birdlike feet

Gallimimus Side View

Like many modern birds, this bipedal dinosaur would have fed upon a wide variety of food because of his sifting beak similar to that of a duck's. The gallimimus could crunch small food like eggs and insects or even small rodents.

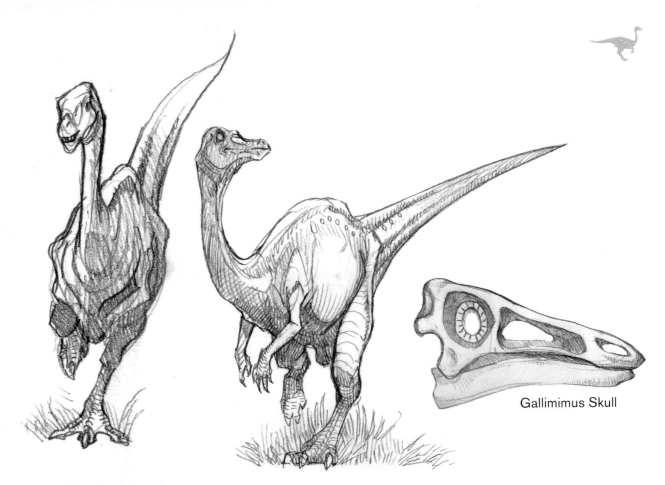

Gallimimus Skull

A Need for Speed

Without armor or horns, speed would have been the gallimimus'
main defense against the large predators of the Cretaceous period.
Ostriches can run up to 40mph (64km), making them the fastest birds
in the world. With its long legs and similar design, the gallimimus could
likely reach similar or even greater speeds.

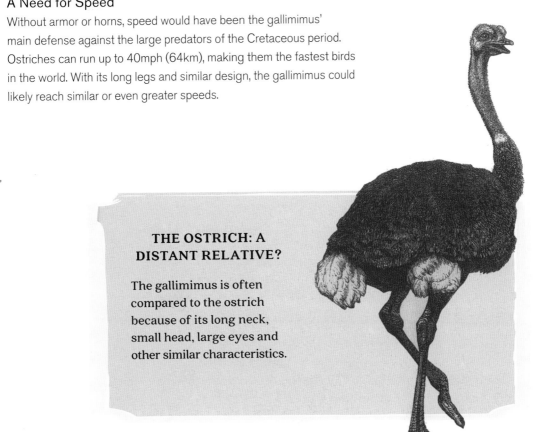

THE OSTRICH: A DISTANT RELATIVE?

The gallimimus is often
compared to the ostrich
because of its long neck,
small head, large eyes and
other similar characteristics.

Visit impact-books.com/hall-of-dinosaurs to download free bonus materials.

55

GALLIMIMUS

My goal for the gallimimus was to illustrate a large flock roaming across a wide plain. There would have been no rolling fields of grass like in today's great plains. The scrubby evergreen ground cover and cycads would be home to insects, grubs, burrowing mammals, dinosaur eggs and small reptiles, an abundant food supply for the foraging gallimimus. The herd would likely have followed animal paths through the brush or dried riverbeds and washes, not unlike today's animals. Similar to many bird species, it is possible that vast gatherings of migrating gallimimus would converge at breeding grounds to mate and lay eggs in nests before moving on.

1 PRELIMINARY THUMBNAIL SKETCHES

Working out the design and composition in quick thumbnail sketches is an essential first step to starting a drawing.

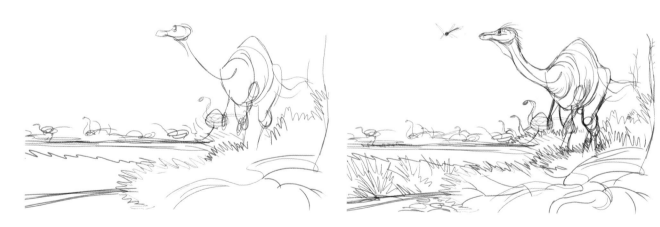

2 SKETCHING THE FINAL DRAWING

Loosely draw out your composition. This image was sketched in the computer using a drawing tablet and stylus with my thumbnails from my sketchbook as a guide. I added a dragonfly in the foreground that has attracted the gallimimus' attention. This invertebrate evolved hundreds of millions of years ago and would make a nice tasty morsel to a hungry dinosaur.

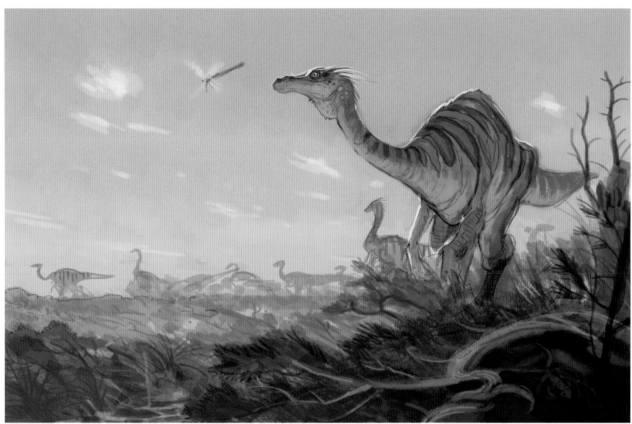

3 **ESTABLISHING THE UNDERPAINTING**

Using a variety of texture brushes and broad strokes, block in the basic forms of the image, trying to achieve an overall environmental effect rather than a detailed drawing. I want the scene to look hot and sunny in a wide open plain, the flock of gallimimus creating a dust cloud in the background.

Color Palette

CREATE YOUR OWN CUSTOM BRUSHES

There are many digital painting programs out there and they each provide myriad default brush shapes with parameters you can alter. Experiment with the settings and build your own set of custom brushes.

Scribble-Scrabble Brush
I named this fun custom brush "scribble-scrabble." It is helpful for laying down a block of texture for brambles, grass or underbrush.

Texture Brush for Bark and Stone
I applied many variables to the brush tip shape such as Dual Brush, Scattering, Texture and Wet Edges to create this custom brush useful for tree bark and stone textures.

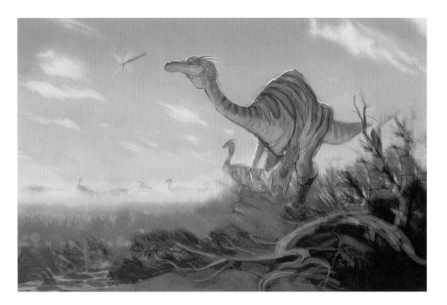

4 REFINING THE BACKGROUND DETAILS

The scene of a gallimimus herd is a great opportunity to use the forced perspective technique between the background and foreground. In the hazy dusty distance, the flock of gallimimus creates visual space using atmospheric perspective between the different elements.

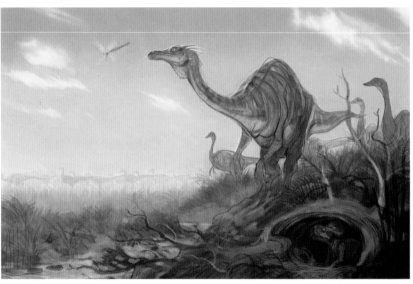

5 COMPLETING THE MIDDLE GROUND AND SUBJECT

Moving toward the viewer the details become more focused and the main dinosaur subject in the central spotlight begins to occupy the focal point in the design. The addition of several middle ground gallimimus adds more depth, as well.

Detail of Microceratus

What began as a burrowed small lizard in the foreground of my initial sketches has evolved into a microceratus. At this stage you can still see the sketch lines and rough blocking of color. See page 101 for more on the microceratus.

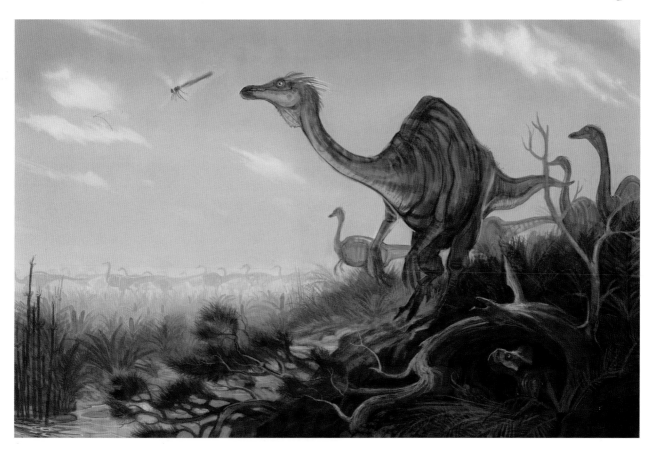

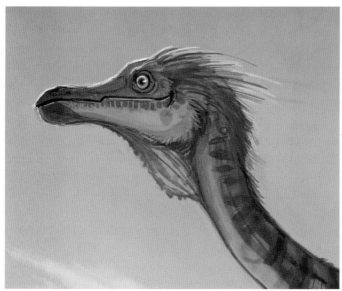

Detail of Gallimimus in Profile

6 FOREGROUND AND FINISHING DETAILS

Moving into the foreground, add environmental details to create realistic texture that strongly contrasts against the smooth blue background. The small gully helps lead the viewer's attention from our space into the picture space much like a pathway. A small creek like this in the desert would host an oasis of life. Reptiles, insects and every plant of the region would compete to be near the riverbank. I've included cycads, scrub evergreens, horsetails and palms. The strong vertical branch on the right helps the composition flow up out of the dark corner.

Visit impact-books.com/hall-of-dinosaurs to download free bonus materials.

59

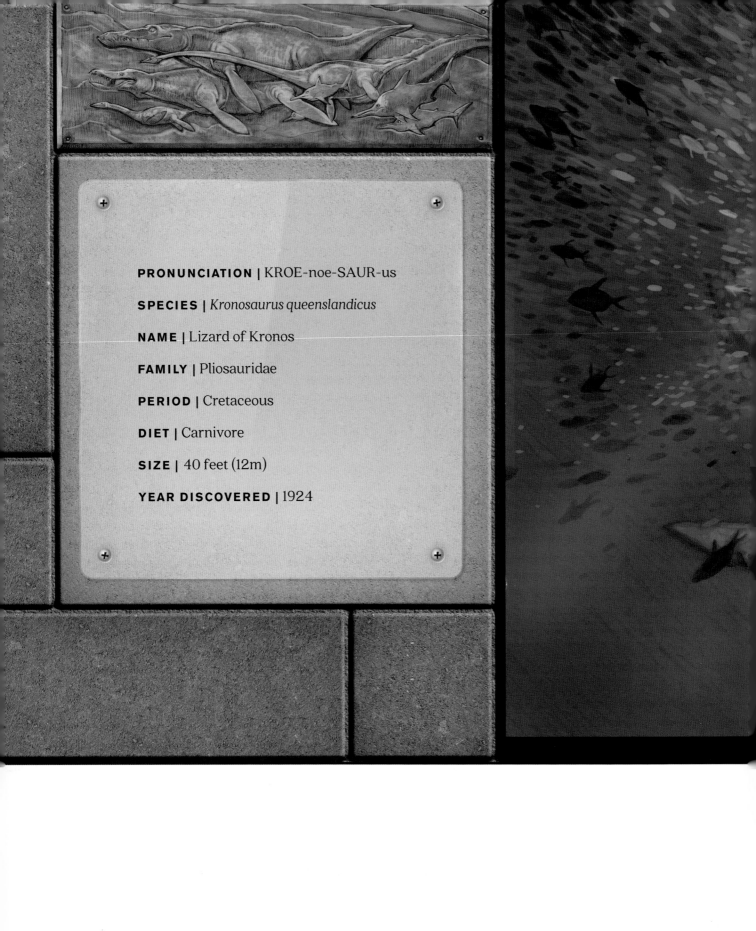

PRONUNCIATION | KROE-noe-SAUR-us

SPECIES | *Kronosaurus queenslandicus*

NAME | Lizard of Kronos

FAMILY | Pliosauridae

PERIOD | Cretaceous

DIET | Carnivore

SIZE | 40 feet (12m)

YEAR DISCOVERED | 1924

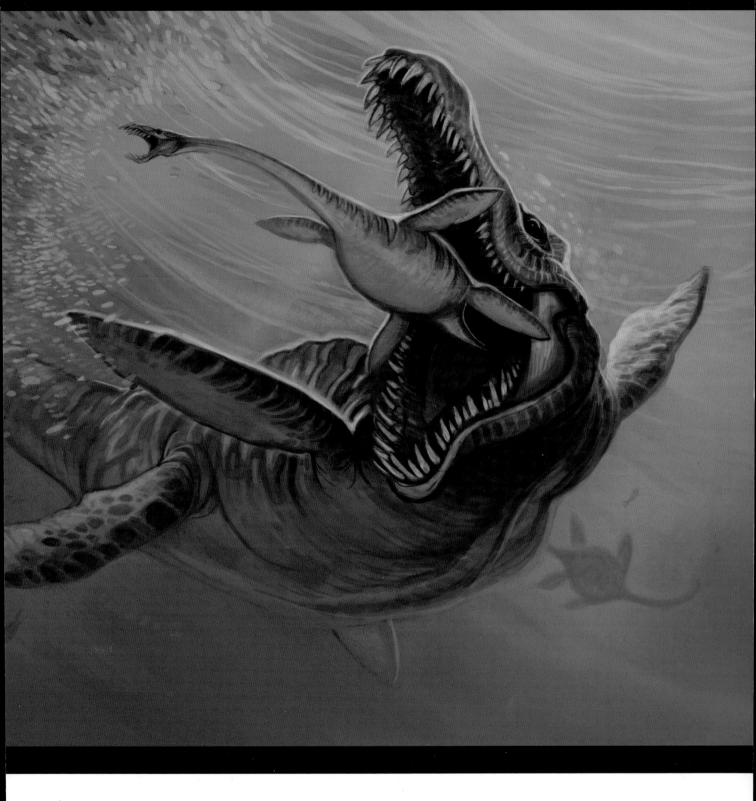

KRONOSAURUS

DESCRIPTION AND BIOLOGY

Dinosaurs are one of the most successful and varied classes of animals in earth's history, adapting and evolving over 200 million years to dominate not only the land and the air but also the sea. *Kronosaurus*, perhaps the largest carnivorous dinosaur, was a titan among titans. Named after supreme Greek god Kronos, this marine dinosaur of the Pliosauridae family was large and powerful enough to eat a tyrannosaurus and was one of the undisputed apex predators of the Mesozoic Era.

Despite its massive size, kronosaurus would have needed to beach itself in order to lay eggs much like today's sea turtles. The vulnerable position of this behavior would have made even the biggest specimens subject to attack, and the hatchlings would make easy prey for Cretaceous-period predators.

Diet

The sleek flippered body of the kronosaurus would be capable of impressive bursts of speed when hunting its prey of large fish, sharks and other marine dinosaurs.

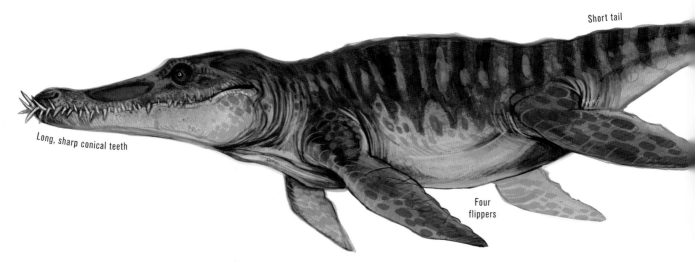

Short tail

Long, sharp conical teeth

Four flippers

Kronosaurus Side View

It is likely that an adult kronosaurus living to its maximum size would be rare, much like adult sea turtles and their hatchlings. Paleontological discoveries have shown another marine dinosaur, the ichthyosaurus (see page 67), to have carried their unborn inside them for live birth at sea. If this is true, then marine dinosaurs would have evolved this trait millions of years before marine mammals like whales.

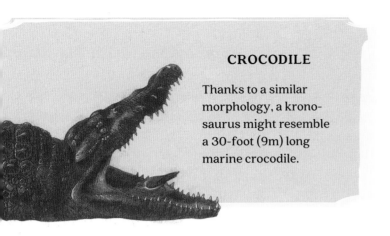

CROCODILE

Thanks to a similar morphology, a kronosaurus might resemble a 30-foot (9m) long marine crocodile.

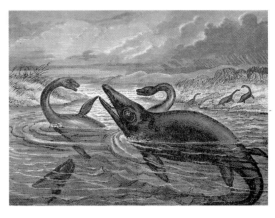

Historical Interpretation
A nineteenth-century reconstruction of kronosaurus.

Hunting Style
The huge carnivorous marine dinosaur would likely cruise lazily in the warm shallows of the Pangaean Sea allowing the sun to warm its massive body, similar to a crocodile or great white shark. But unlike a shark's body that needs to keep moving, kronosaurus may even have simply drifted, waiting for a hunting opportunity to present itself.

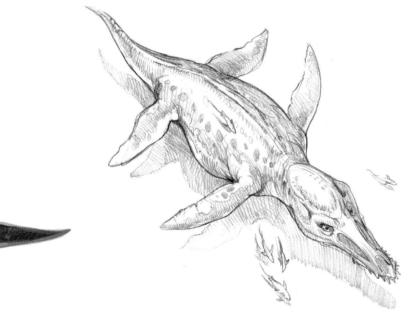

An Impressive Jaw
With a massive jaw and teeth similar to its crocodilian cousin, kronosaurus could have likely killed its prey with one great bite. Its oversized head and long, thick teeth could snap and hold onto its prey, possibly even using a crocodile-like death roll to drown and kill it. This is in contrast to sharks, whose serrated, razor-sharp teeth are used to separate its prey into small pieces.

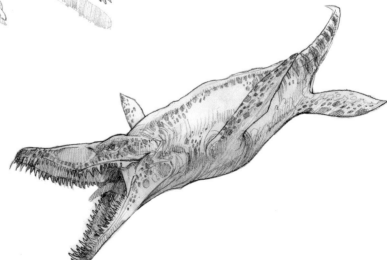

KRONOSAURUS

Kronosaurus must have been extremely beautiful to behold much like a great white shark today. Spending most of its time slowly cruising the shallow, warm seas of Pangaea, it would possess massive power, able to explode into attack speed. It might even breach the water's surface or surf onto beaches like killer whales to snatch wading, unsuspecting hadrosaurs. The sheer inertia of the attack would be enough to kill any animal with a single bite. I tried to imagine this power in visual form.

In this scenario, my goal was to illustrate a variety of animals in the food chain, just as we see in today's oceans. Schools of sardines attract larger predators like elasmosaurus, and the presence of elasmosaurus brings the megahunter kronosaurus in from hiding for a meal in the swirling chaos. There's always a bigger fish.

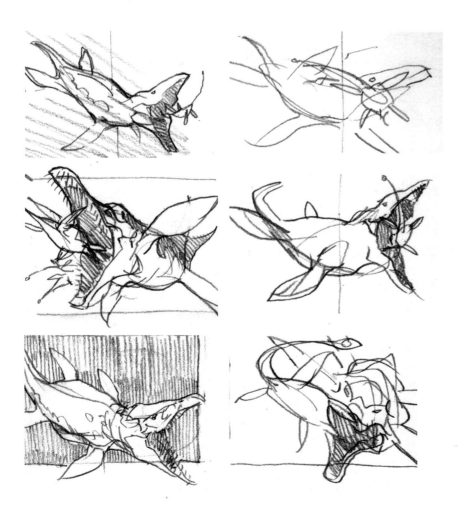

1 PRELIMINARY THUMBNAIL SKETCHES

Quickly rough out some basic design options. The sensation of flying and swift movement are my goals, so the central element of the kronosaurus needs to float in the composition without touching the sides or bottom.

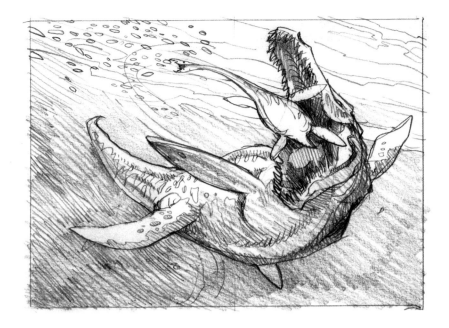

2 SKETCHING THE FINAL DRAWING

I want to achieve a twisting shape to the kronosaurus so I look to killer whales, which are approximately the same shape and size and possess similar hunting techniques. Watching a few online videos gives me the inspiration I need to complete the final drawing on an 11" × 15" (28cm × 38cm) piece of paper.

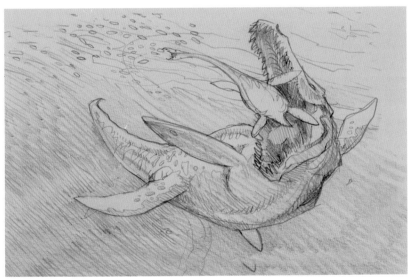

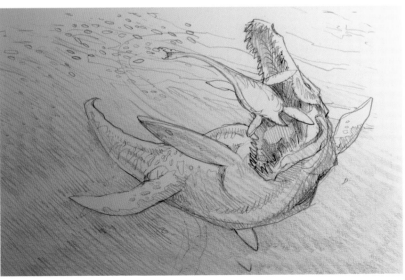

3 ESTABLISHING THE UNDERPAINTING

The most important step of the underpainting is to establish the direction and quality of the light source. Light in water quickly diffuses, which is helpful when establishing perspective in an environment with no objects to help establish scale and distance. To depict the kronosaurus' massive size in this image, I created the illusion of a tail so big that it almost disappears into the murky depths. In this stage I'm using a digital gradient tool multiplied over the drawing. I've chosen an aqua green foreground and a deep blue background in a simple linear blend from top right to bottom left.

Visit impact-books.com/hall-of-dinosaurs to download free bonus materials.

65

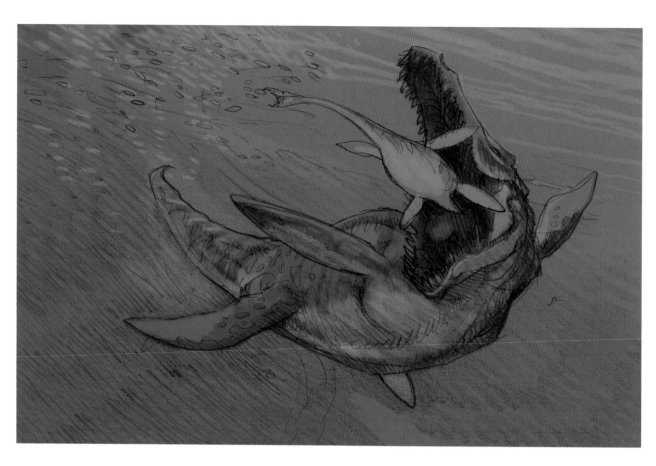

DIFFUSE A WATER SCENE

Select a wide, soft airbrush with a feathered edge to depict broad shapes of color and light then blend gradients of diffused water. I tried to use limited texture to render the environment since water becomes darker as it gets deeper.

4 **PAINTING WATER**

Now that the basic color palette and lighting of the scene have been established, rough in the surface ripples, dinosaurs and shoal of fish using natural brushes.

66

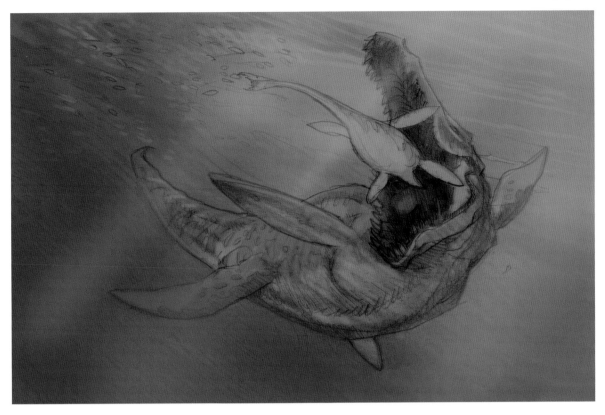

5 CREATING BEAMS OF LIGHT

Working with digital tools allows you to create a variety of painterly effects that would be almost impossible in a more traditional medium. To create sunbeams streaming in from the surface, use a soft airbrush at a low opacity/flow (10%) to quickly "snap" straight lines. To do this, click the brush in one spot then shift-click in a second spot to snap a straight brush line. Try different brush modes and separate layers such as Color Dodge or Lighten to experiment with a variety of effects. Layer and erase the texture at the bottom of the painting to smooth out the effects.

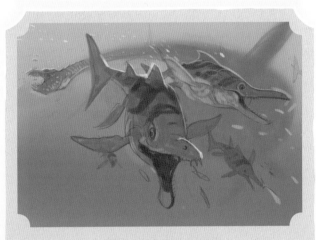

ICHTHYOSAURUS

The *ichthyosaurs* ("Fish Lizards") were a Mesozoic family of marine dinosaurs that filled the primeval oceans. These fleet dolphin-like dinosaurs, close in size to modern porpoises, evolved over a hundred million years before the first whales.

Ichthyosaurus communis
Length 6 to 13 feet (2 to 4m)

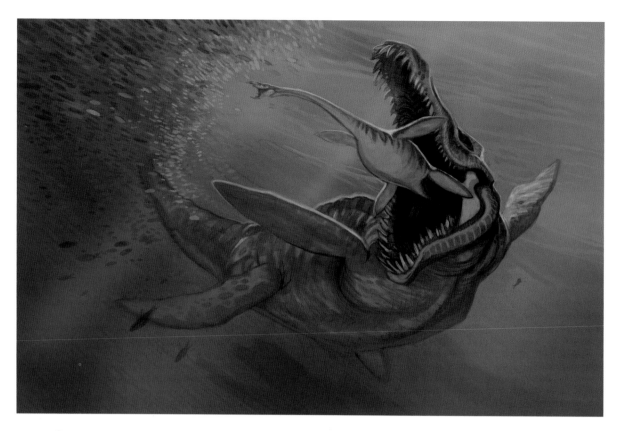

6 **COMPLETING THE MIDDLE GROUND AND SUBJECT**

Once the basic underpainting is established, refine the details and colors. The play of light and shadow on the kronosaurus' big open mouth creates sharp contrast as a focal point.

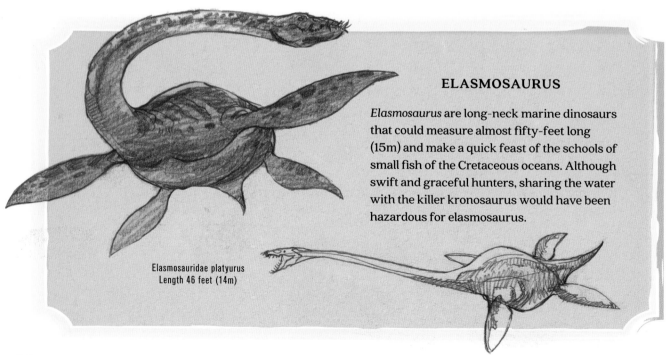

ELASMOSAURUS

Elasmosaurus are long-neck marine dinosaurs that could measure almost fifty-feet long (15m) and make a quick feast of the schools of small fish of the Cretaceous oceans. Although swift and graceful hunters, sharing the water with the killer kronosaurus would have been hazardous for elasmosaurus.

Elasmosauridae platyurus
Length 46 feet (14m)

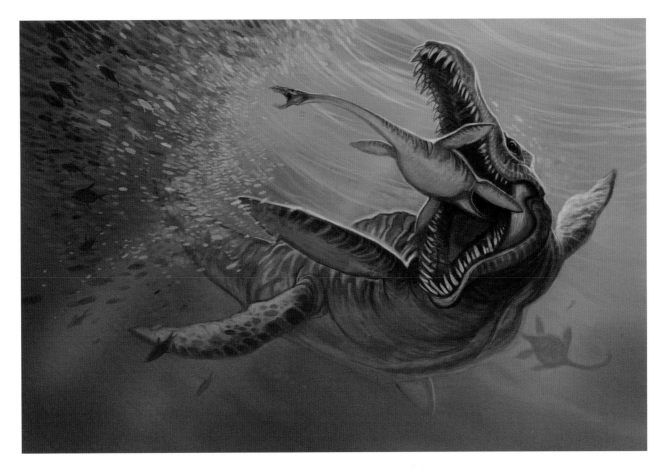

7 FOREGROUND AND FINISHING DETAILS

The foreground elements of this painting are the only aspects with any texture or detail. The kronosaurus and elasmosaurus skin markings as well as the school of small sardine-like fish provide the illusion of depth in their extreme foreshortening. A few bubbles, glittering foreground fish and the inclusion of a second elasmosaurus in the distance complete the painting.

Details of Elasmosaurus and Kronosaurus

Visit impact-books.com/hall-of-dinosaurs to download free bonus materials.

69

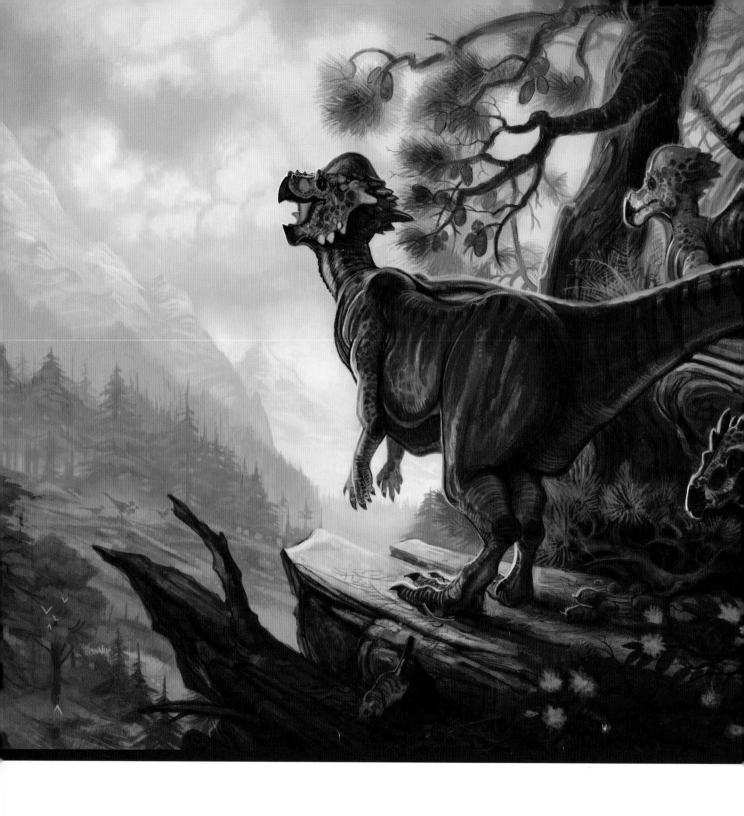

PACHYCEPHALOSAURUS

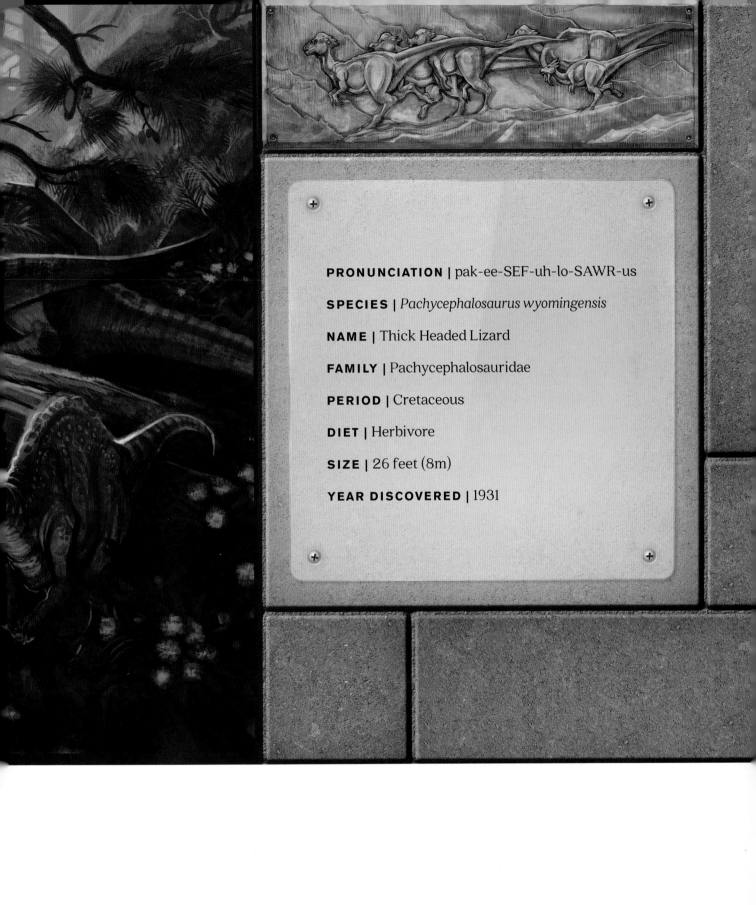

PRONUNCIATION | pak-ee-SEF-uh-lo-SAWR-us

SPECIES | *Pachycephalosaurus wyomingensis*

NAME | Thick Headed Lizard

FAMILY | Pachycephalosauridae

PERIOD | Cretaceous

DIET | Herbivore

SIZE | 26 feet (8m)

YEAR DISCOVERED | 1931

DESCRIPTION AND BIOLOGY

The *pachycephalosaurus* (also known as pachy) is one of the most unique and unusual of all of dinosaurs. Its domed and horned crown is the most notable aspect of this bipedal herbivore and has created intense debate among paleontologists. Some speculate that the function of the crests is for display, others suggest its purpose to be for rutting behavior between males. The bang of two pachy skulls together would have made a huge noise.

The pachy has the body of a theropod and the head of a triceratops. Its small stature (no larger than a pony) would place it at a disadvantage to other herbivores such as triceratops and apatosaurus and no match for large carnivores like T-rex.

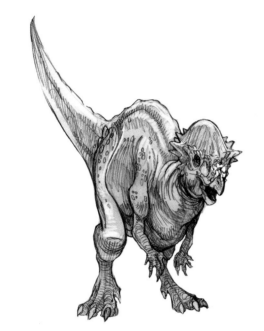

Versatile Dino

It's reasonable to speculate that the pachy was a versatile creature, fast and agile to navigate rocky terrain, but at the same time quick and small to evade large predators. Pachys are also thought to enjoy plants, berries and fruit that were beginning to evolve in the late Cretaceous environment.

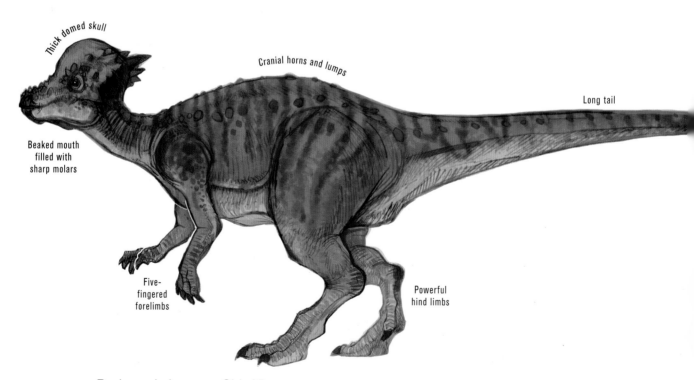

Thick domed skull

Cranial horns and lumps

Long tail

Beaked mouth filled with sharp molars

Five-fingered forelimbs

Powerful hind limbs

Pachycephalosaurus Side View

Attributes other than its domed crest make the pachy unique. Its beaked mouth make it appear to be herbivorous, yet its small bipedal design along with sharp molars and possible binocular vision make it appear carnivorous. Paleontologists believe that the pachy had a gizzard similar to modern birds for digesting tougher plants.

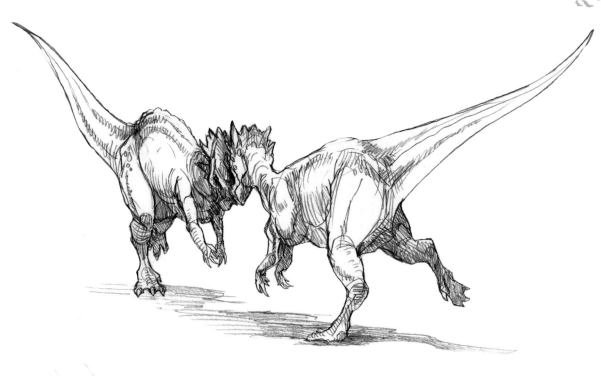

Domed Skull

As with many modern animals it is thought that the thick domed skull of the pachy was used in dominance and courtship duels among males. Pachycephalosaurus could lock and align its neck and spine to create a rigid, battering impact.

Habitat

It's possible that the pachycephalosaurus, like modern mountain goats, made its home in the rocky crags of the Cretaceous mountains, which would provided safety from predators. The rugged terrain and plants of this environment would make for an equally rugged and unique dinosaur. Fossil remains of pachycephalosaurus and its cousins have been found as far north as Montana, Wyoming and Canada.

Visit impact-books.com/hall-of-dinosaurs to download free bonus materials.

73

PACHYCEPHALOSAURUS

The thought of pachys clashing skulls similar to bighorn sheep made me think of the environment of mountain goats. I realized I'd never seen a depiction of a dinosaur in the mountains. I imagined a rugged subalpine terrain where they would be safe from large carnivores like T-rex. Its habitat would be filled with conifers and varied vegetation to feed on, and inaccessible to large herbivores like sauropods. The reason that a diverse collection of today's reptiles, birds and mammals live in this environment might be the same as the dinosaurs living millions of years ago.

For this painting, I envisioned a sweeping vista across a mountain valley to create a sense of scale and perspective. Winter is moving in fast as these fleet-footed dinos traverse a high mountain pass to migrate like birds to new winter grounds in the warm south. Illustrating a small family of pachys will help show the different crests that some paleontologists believe existed through the different growth stages and sexes of the same species. Like birds, the alpha male calls to another pachy group on the other side of the valley.

1 **PRELIMINARY THUMBNAIL SKETCHES AND COLOR STUDY**

Sketch a few sample compositions to plan the drawing.

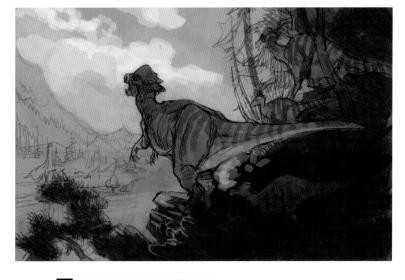

2 **SIMPLE COLOR STUDY**

A rough digital sketch of the pachycephalosaurus in an autumn mountain vista.

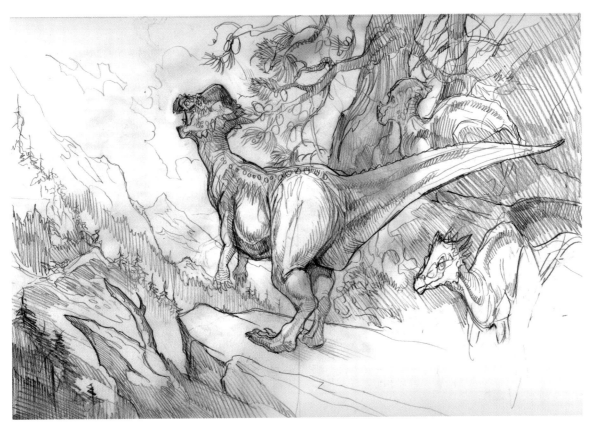

3 SKETCHING THE FINAL DRAWING

Render the finished drawing with pencil on paper using the preliminary sketches
as a guide along with references from books and online.

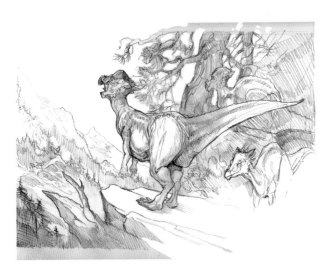
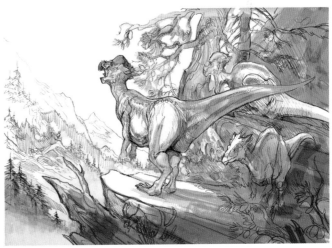

4 SCANNING THE DRAWING

Import the drawing into the computer to make additional quick alterations and
refinements.

Visit impact-books.com/hall-of-dinosaurs to download free bonus materials.

75

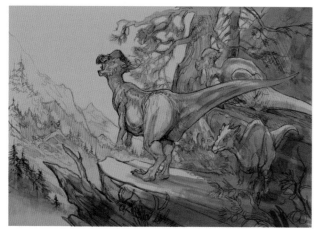
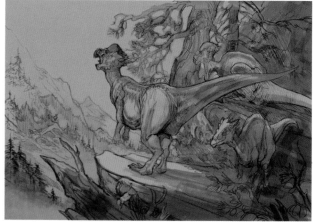

5 ESTABLISHING THE UNDERPAINTING

Beginning with broad, loose brushstrokes, establish the forms of color and light to create depth and atmosphere. Remember that this stage is for setting the tone of the overall image. Think about where the light is coming from and what time of day it is. Here I have created a twilight mood with low gold light from the foreground illuminating the distant peaks and clouds.

Color Palette and Key Brush

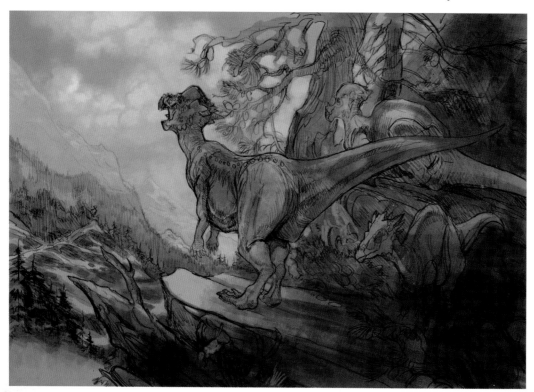

6 REFINING THE BACKGROUND DETAILS

Using a variety of textural and natural brushes, refine the shapes of the clouds and mountains. This backdrop will be essential for framing the central focal point later.

TUTORIAL | Pachycephalosaurus Head

For the head of the pachycephalosaurus, begin by establishing basic shapes for the crown, eye socket and jaw. Refine these forms and add details such as spikes and eyelids to bring the drawing into focus until color can be added on top. Exploring reference of birds will allow you to experiment with possible color patterns.

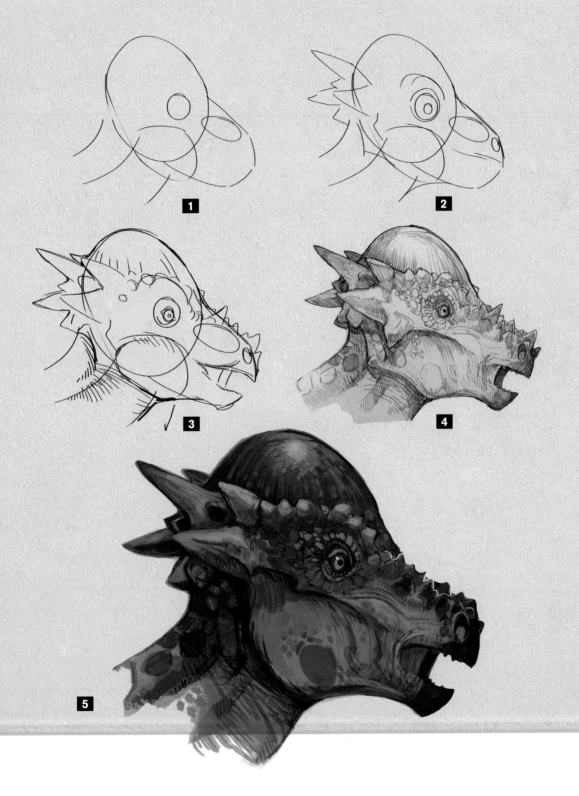

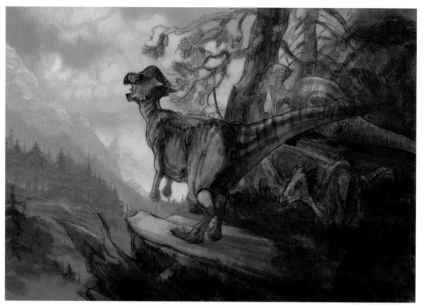

7 COMPLETING THE MIDDLE GROUND AND SUBJECT

Silhouetting the main element of the male pachycephalosaurus in the center of the composition is the primary goal of this image. Refine the shape of the unique head of the pachy that dominates the middle ground of the painting. Add details to the hide and markings of the other dinosaurs, including the dracorexus on the right, to round out this family group.

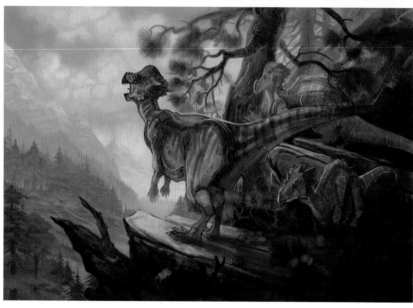

8 REFINING THE BACKGROUND DETAILS

Soft airbrush washes are used to create the foggy backdrop of the Cretaceous swamp.

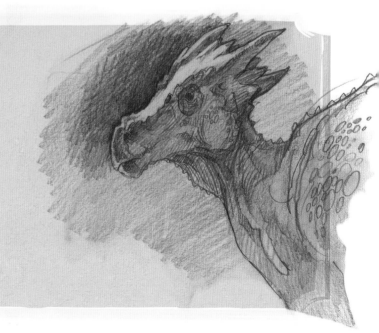

DRACOREX

First discovered in 2006 and classified as a new species, *dracorex* ("Dragon King of Hogwarts") is now thought to have been a younger version of the pachy with an undeveloped head dome.

Dracorex hogwartsia
Length 10 feet (3m)

78

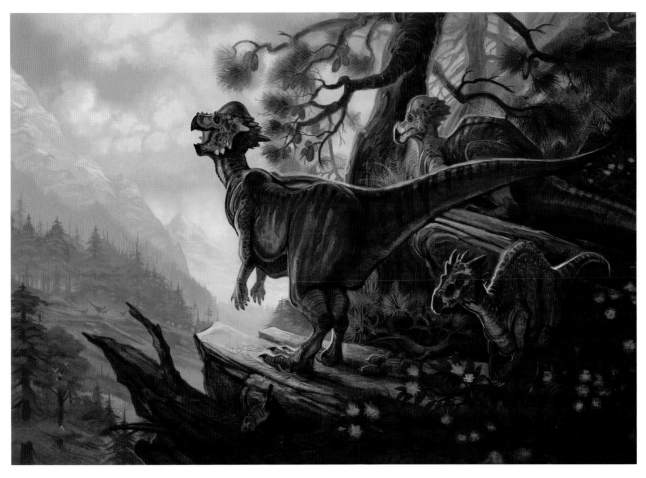

9 FOREGROUND AND FINISHING DETAILS

Add the foreground details to complete the painting. Here I included some early species of mountain laurel and pinecone-bearing conifers that may have existed in the late Cretaceous mountains. A small ground rodent dashes from his hole under the watchful stare of a young pachycephalosaurus.

Details of Pachycephalosaurus

Visit impact-books.com/hall-of-dinosaurs to download free bonus materials.

79

PRONUNCIATION | PAR-a-sore-OL-oh-fus

SPECIES | *Parasaurolophus walkeri*

NAME | Near Crested Lizard

FAMILY | Hadrosauridae

PERIOD | Cretaceous

DIET | Herbivore

SIZE | 30 feet (9m)

YEAR DISCOVERED | 1922

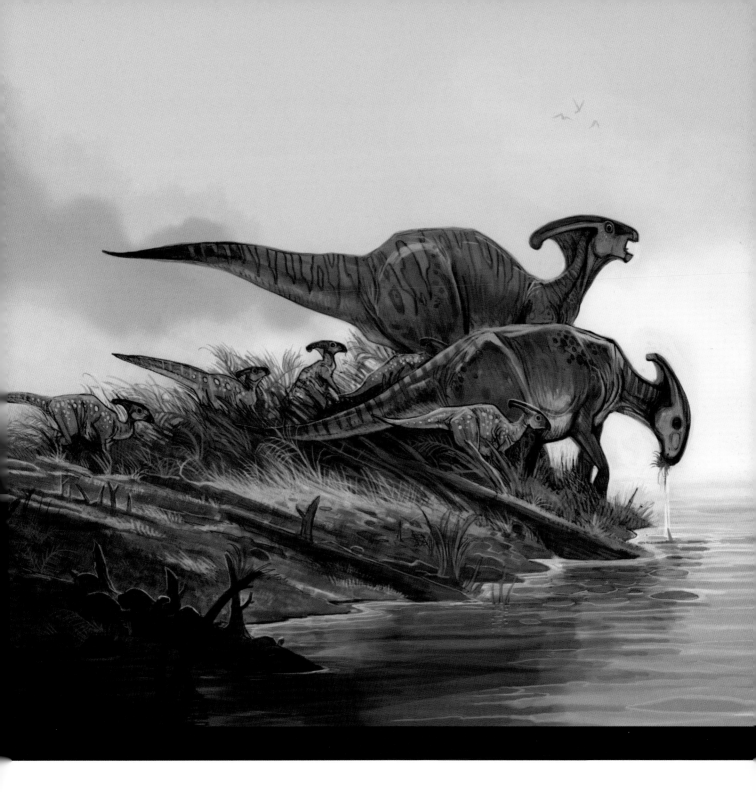

PARASAUROLOPHUS

DESCRIPTION AND BIOLOGY

The *parasaurolophus* is a member of the Hadrosauridae family and was common throughout the Cretaceous period. Commonly referred to as duck-billed dinosaurs, these large social animals are thought to have been herbivores that grazed in massive herds. Group fossil discoveries suggest herd migration, including forded river crossings, and that they may have been in close contact during a disaster that formed the fossil deposits.

Head in Profile

The silhouette of the parasaurolophus is uniquely identifiable by its hollow bony crest that can reach up to 6 feet (2m) in length. The crest was a long hollow sounding chamber for calls. With lungs the size of an office desk, parasaurolophus could have mate calls as loud as a fog horn and heard for miles. A whole herd calling and honking at the same time would have been deafening. Whether there was a fleshy membrane draped from the crest is unknown and open to the artist's interpretation.

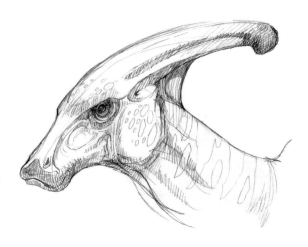

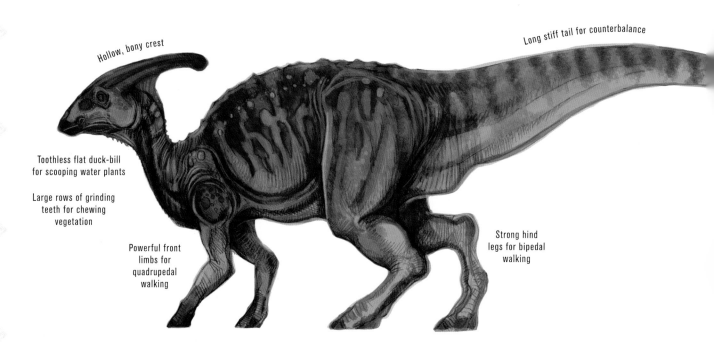

Hollow, bony crest

Long stiff tail for counterbalance

Toothless flat duck-bill for scooping water plants

Large rows of grinding teeth for chewing vegetation

Powerful front limbs for quadrupedal walking

Strong hind legs for bipedal walking

Parasaurolophus Side View

The parasaurolophus is most easily identified by its large head crest, which paleontologists have deduced was a sounding chamber to create distinct and powerful horn calls. As with modern day birds, these calls were likely used for communication between individuals as well as mating.

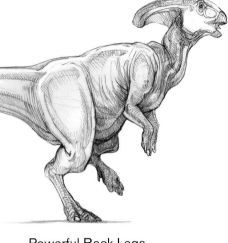

Powerful Back Legs

Though these large hadrosaurs were able to move on four legs to graze, they could also run on their two powerful back legs.

Social Creatures

It is reasonable to assume that like modern birds, parasaurolophus congregated in large flocks. Like penguins, young hatchlings could discern their own parents' calls out of the hundreds of individuals in a herd.

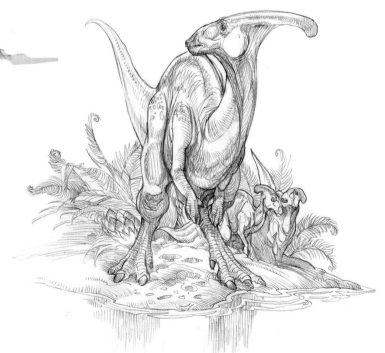

Visit impact-books.com/hall-of-dinosaurs to download free bonus materials.

83

Demonstration

PARASAUROLOPHUS

Make way for hadrosaurlings! The parasaurolophus is understood to have been a social species. Playing upon the nickname of the duck-billed dinosaur, I imagined a scene reminiscent of modern-day ducks. I decided to focus my design on a single family group with the adult parents leading a string of hatchlings to the waterfront to feed. The father honking into the fog to locate any other para-saurolophus nearby.

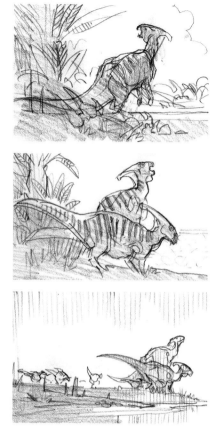

1 PRELIMINARY THUMBNAIL SKETCHES

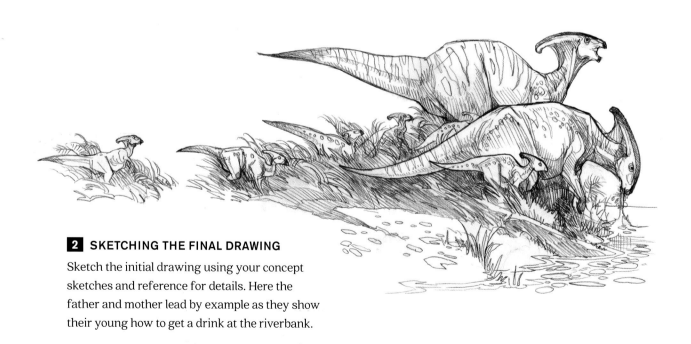

2 SKETCHING THE FINAL DRAWING

Sketch the initial drawing using your concept sketches and reference for details. Here the father and mother lead by example as they show their young how to get a drink at the riverbank.

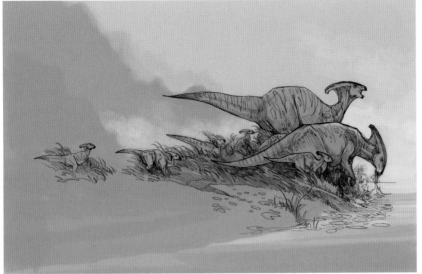

3 SCANNING THE DRAWING

Import the pencil sketch into the computer using a flatbed scanner. Open a new Multiply mode layer over the sketch. This will allow you to paint directly over the sketch without obliterating the drawing.

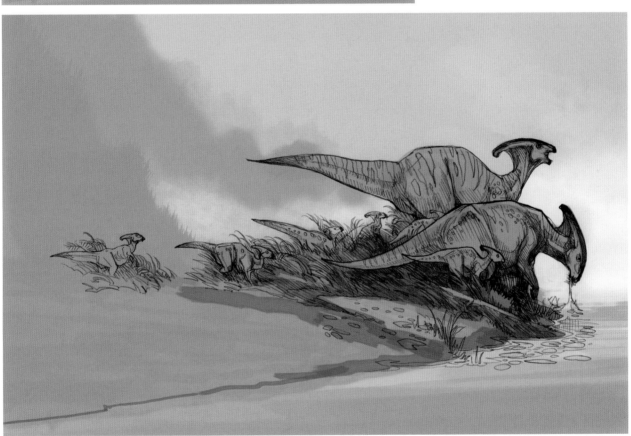

4 ESTABLISHING THE UNDERPAINTING

Begin blocking in large areas of local color such as the beach, sky and water. A low value grayscale palette is ideal for the foggy background.

Color Palette

Visit impact-books.com/hall-of-dinosaurs to download free bonus materials.

85

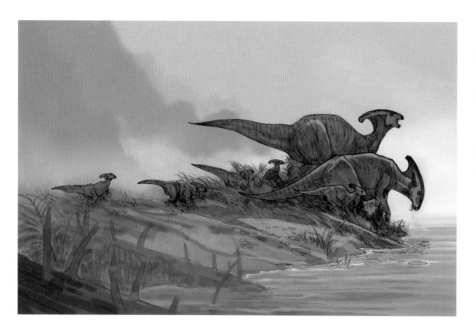

5 REFINING THE BACKGROUND DETAILS

Refine the riverbank and block in the base colors of the parasaurolophus. The central focal area will be the two adult dinos and the baby at the water's edge.

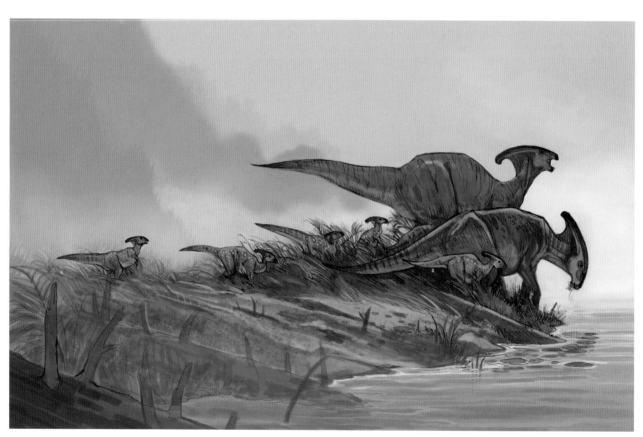

6 ADDING COLORATION AND MARKINGS

Establish some unique markings on the individual dinosaurs. The male is brightly colored with green stripes and has a red face. The female is colored in mottled camouflage while the hatchlings are a spotted camouflage like baby fawns. Render these elements in a new 100% opaque Normal Mode layer.

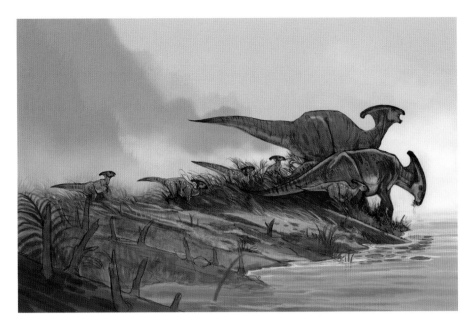

Continue building the highlights of the sandy bank and sketch a bale of turtles sitting on a log in the foreground.

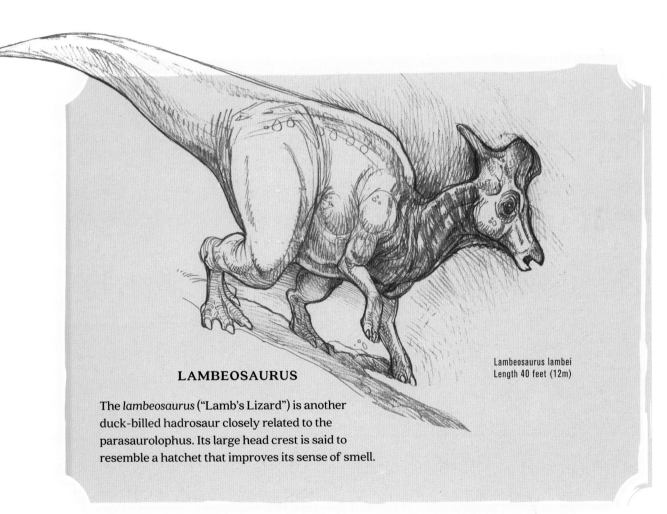

Lambeosaurus lambei
Length 40 feet (12m)

LAMBEOSAURUS

The *lambeosaurus* ("Lamb's Lizard") is another duck-billed hadrosaur closely related to the parasaurolophus. Its large head crest is said to resemble a hatchet that improves its sense of smell.

Visit impact-books.com/hall-of-dinosaurs to download free bonus materials.

87

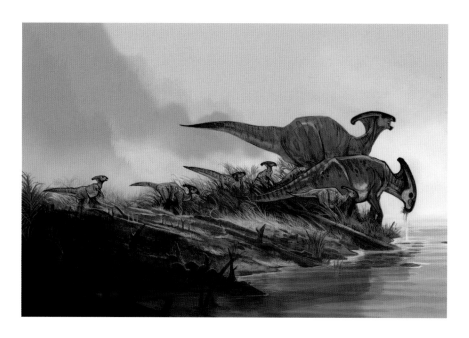

8 REFINING THE FOREGROUND

Once the colors and elements have all been established it is time to start focusing on some of the finer nuances of the image. Moss and ferns blanketing the water's edge along with rotted bark and markings on the turtles add texture to the scene. At this point in the late Cretaceous, early grasses and seabirds would be evolving in the dinosaurs' environment.

TUTORIAL | Parasaurolophus Sketch

Begin by sketching the skeletal structure starting with the shape of the spine. Building off this foundation, add the anatomy of muscles followed by textural details like skin and markings. See page 82 for the finished colored drawing.

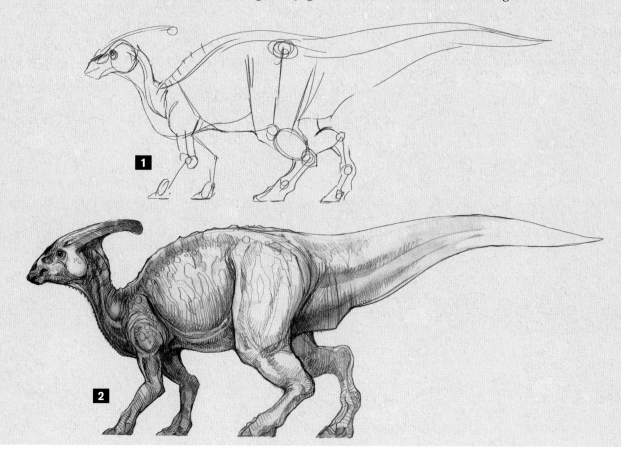

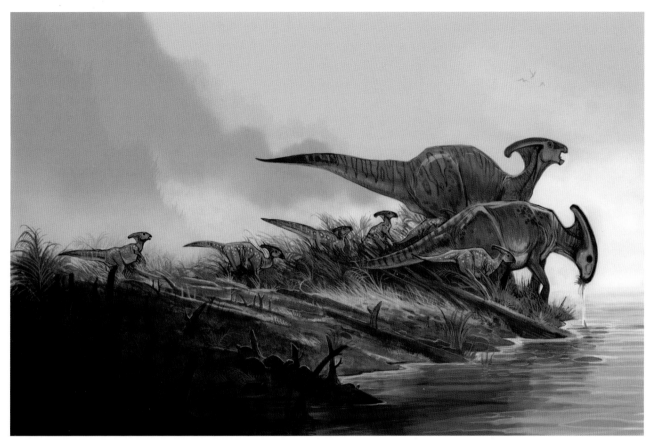

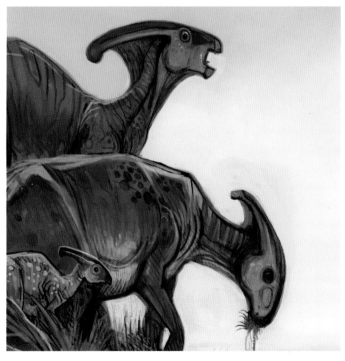

Detail of Parasaurolophus

9 FOREGROUND AND FINISHING DETAILS

Refine the foreground details to add depth and scale to the painting. Use small detail brushes to add fern fronds, bark texture and highlights on the surface of the water.

Visit impact-books.com/hall-of-dinosaurs to download free bonus materials.

89

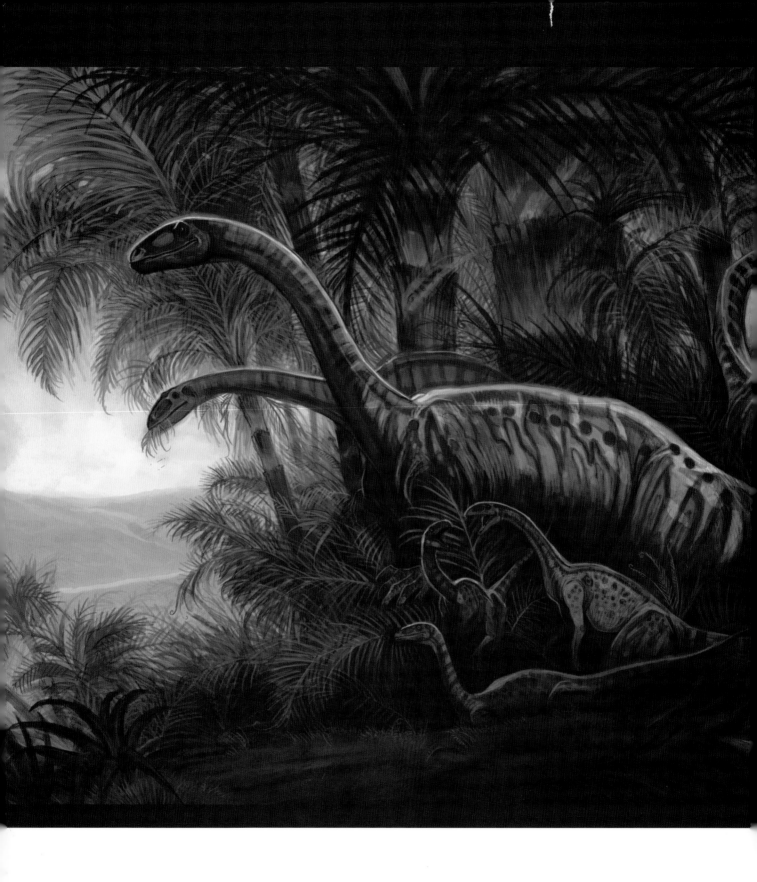

PLATEOSAURUS

PRONUNCIATION | PLAY-tee-uh-SAWR-us

SPECIES | *Plateosaurus engelhardti*

NAME | Broad Lizard

FAMILY | Plateosauridae

PERIOD | Triassic

DIET | Herbivore

SIZE | 30 feet (9m)

YEAR DISCOVERED | 1837

DESCRIPTION AND BIOLOGY

Plateosaurus is one of the earliest dinosaurs both to evolve and to be discovered by paleontologists. Appearing during the Triassic period more than 200 million years ago, plateosaurus is an archetypal dinosaur that would later evolve into many of the more well-known species of sauropods and hadrosaurs, making it one of the grandfathers of all dinosaurs.

Head in Profile

Plateosaurus' short blunt head with peg teeth was adapted for grazing among the ferns and palms of the Triassic period. This design would later evolve into the many different species of sauropods.

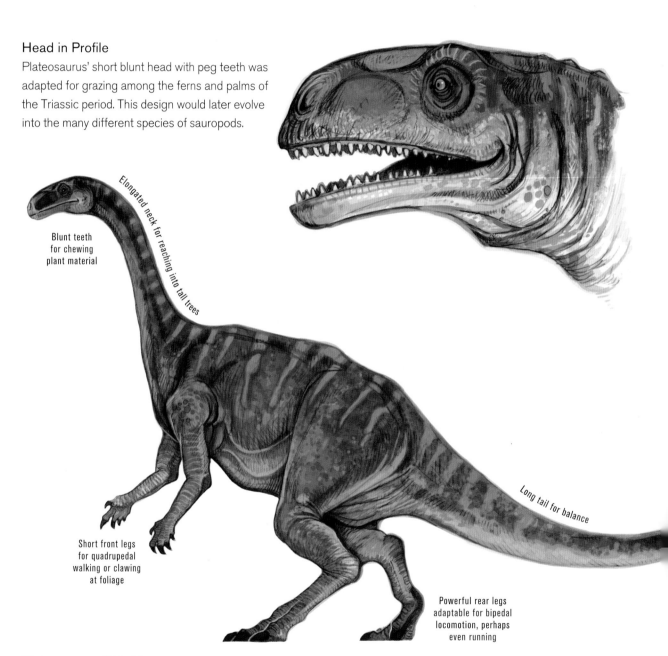

Blunt teeth for chewing plant material

Elongated neck for reaching into tall trees

Long tail for balance

Short front legs for quadrupedal walking or clawing at foliage

Powerful rear legs adaptable for bipedal locomotion, perhaps even running

Plateosaurus Side View

Plateosaurus is one of the early examples of dinosaurs evolving in competition with plants. As herbivore dinosaurs ventured further and grew larger, the forests also became bigger. Ecosystems adapted and grew toward the once barren inland with dinosaurs close behind.

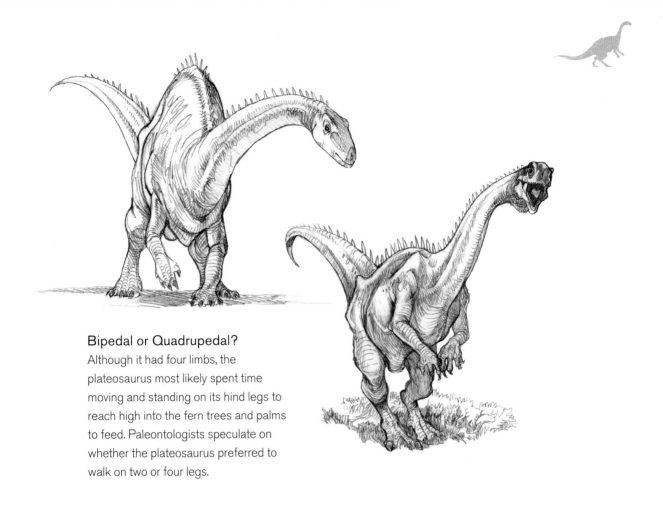

Bipedal or Quadrupedal?

Although it had four limbs, the plateosaurus most likely spent time moving and standing on its hind legs to reach high into the fern trees and palms to feed. Paleontologists speculate on whether the plateosaurus preferred to walk on two or four legs.

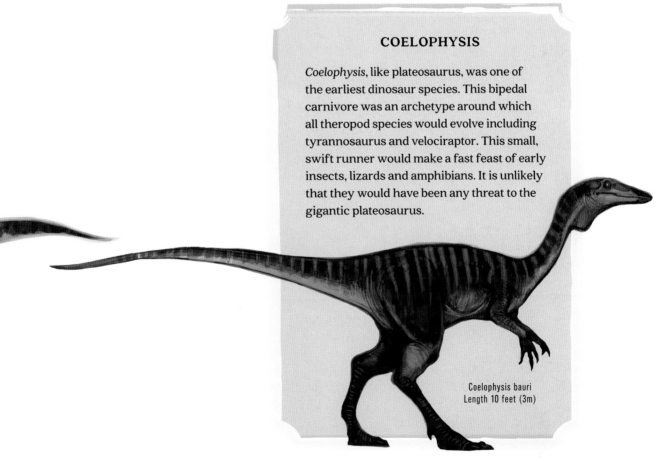

COELOPHYSIS

Coelophysis, like plateosaurus, was one of the earliest dinosaur species. This bipedal carnivore was an archetype around which all theropod species would evolve including tyrannosaurus and velociraptor. This small, swift runner would make a fast feast of early insects, lizards and amphibians. It is unlikely that they would have been any threat to the gigantic plateosaurus.

Coelophysis bauri
Length 10 feet (3m)

PLATEOSAURUS

To plan your design, start with a series of small thumbnail sketches. I wanted to show a family of plateosaurus grazing among an oasis of palms and ferns of the Triassic with the barren landscape looming in the distance. Early dinosaurs thrived inside these shady enclaves, feeding on the plentiful foliage. Since the social behavior of early Triassic dinosaurs is unknown, I chose to speculate them as social animals living in communal groups and caring for their young.

1 **PRELIMINARY THUMBNAIL SKETCHES**
Small thumbnail sketches help develop the composition.

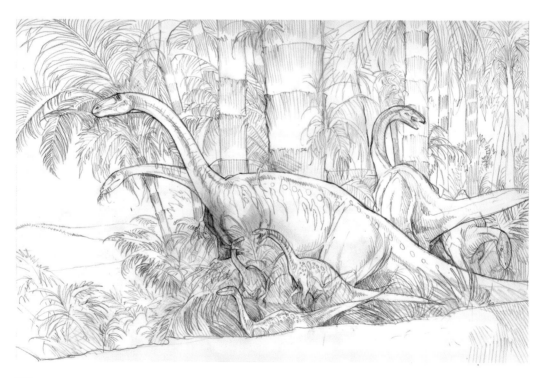

2 **SKETCHING THE FINAL DRAWING**

Develop a detailed pencil sketch using thumbnails and reference from the library, museums and online. By choosing to show a group of animals as well as younglings it's possible to illustrate a variety of angles to best display the anatomy and behavior. By including a coelophysis in the foreground, you can scale the evolution of size of the plateosaurus. It's from these two basic animals that all of the strange and varied species of later dinosaurs would evolve and eventually lead to birds.

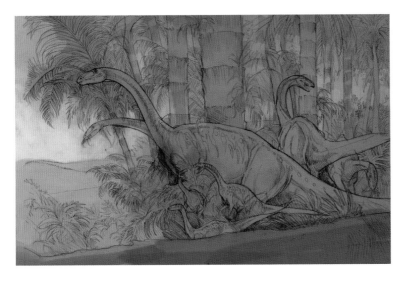

3 ESTABLISHING THE UNDERPAINTING

Scan the drawing and import into photo editing software. Block in the underpainting over the sketch using a new Multiply layer so the drawing shows through underneath. This stage helps establish form, color and light, and creates very rough texture since much of this work will be refined in later stages.

Color Palette and Key Brush

A basic color palette for the underpainting and my custom "hair brush" that I use to create grassy plant texture.

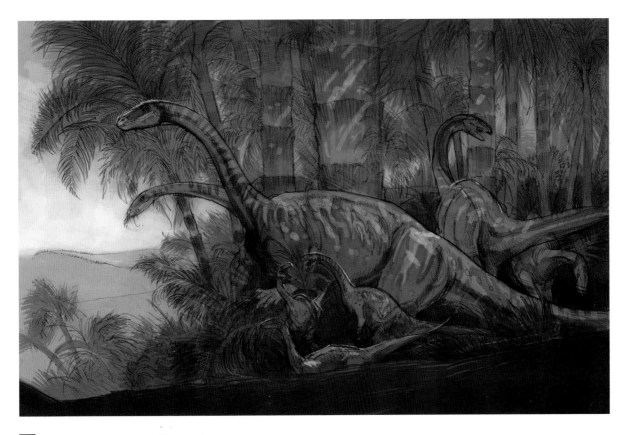

4 DEVELOPING THE FOREGROUND

Establish the dark foreground, clouds and forest using broad textural brushes and a simple color palette. Use a Multiply layer if working digitally, or transparent paint washes, to allow the sketch to show through. Flesh out the details of the plants, palms and the dinosaurs' markings.

Visit impact-books.com/hall-of-dinosaurs to download free bonus materials.

95

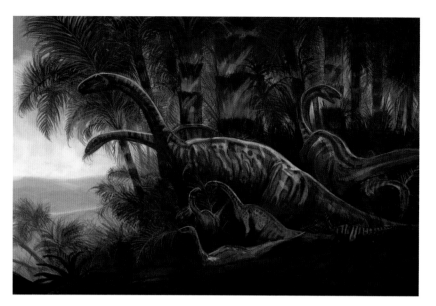

5 **REFINING THE BACKGROUND AND MIDDLE GROUND DETAILS**

Using the three key elements outlined on page 7 as a guide, render the background details then move forward to the middle ground to embellish the thick palm grove and dinosaurs. Paint opaquely and use smaller brushes to achieve the small details.

TUTORIAL | Plateosaurus Sketch

Beginning with a strong central spinal line, develop the anatomy of the plateosaurus by placing the bones and muscles. Render the finishing details of hide and skin before adding color. See page 92 for the finished colored drawing.

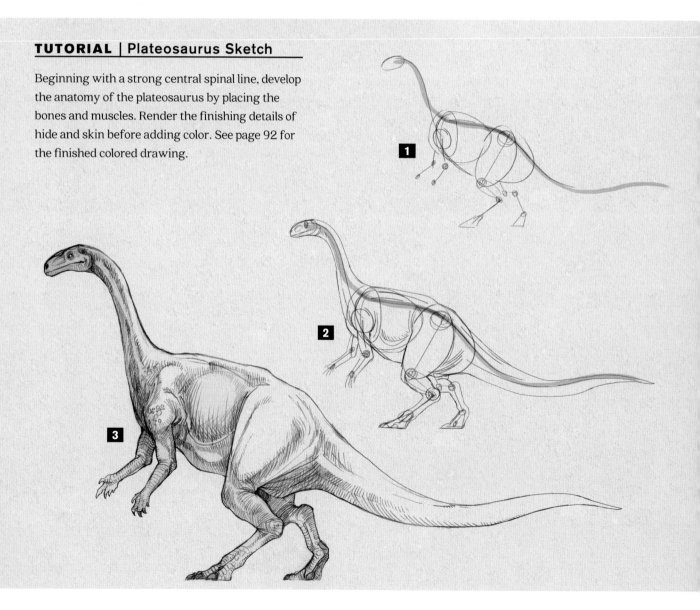

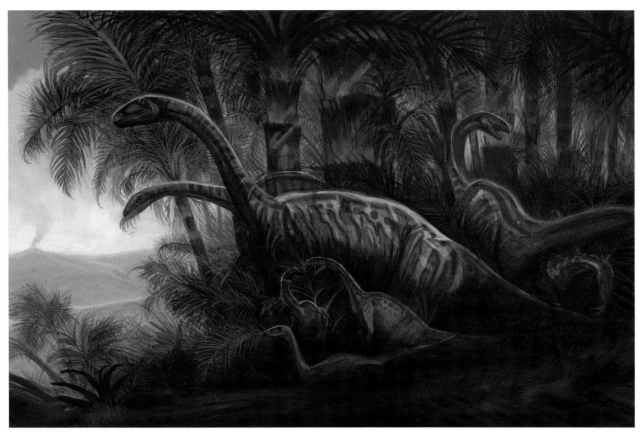

6 FOREGROUND AND FINISHING DETAILS

Final details are painted into the composition using smaller brushes and more saturated colors to help bring the details into focus. Complete the final foreground framing element of cycads and the log with the coelophysis (see page 93) to set the scene.

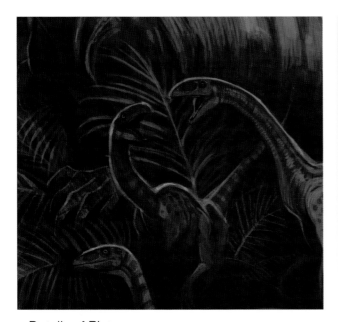

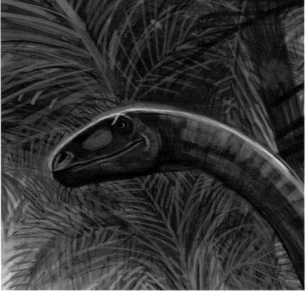

Details of Plateosaurus

Visit impact-books.com/hall-of-dinosaurs to download free bonus materials.

97

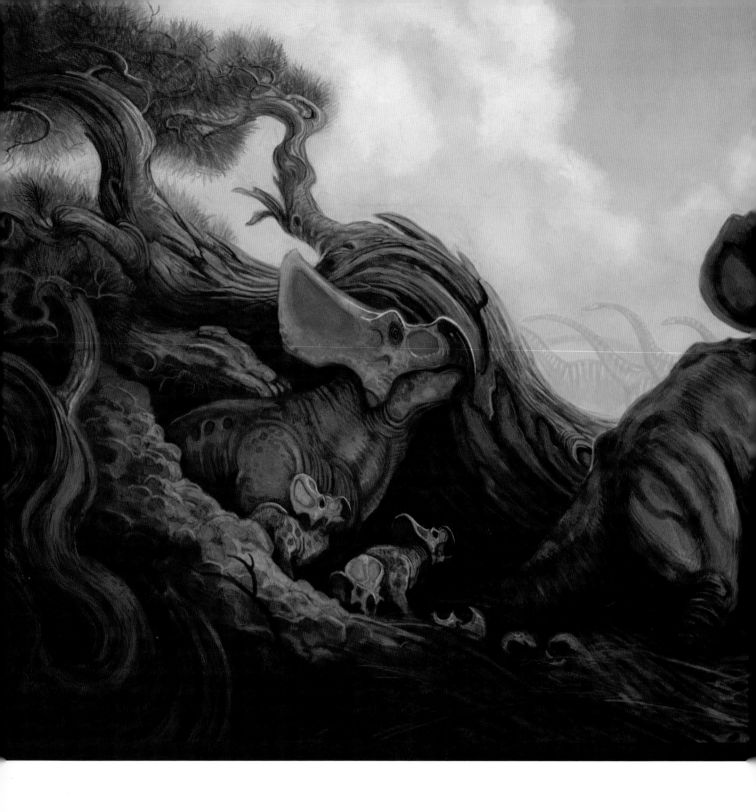

PROTOCERATOPS

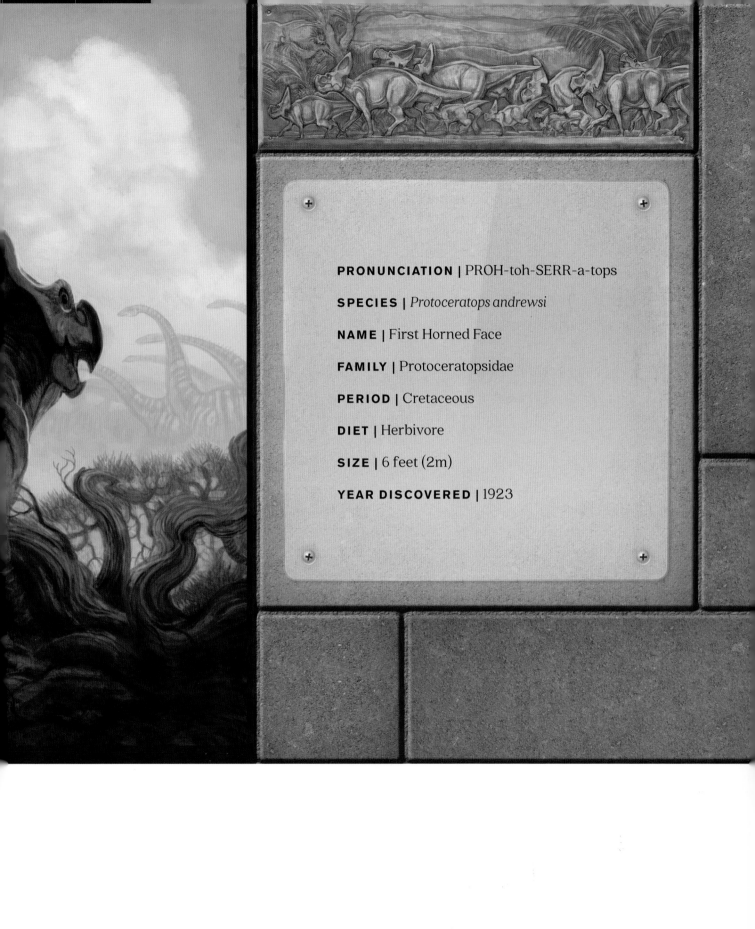

PRONUNCIATION | PROH-toh-SERR-a-tops

SPECIES | *Protoceratops andrewsi*

NAME | First Horned Face

FAMILY | Protoceratopsidae

PERIOD | Cretaceous

DIET | Herbivore

SIZE | 6 feet (2m)

YEAR DISCOVERED | 1923

DESCRIPTION AND BIOLOGY

Protoceratops was a small quadrupedal dinosaur from the Cretaceous period. Related to the triceratops, protoceratops possessed similar traits such as the neck frill and beaked mouth, but did not have the impressive horns or size as other species of Ceratopsidae. This herbivore was thought to live in large communities of hundreds of animals congregating within close proximity to one another.

Fossil remains have shown that protoceratops was hunted by velociraptor. The small protoceratops would only have been able to protect their young from such dangerous foe by hiding them in protective herds, nests and burrows.

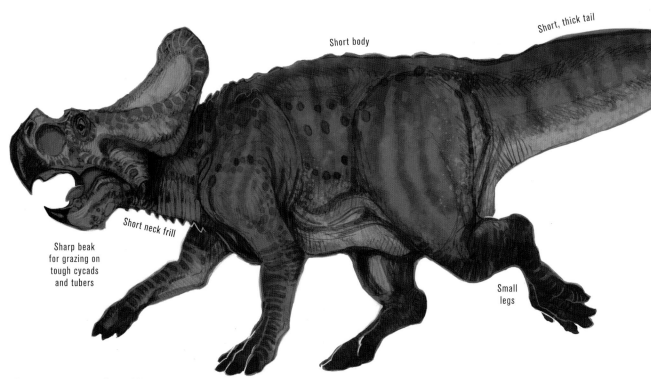

Head in Profile
Like other Ceratopsidae, protoceratops possessed a neck frill. Unlike triceratops or styracosaurus, the frill was small and without horns, suggesting that its function was ornamental.

Short body

Short, thick tail

Short neck frill

Sharp beak for grazing on tough cycads and tubers

Small legs

Protoceratops Side View
Fossil remains of protoceratops have been abundant, making them one of the more common dinosaurs, and one of the earliest, hence their name "First Horned Face." Remains of protoceratops of all ages—from egg and hatchling to young and into adulthood—have all been discovered together.

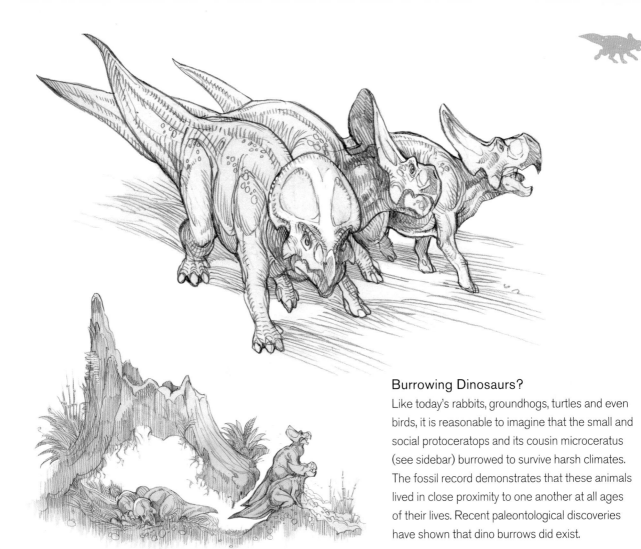

Burrowing Dinosaurs?

Like today's rabbits, groundhogs, turtles and even birds, it is reasonable to imagine that the small and social protoceratops and its cousin microceratus (see sidebar) burrowed to survive harsh climates. The fossil record demonstrates that these animals lived in close proximity to one another at all ages of their lives. Recent paleontological discoveries have shown that dino burrows did exist.

MICROCERATUS

Closely related to its cousin protoceratops, the diminutive *microceratus* had a long tail and strong back legs, suggesting it ran nimbly on its hind legs. Easy prey to the velociraptors and other predators in the bush, microceratus may have burrowed or hid in tight spaces to evade capture.

Microceratus gobiensis
Length 2 feet (60cm)

PROTOCERATOPS

The protoceratops has been one of my favorite dinosaurs since childhood. They remind me of pigs. My first thought when conceiving an environment for the protoceratops was how such a small and relatively defenseless animal could live in a world surrounded by titan sauropods and theropods, while hunted at night by packs of velociraptors. This idea led me to research how similar contemporary animals live and I struck on the idea of burrowing prairie dogs and meerkats.

I begin my concept by imagining a family group of protoceratops rudely awoken by a sauropod stampede. The male sticks his head up to investigate while the female and hatchlings wait in the burrow.

1 PRELIMINARY THUMBNAIL SKETCHES

I completed these small drawings in a 3" × 5" (8cm × 13cm) sketchbook.

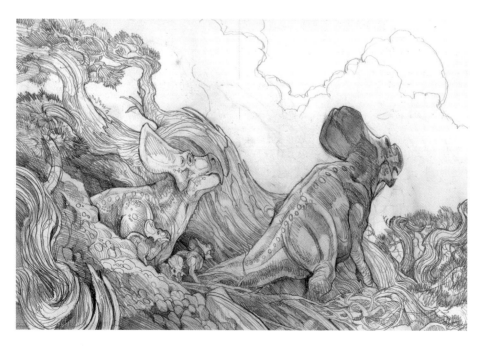

2 SKETCHING THE FINAL DRAWING

I combined my research and thumbnail sketches to create the final 11" × 15" (28cm × 38cm) pencil drawing on paper. Photo reference of twisted and wind-whipped trees that survive in high deserts helped me envision the landscape.

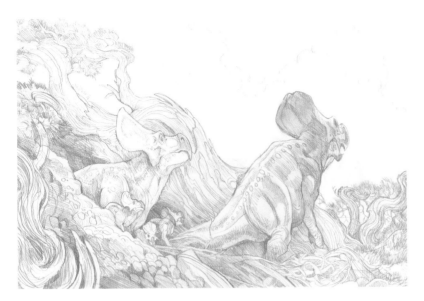

3 SCANNING THE DRAWING

Scan the initial drawing and import into the computer. Open a new Multiple layer in painting software to allow all of the details to show through.

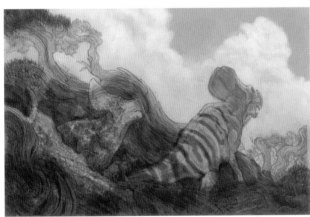

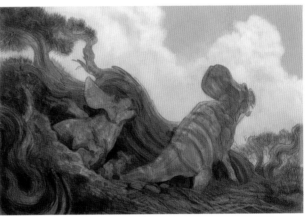

4 ESTABLISHING THE UNDERPAINTING

Block in local colors to establish the main forms with a variety of brushes broadly carving out shapes of color. I chose a base tint of blue because I want the burrow to have a cool, shady feeling contrasting against the harsh dusty light of the background.

Color Palette

Visit impact-books.com/hall-of-dinosaurs to download free bonus materials.

103

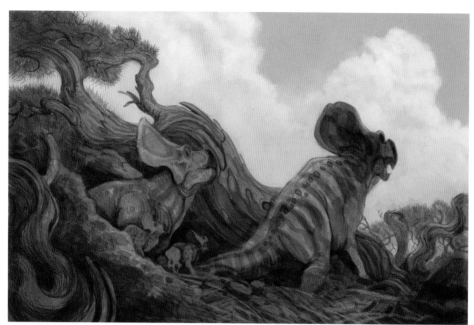

5 REFINING THE BACKGROUND

After the underpainting has been established and all the forms of the picture have been defined with color and light, move on to the details. Here I used a variety of custom textural brushes to create the effects of dirt, bark, foliage and dinosaur hide.

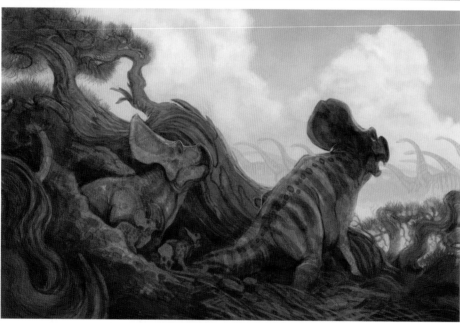

6 ADDING A DISTANT SUBJECT

Subtly incorporate the herd of sauropods stampeding in the dusty distance. Add some highlights and rim light around the edge of the left protoceratops.

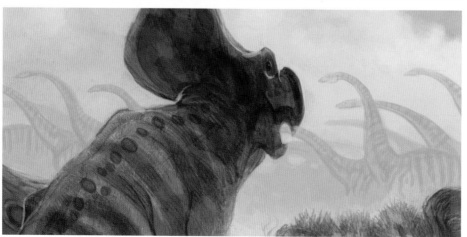

Detail of Sauropod Herd

TUTORIAL | Protoceratops Sketch

To sketch the protoceratops, begin with simple shapes to indicate the location and proportions of the skull, rib cage and joint connections. Flesh out the skeletal design with muscles then render the details of the hide to complete the sketch. See page 100 for the finished colored drawing.

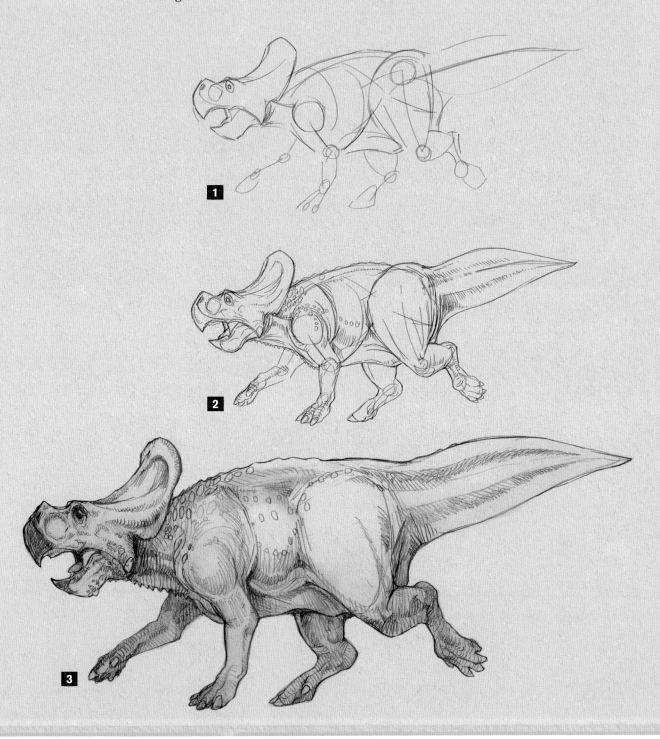

Visit impact-books.com/hall-of-dinosaurs to download free bonus materials.

105

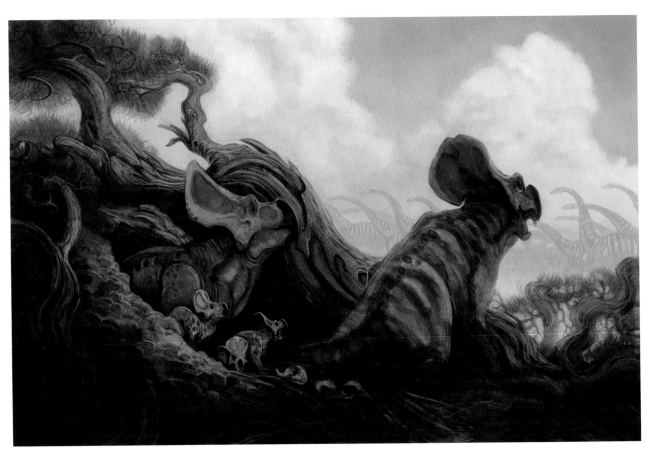

7 COMPLETING THE SUBJECTS

Use a variety of textural brushes to render the markings and details of the protoceratops family—the central focal point of the painting. Baby protos with egg shells and nest debris add to the texture of the scene.

SEEK INSPIRATION FROM MODERN ANIMALS

A wild pig is about the same size and structure of a protoceratops, and also digs burrows to protect its young and shelter itself from predators and weather. Rhinos and parrots also make great dino reference.

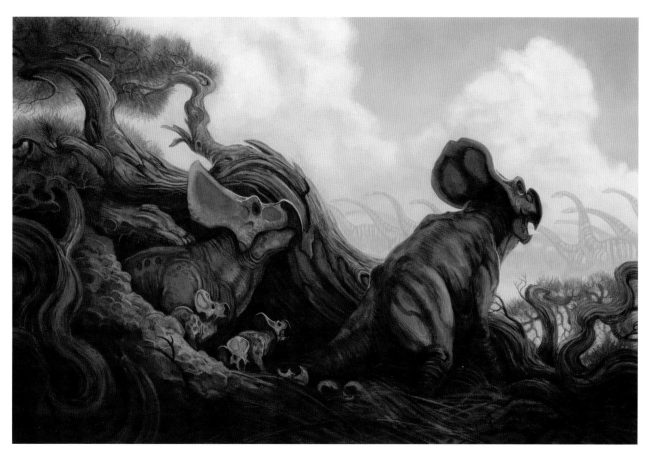

8 FOREGROUND AND FINISHING DETAILS

Final details in the foreground will help set the tone. Bark texture, highlights and additional markings on the dinos and pine needles help the scene feel more realistic.

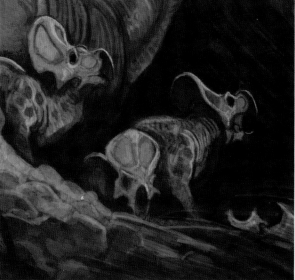

Details of Protoceratops

Visit impact-books.com/hall-of-dinosaurs to download free bonus materials.

107

PRONUNCIATION | teh-RAN-oh-don

SPECIES | *Pteranodon longiceps*

NAME | Toothless Wings

FAMILY | Pteranodontidae

PERIOD | Cretaceous

DIET | Carnivore

SIZE | 20 feet (6m)

YEAR DISCOVERED | 1876

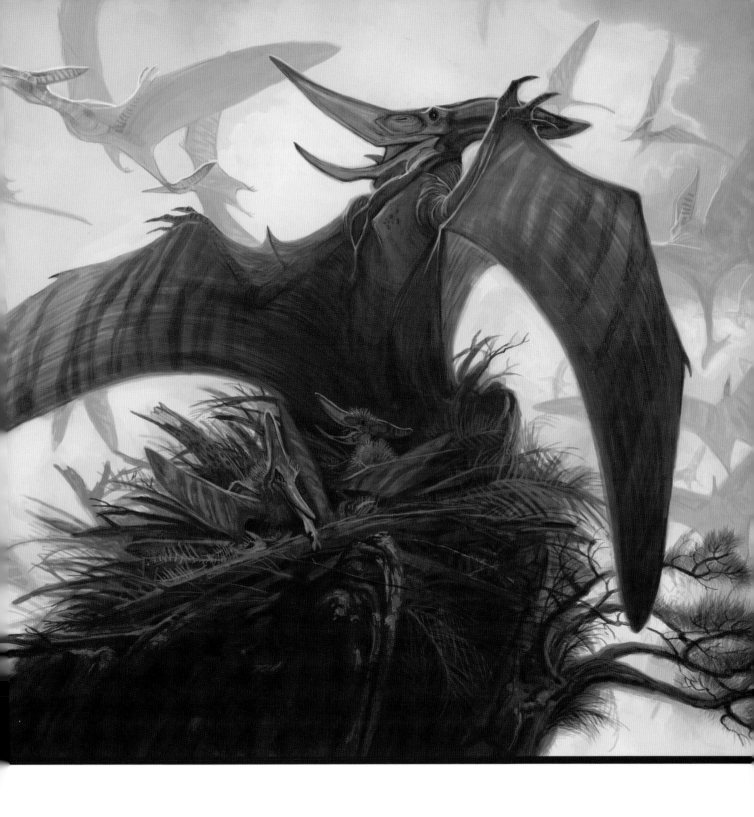

PTERANODON

DESCRIPTION AND BIOLOGY

Pteranodon is one of the best known species in paleontology due to the vast numbers of fossils discovered of this flying giant. Although pteranodon is technically not a dinosaur (it's classified in the order of pterosaurs), this flying reptile is so closely associated to its dinosaur cousins they are usually studied together.

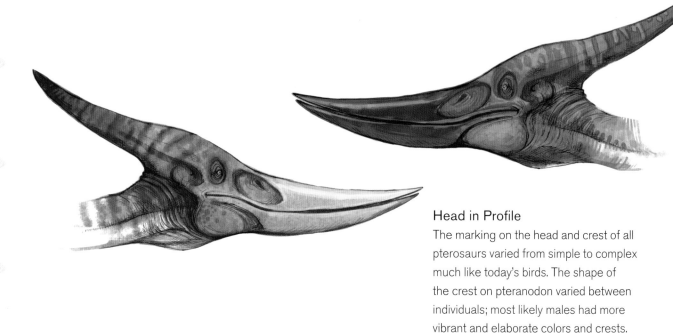

Head in Profile

The marking on the head and crest of all pterosaurs varied from simple to complex much like today's birds. The shape of the crest on pteranodon varied between individuals; most likely males had more vibrant and elaborate colors and crests.

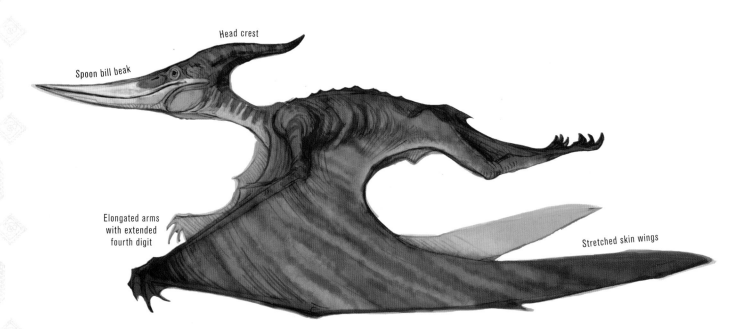

Head crest

Spoon bill beak

Elongated arms
with extended
fourth digit

Stretched skin wings

Pteranodon Side View

Although there are hundreds of species of pterosaurs, the pteranodon is most recognizable by its long pelican-like beak and massive cranial crest. Paleontologists believe the function of this design varies. Perhaps the head crest acted as a counterbalance to the heavy beak and worked as a vertical stabilizer, like a rudder, to help the pteranodon maneuver in flight. Or maybe the large crests were used as displays during mating season.

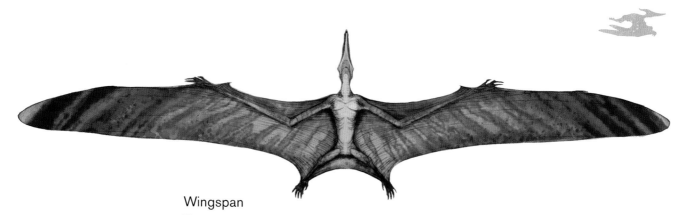

Wingspan

The pteranodon has captured the imaginations of paleontologists and paleoartists for more than 100 years, and many argue that they are the basis for traditional dragon myths throughout the world. Sightings of pteranodons are still reported in some remote locations much to the excitement of cryptozoologists.

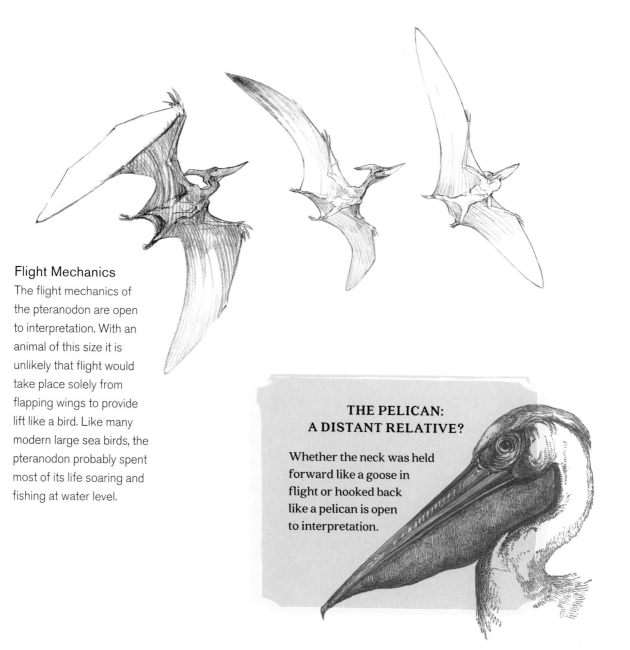

Flight Mechanics

The flight mechanics of the pteranodon are open to interpretation. With an animal of this size it is unlikely that flight would take place solely from flapping wings to provide lift like a bird. Like many modern large sea birds, the pteranodon probably spent most of its life soaring and fishing at water level.

THE PELICAN: A DISTANT RELATIVE?

Whether the neck was held forward like a goose in flight or hooked back like a pelican is open to interpretation.

Demonstration
PTERANODON

The most unique quality of the pteranodon is its massive wingspan, which could be as long as 20 feet (6m). The modern albatross and condor each have a 10-foot (3m) wingspan, and the average pteranodon is thought to be twice the size. Some pterosaurs (like quetzalcoatlus) actually achieved a wingspan as massive as that of a small airplane. My goal for this painting's composition is to illustrate the animal's wingspan as well as its environment along the Pangaean coastline where they would make their nests. Many thousands of animals would use the safety of the cliffs as a breeding ground much like modern-day rookeries.

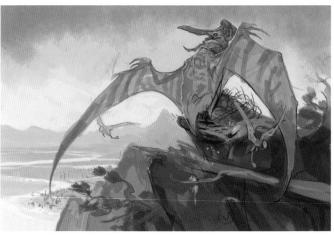

1 **PRELIMINARY THUMBNAILS AND CONCEPT SKETCH**

This digital concept sketch shows a large pterosaur being harassed by a flight of smaller long-tailed rhamphorhynchus. Further investigation and research revealed that these two animals lived millions of years apart from one another, but I still like the idea.

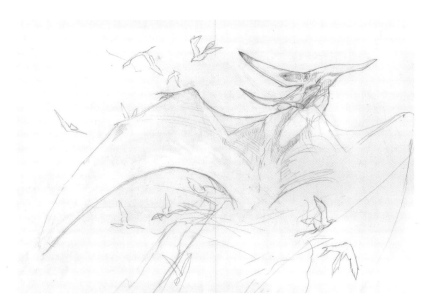

2 **PLANNING THE DRAWING**

I used reference of frigatebirds, albatross and pelicans to plan my pencil sketch. What begins as a simple design of a pteranodon on a rock being harassed by early sea birds evolves into a swirling eddy of pteranodons circling high in the seaside mist. With no landscape or horizon to give a sense of height or perspective, I felt that filling the sky with pteranodons gave the impression of a limitless sky.

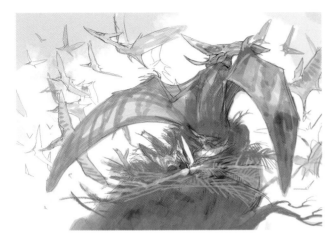
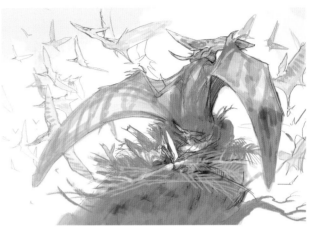

3 SKETCHING THE FINAL DRAWING

Though I made the initial drawing with pencil on paper in step 2, I decided to bring the drawing into the computer to complete it on a tablet since there are several alterations I want to make to better reflect the original concept. Once the drawing has been scanned and opened in Photoshop, I scaled the drawing down about 75% to better fit the wings into the composition. I also rotated the drawing counterclockwise, erased the birds and replaced them with a flock of pterosaurs.

4 ADJUSTING THE COLOR BALANCE

Adjust the color balance and contrast levels to a blue tone that will be the basis for the color palette.

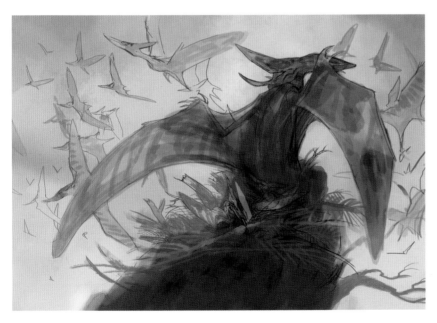

Color Palette and Key Brush

5 ESTABLISHING THE UNDERPAINTING

Here I chose tones of gray-purples and gray-blues to create a complementary backdrop to the red markings of the pteranodons' crests. Use a slightly textured scumbling brush to block in a soft, flat backdrop with a hint of texture. When things are too smooth they tend to look fake.

Visit impact-books.com/hall-of-dinosaurs to download free bonus materials.

113

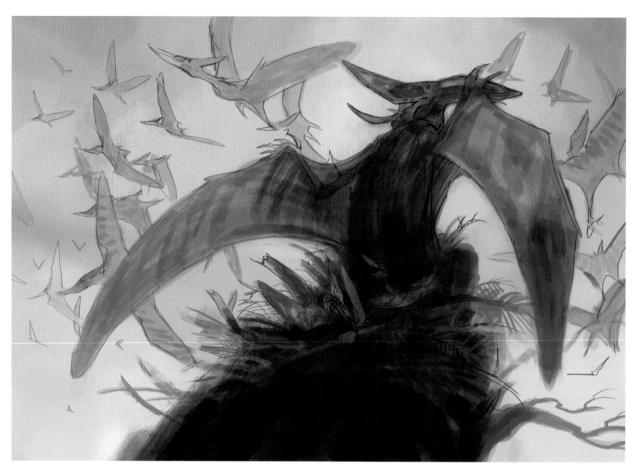

6 **COMPLETING THE UNDERPAINTING**

Scumbles, splatters and mottling are expressive and fun at this stage. Most of this roughness will be overpainted in the detail stages, but some will be left to peek through.

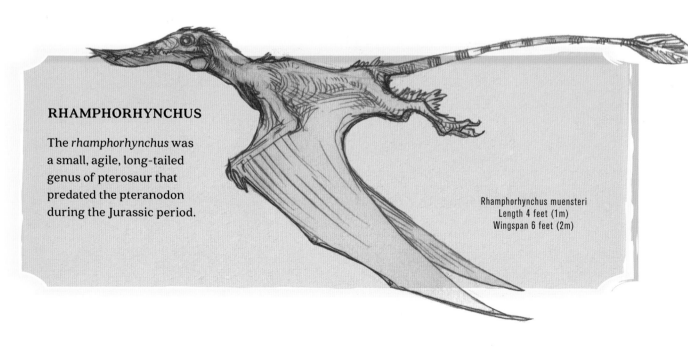

RHAMPHORHYNCHUS

The *rhamphorhynchus* was a small, agile, long-tailed genus of pterosaur that predated the pteranodon during the Jurassic period.

Rhamphorhynchus muensteri
Length 4 feet (1m)
Wingspan 6 feet (2m)

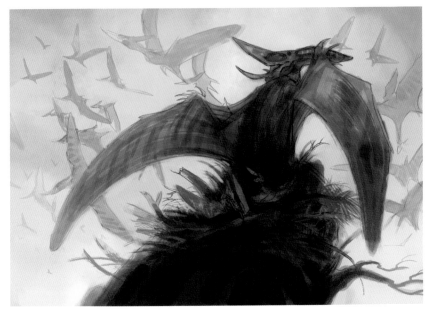

BEGINNING THE BACKGROUND

Refine the background first using a subtle color palette of diffused blues to set the flock of pterosaurs into the distance.

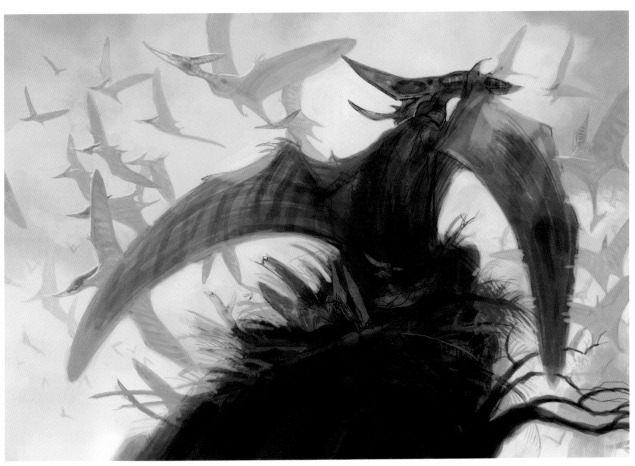

Visit impact-books.com/hall-of-dinosaurs to download free bonus materials.

115

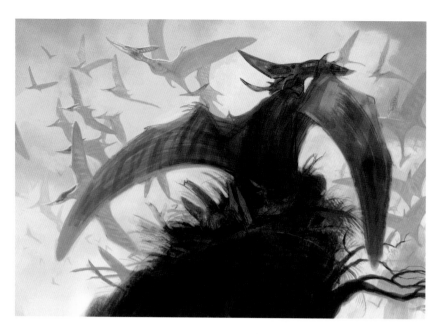

8 COMPLETING THE MIDDLE GROUND AND SUBJECT

At this stage, spend time on the middle ground and main subject. Use bright colors and small brushes to sharpen edges and add details to bring the pteranodon into focus.

TUTORIAL | Pteranodon Sketch

To draw a pteranodon, begin with a simple skeleton to establish the proportions and anatomy. Roughly build the muscles on top of the skeleton then finish the drawing by rendering details over the foundation. See page 110 for the finished colored drawing.

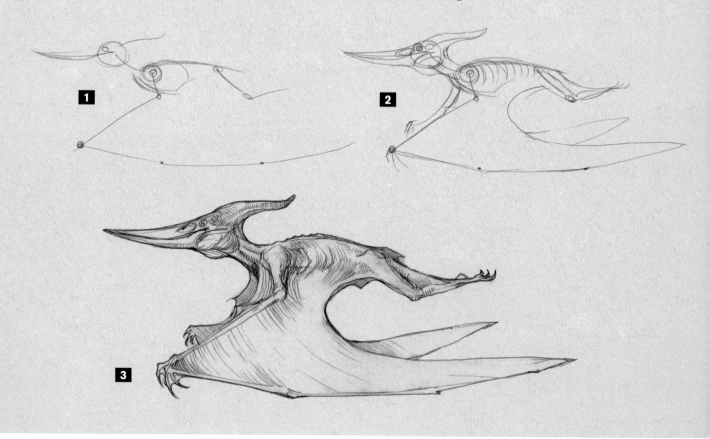

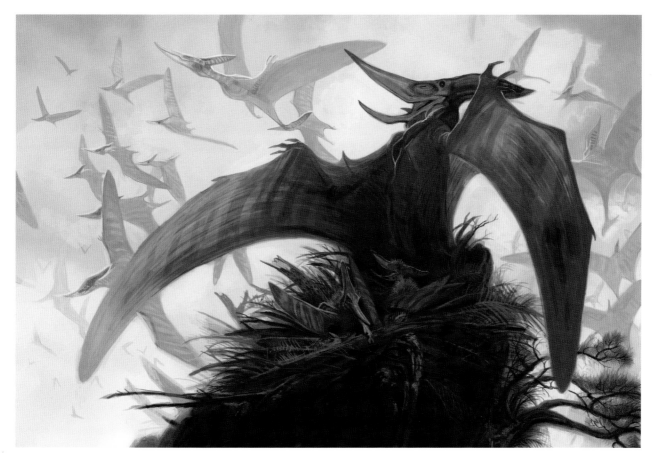

9 **FOREGROUND AND FINISHING DETAILS**

Working with smaller brushes, render the smaller details of the subject and the foreground elements. Palm fronds and branches lining the nest, hatchlings, pine needles, rock texture, skin texture and droppings give the image added touches of realism and improve the scale.

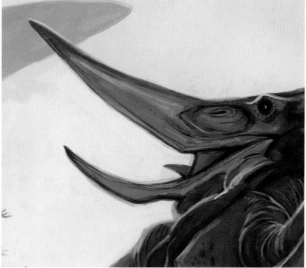

Details of Pteranodon

Visit impact-books.com/hall-of-dinosaurs to download free bonus materials.

117

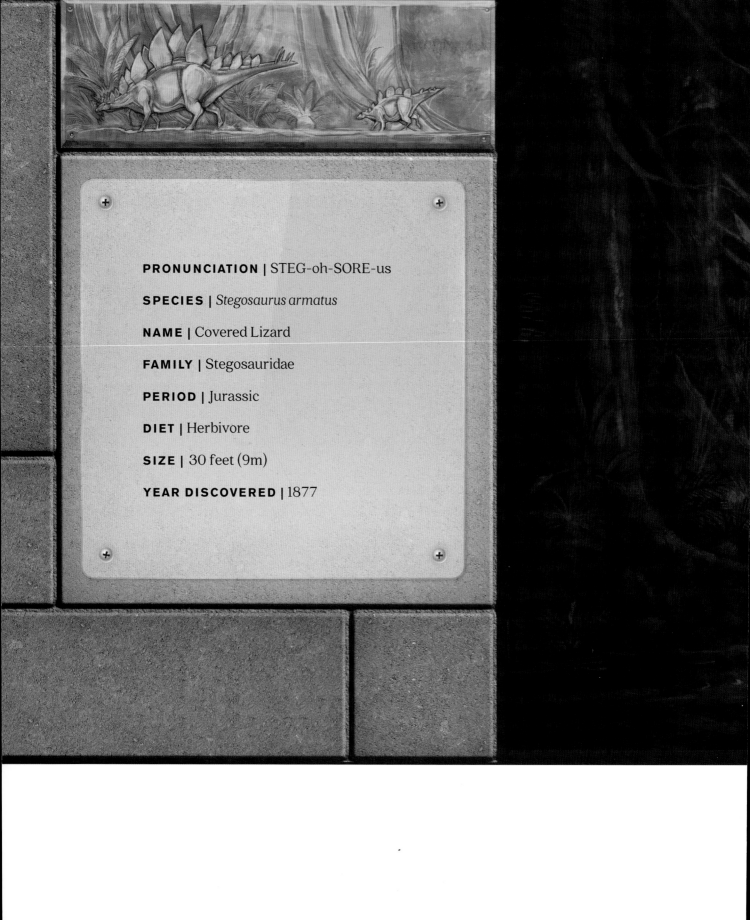

PRONUNCIATION | STEG-oh-SORE-us

SPECIES | *Stegosaurus armatus*

NAME | Covered Lizard

FAMILY | Stegosauridae

PERIOD | Jurassic

DIET | Herbivore

SIZE | 30 feet (9m)

YEAR DISCOVERED | 1877

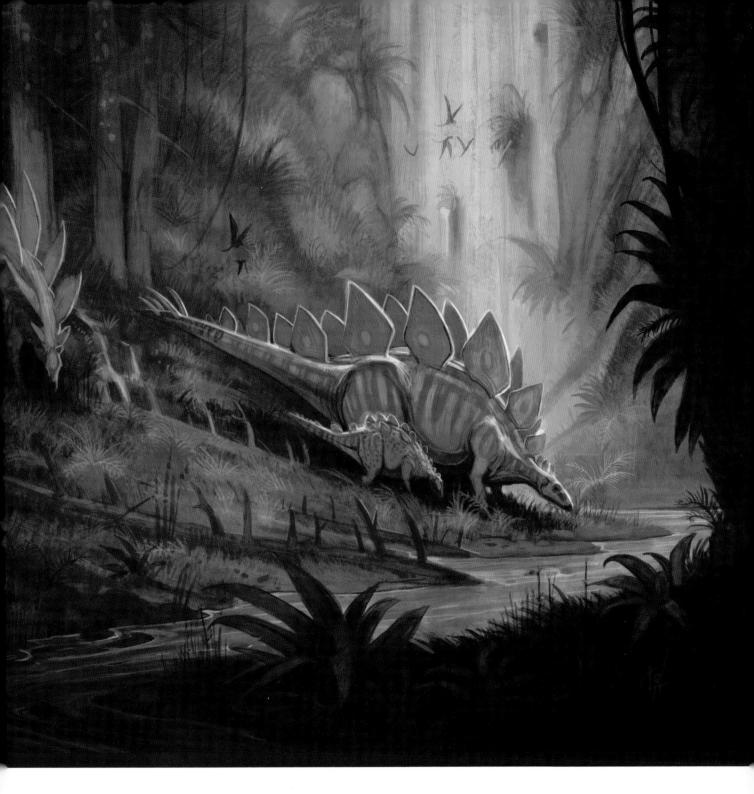

STEGOSAURUS

DESCRIPTION AND BIOLOGY

Stegosaurus is one of the most famous and popular dinosaurs. This gigantic plant-eating quadrupedal dinosaur was covered in armored plates and was able to defend itself with its formidable spiked tail that would keep most Jurassic predators at bay. As the largest of the plated dinosaurs in the Stegosauridae family, the stegosaurus was twice the size of an elephant.

Shifting Plate Colors

It's possible that the blood flow would allow the plates to change color like a chameleon, turning bright colors to warn off a predator or attract a mate, or blending into brush like camouflage.

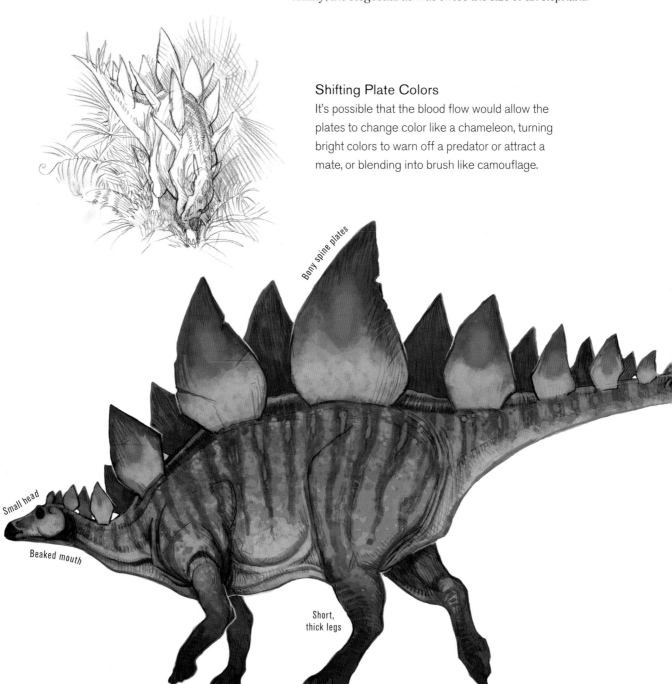

Bony spine plates

Small head

Beaked mouth

Short, thick legs

Stegosaurus Side View

Paleontologists have debated the function of the stegosaurus plates. Some argue they were for defense while others say they were for display. Still others argue the small blood vessels that coursed through the plates would have helped stegosaurus to regulate its body temperature.

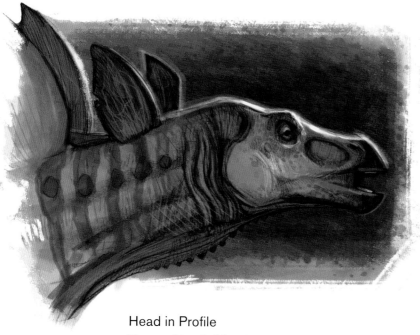

Head in Profile

The small head of the stegosaurus would contain a tiny brain. Like many other large grazing dinosaurs, this animal would have spent most of its life eating. The beaked mouth would bite off vegetation while an inner gizzard digested the tough plants.

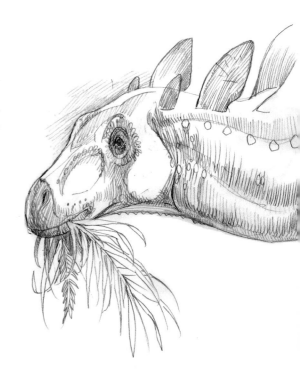

Tail spikes

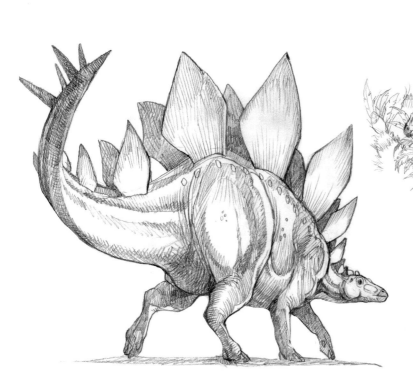

A Formidable Prey

The heavy, lumbering build of the stegosaurus would have made it impossible to outrun a predator. But because of its large spine plates, spiked tail and sheer size, most carnivores would have gone after easier prey.

Visit impact-books.com/hall-of-dinosaurs to download free bonus materials.

121

Demonstration

STEGOSAURUS

Although the stegosaurus is a massive creature (about the size of a school bus), I wanted to demonstrate that it was in fact a mild-mannered Jurassic vegetarian. I conceived a bucolic environment with a small family group of stegosauri grazing in a lush waterfall glade. It is likely that the young would have stayed close to their parents until large enough to fend for themselves.

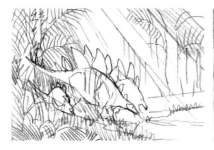 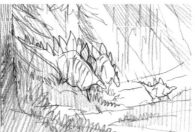

1 PRELIMINARY THUMBNAIL SKETCHES

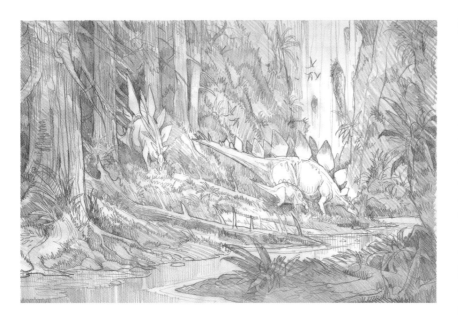

2 SKETCHING THE FINAL DRAWING

I designed this painting so the stegosaurus would blend into the environment. A sense of scale is created by making the animals fairly small in comparison to the landscape. Anyone who has ever been spent time in the woods knows that most terrain is uneven, intersected by gullies and washes, waterfalls and ravines. My goal for the viewer was to create the same feeling as coming upon a group of deer in the woods while hiking.

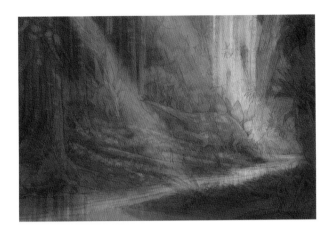
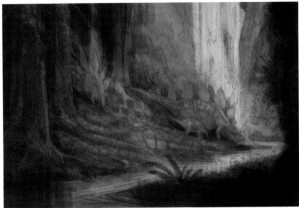

3 ESTABLISHING THE UNDERPAINTING

I selected a green-blue palette to render a verdant glade scene with a waterfall in the depths of an evergreen rainforest. Patches of dappled sunlight filtered down into the cool depths of the glen spotlighting the subjects. Use textured brushes to quickly lay broad shapes of bark, rock, water and plants. Soften the beams of light streaming through the trees. Make sure to use Multiply mode so the finished drawing from step 2 shows through.

Color Palette

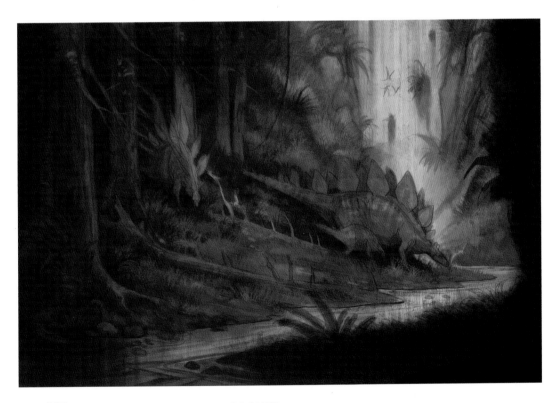

4 COMPLETING THE MIDDLE GROUND

Adding details into the scene makes for a more believable environment. Here I placed a wide variety of conifers, cycads, bromeliads, ferns, palms and horsetail in this wet chasm. The trees drip with moss and mushrooms flourish in the shadows. It is a safe nursery for a young stegosaurus family with plenty of food and fresh water.

Visit impact-books.com/hall-of-dinosaurs to download free bonus materials.

123

TUTORIAL | Stegosaurus Sketch

To draw the stegosaurus, begin with a simple skeletal framework centering around the strong spine to lay the forms in proper proportion. Next, build muscles and refine the anatomy by adding textured hide and final details. See page 120 for the finished colored drawing.

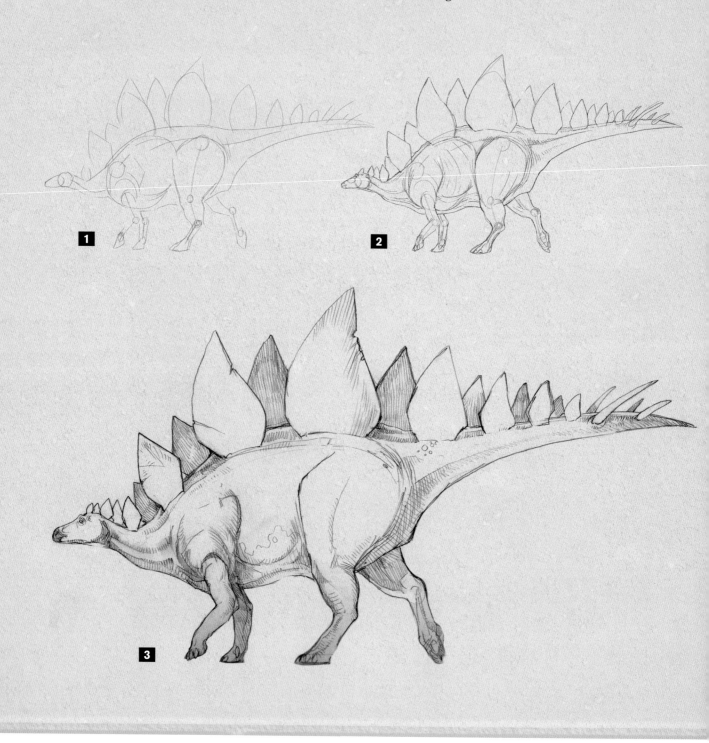

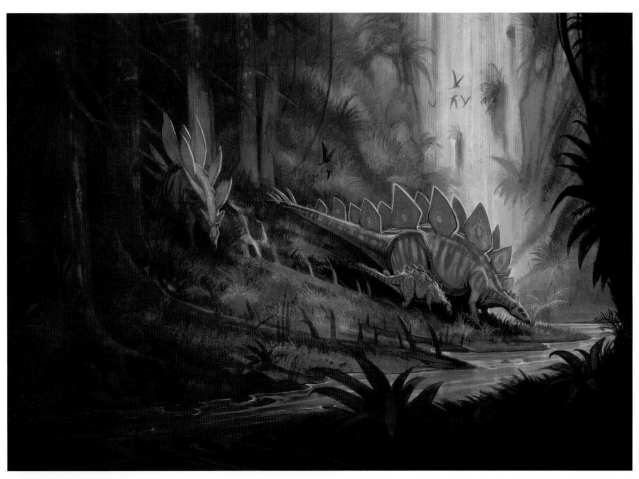

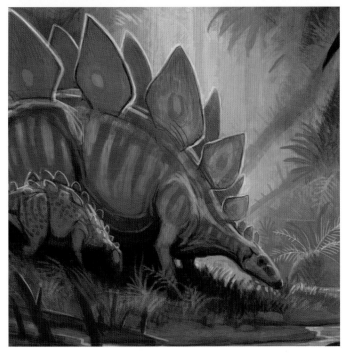

Detail of Stegosaurus

5 FOREGROUND AND FINISHING DETAILS

Complete the details of the stegosaurus. The baby stegosaurus has brown spotted camouflage similar to the mottling seen on young birds. Detail some rhamphorhynchus (see page 114) flying high in the distant forest to give the painting some added depth.

Visit impact-books.com/hall-of-dinosaurs to download free bonus materials.

125

PRONUNCIATION | try-SAIR-a-tops

SPECIES | *Triceratops horridus*

NAME | Three Horn Face

FAMILY | Ceratopsidae

PERIOD | Late Cretaceous

DIET | Herbivore

SIZE | 20 feet (6m)

YEAR DISCOVERED | 1889

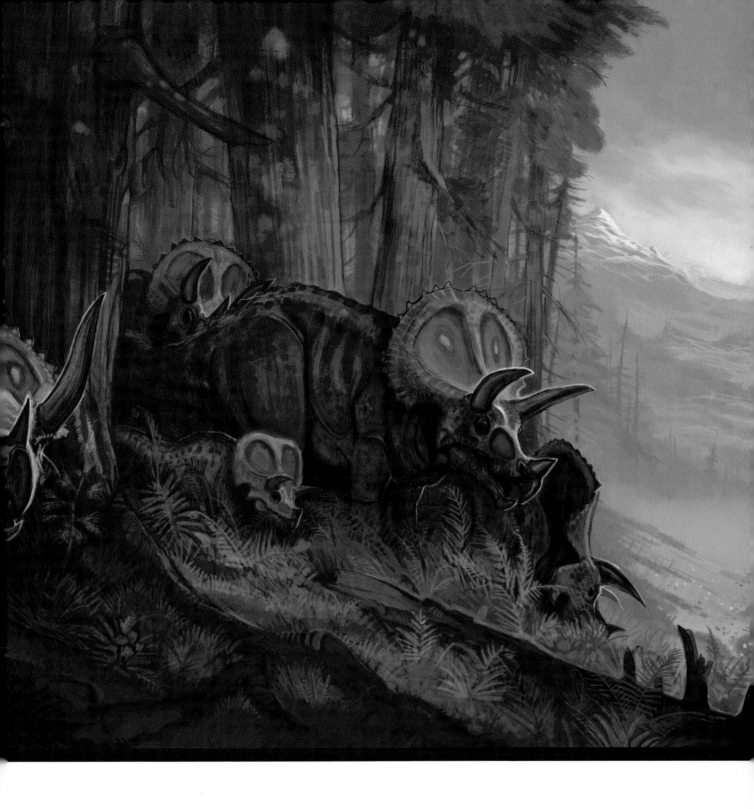

TRICERATOPS

DESCRIPTION AND BIOLOGY

Triceratops is another popular species of dinosaur and a member of the widely varied family of ceratopsids. This large, quadrupedal herbivore was famous for its showy neck frill and formidable horns. Paleontologists have recently come to the opinion that the frill served more as a display than a defensive function, not unlike modern deer and elk. Fossil remains of triceratops show scar evidence that suggest attacks from predators such as T-rex and rutting damage from other triceratops.

Horns and frills were common to all ceratopsids. A recent paleontological study revealed that separate species of cera-topsids in the triceratops genus were actually true triceratops at various age and gender orientations with a wide range of horn and frill developments.

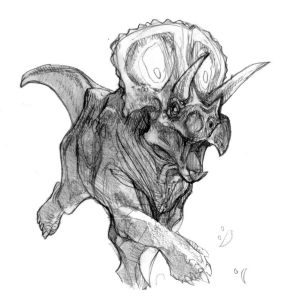

A Powerful Foe
At twice the size of a rhinoceros, a charging triceratops would be intimidating enough to scare off any predator that threatened the herd.

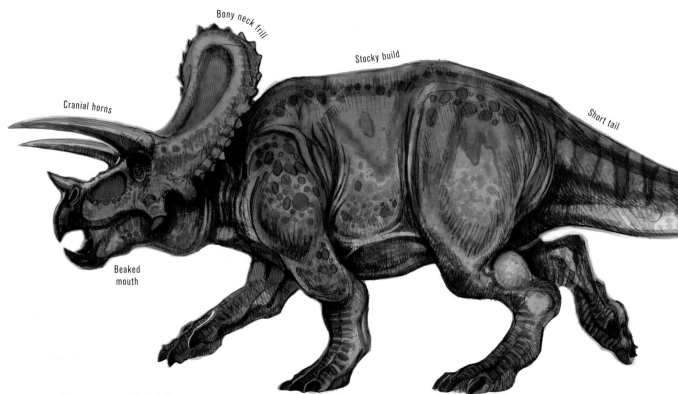

Triceratops Side View
The neck frills and horns are the most recognizable features of all the ceratopsids, and their function has been widely speculated among paleontologists. As an artist, how you choose to decorate the frill is completely open to your imagination.

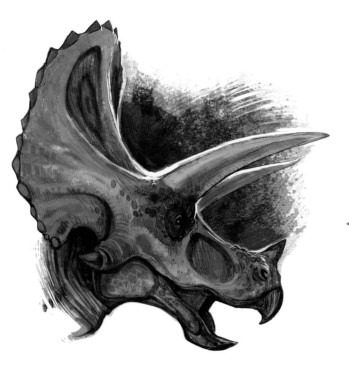

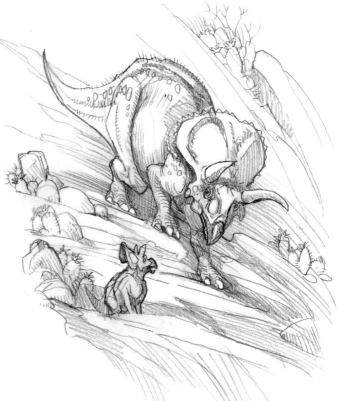

Head in Profile

The horns, frill and patterning on the triceratops is believed to vary greatly between individual specimens. This would make it easier for young to identify family members, and for the age of the dinosaur to be immediately recognizable. Like flukes on whales or horns on elephants it's likely that each family group had the same distinctive patterning for identification.

Social Habits

Like other herd animals, it is likely that triceratops were social creatures, staying with extended family until old enough to fend for themselves.

TRICERATOPS

For the concept design of the triceratops scene, I wanted to include several aspects of the late Cretaceous ecosystem as well as the theorized social behavior of the species. Triceratops was a large herd herbivore, but unlike massive sauropods such as apatosaurus (see page 18) that fed on the tops of large conifers, triceratops was a grazer that used its large beaked mouth to crunch shrubby ferns and cycads carpeting the forest floor. The late Cretaceous period would also have seen the advent of grasses, pinenuts and flowering plants to enhance this herbivore's diet.

Recent paleontological research suggests that many dinosaurs were able to withstand cold climates. This made me think of the large herds of elk in the American northwest mountains that annually migrate from the highland pastures in summer to lowland plains in winter. I was inspired to design a herd of triceratops as they descended from the woodline of an alpine fir forest in the fall. The foreground family group is perhaps a bit nervous about moving with their young from the relative shelter of the woods into the open field, despite the tempting sweet flowers beyond. The parents look around for Cretaceous carnivores that could potentially threaten the herd as an early winter storm approaches in the mountains beyond.

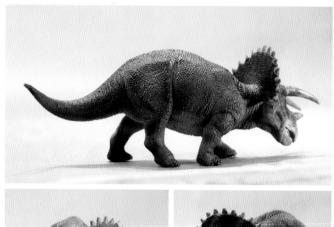

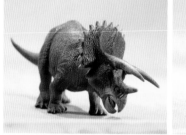

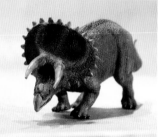

References

Use miniatures as reference to better understand anatomy, light, shadow and foreshortening.

1 PRELIMINARY THUMBNAIL SKETCHES

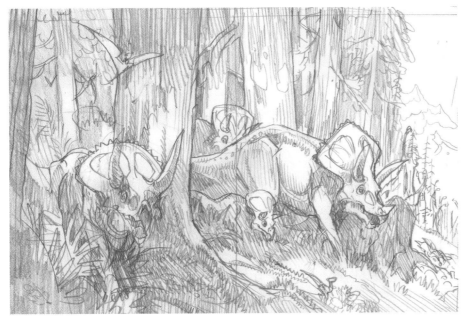

2 **SKETCHING THE FINAL DRAWING**

Work with pencil and paper from thumbnail designs and reference models to develop a more detailed rendition of your concept.

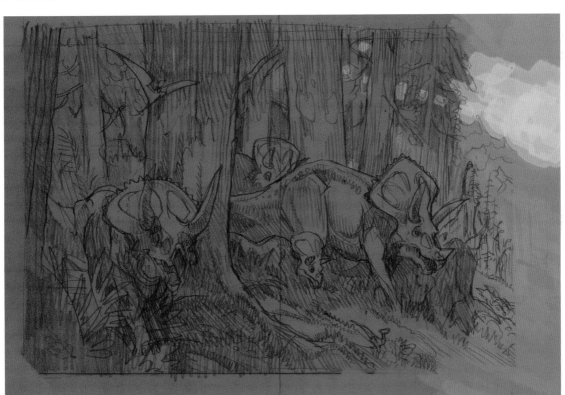

3 **ESTABLISHING THE UNDERPAINTING**

I chose a limited palette of earthtone colors for this diverse scene of woods, green plains, sky and mountains. Use a variety of brushes to loosely block in the large forms of tone, light and shadow. This technique for establishing the underpainting is the same for traditional or digital painting.

Color Palette and Key Brush

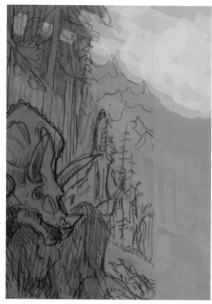

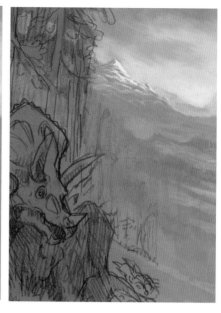

Detail of the Mountain Peak

4 RENDERING MOUNTAINS

Work out the details and colors of the mountains. Anyone who has ever traveled in the American southwest can appreciate being in a lowland prairie while snow is falling in the mountains nearby. I added a snow-capped alpine peak to create an interesting juxtaposition in this dinosaur painting.

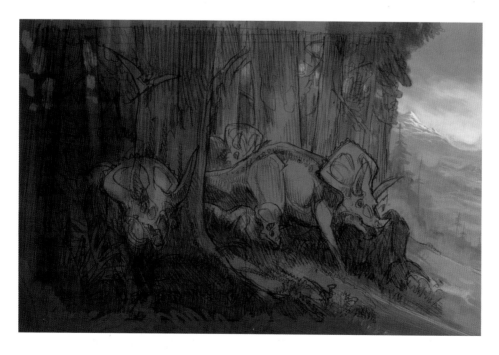

5 COMPLETING THE BACKGROUND

Loosely complete the background with pale tints of purple and green, and complete the trees and shadows with dark greens and browns.

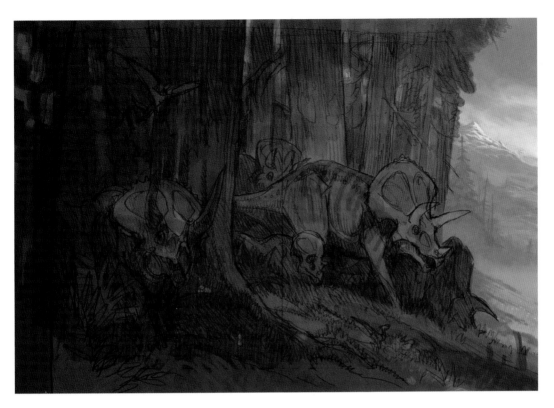

6 COMPLETING THE MIDDLE GROUND AND SUBJECT

Veer from the green-brown palette and introduce a flash of red on the triceratops frill and muzzle. This will help draw attention to the animals. Move forward from the background and begin defining the foreground elements to enhance the sense of depth and scale of the scene.

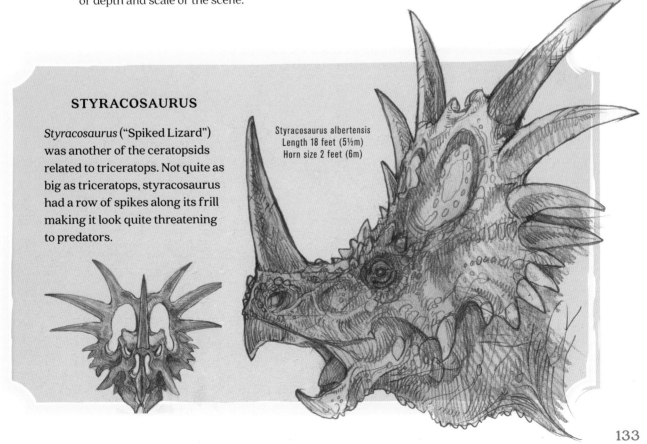

STYRACOSAURUS

Styracosaurus ("Spiked Lizard") was another of the ceratopsids related to triceratops. Not quite as big as triceratops, styracosaurus had a row of spikes along its frill making it look quite threatening to predators.

Styracosaurus albertensis
Length 18 feet (5½m)
Horn size 2 feet (6m)

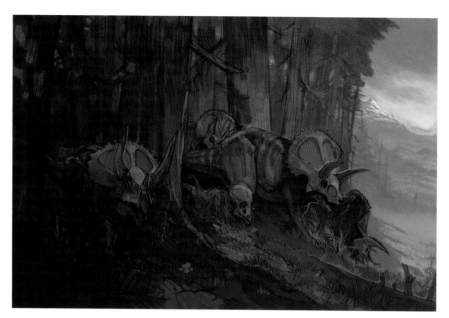

7 MIDDLE GROUND DETAILS
Note a few red flowers here and there to visually connect the red blazes on the triceratops and to introduce a new species of flower that evolved during the late Cretaceous.

TUTORIAL | Triceratops Sketch

Start with the skeletal framework to sketch the triceratops. Use reference to render the anatomy of muscles and flesh over the preliminary design then add details such as the skin, toes and horns. See page 128 for the finished colored drawing.

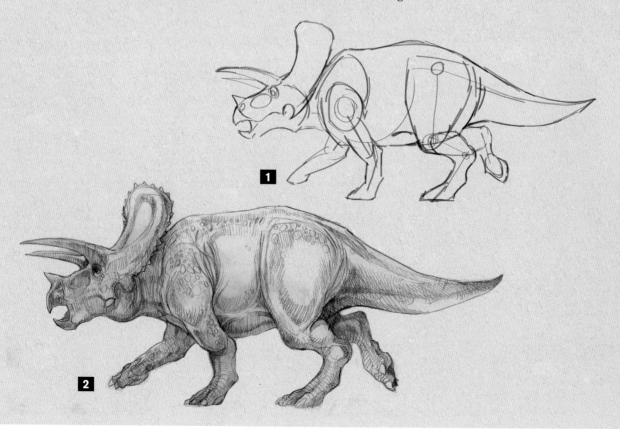

134

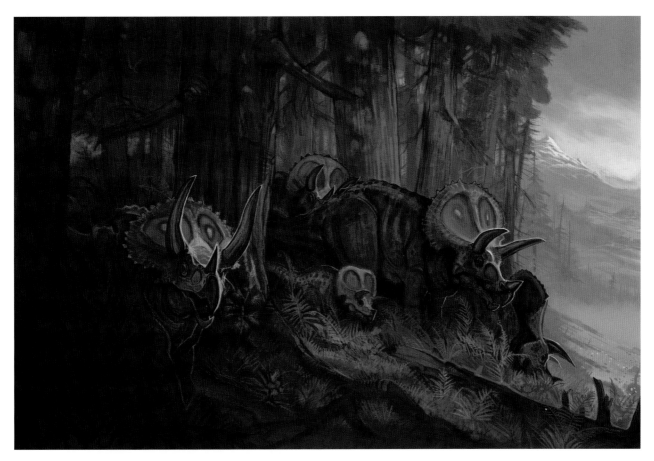

8 FOREGROUND AND FINISHING DETAILS

Give the neck frills some bright red "eyepatches." I borrowed this idea from fish and insects that have patterns that look like eyes to warn off predators. Refine the rest of the work with details like small saplings, fern fronds and skin texture. Although bees and other pollinating insects were beginning to arrive with the appearance of flowers, there were no butterflies until the Eocene epoch about 20 million years after the dinosaurs' extinction.

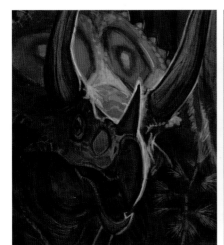
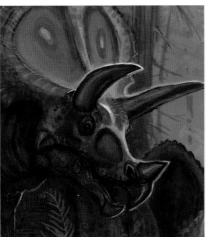

Triceratops Details

Visit impact-books.com/hall-of-dinosaurs to download free bonus materials.

135

PRONUNCIATION | Ty-RAN-oh-SAWR-us

SPECIES | *Tyrannosaurus rex*

NAME | Tyrant Lizard King

FAMILY | Tyrannosauridae

PERIOD | Cretaceous

DIET | Carnivore

SIZE | 40 feet (12m)

YEAR DISCOVERED | 1905

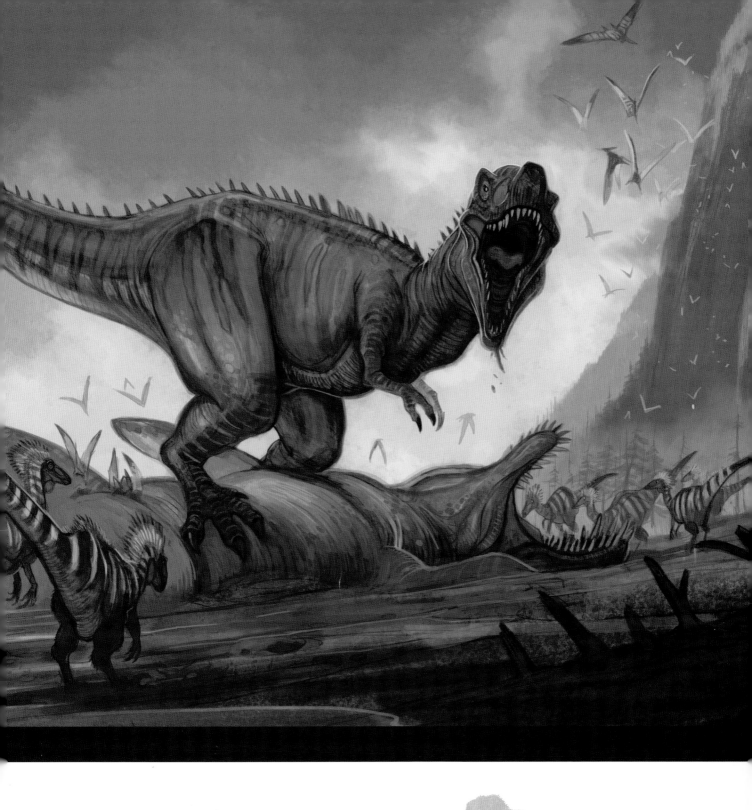

TYRANNOSAURUS

DESCRIPTION AND BIOLOGY

The Tyrant Lizard King! Star of movies and museums all over the world, *Tyrannosaurus rex* is by far the most famous and recognizable of all the dinosaurs. Based on paleontological evidence from multiple fossil specimens, this bipedal theropod was an apex predator of the Cretaceous period. It has been debated for decades whether T-rex was a hunter or a scavenger, but with powerful legs capable of sprinting speeds up to 30mph (48km), and crushing jaws full of fifty 8-inch (20cm) serrated teeth, it's likely that tyrannosaurus lived up to its name.

Head in Profile

The head of the T-rex is the most fascinating aspect of the animal. Compared to other theropods and carnosaurs, the T-rex had an oversized head. With thick ribbons and bunches of muscles at the mandible, neck and top of the skull, the bite force of a T-rex was enough to crush bone and even bite through a car. Combined with scissoring rows of thick dagger-like teeth, this dino could bite and hold on. Notice how the teeth of the lower jaw fit inside the upper teeth to create a shearing effect.

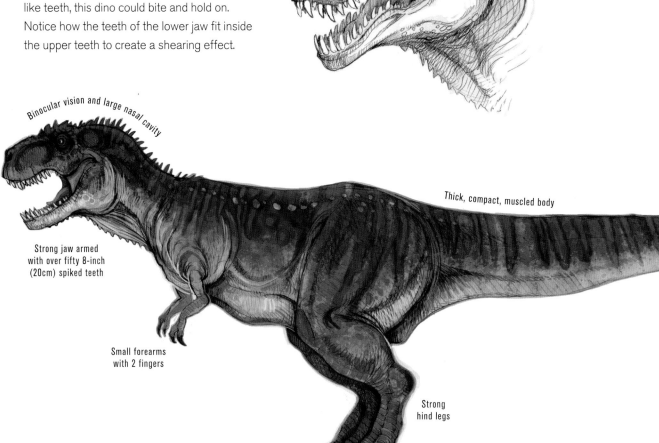

Binocular vision and large nasal cavity

Thick, compact, muscled body

Strong jaw armed with over fifty 8-inch (20cm) spiked teeth

Small forearms with 2 fingers

Strong hind legs

Tyrannosaurus Side View

Tyrannosaurus rex is the namesake of a family of dinosaur species with similar body morphologies, some growing to impressive size. Its thick, compact, muscled body made it one of the most powerful predators to ever walk the earth. Built like a wrestler, this dinosaur was designed to bite and overwhelm its prey by sheer force.

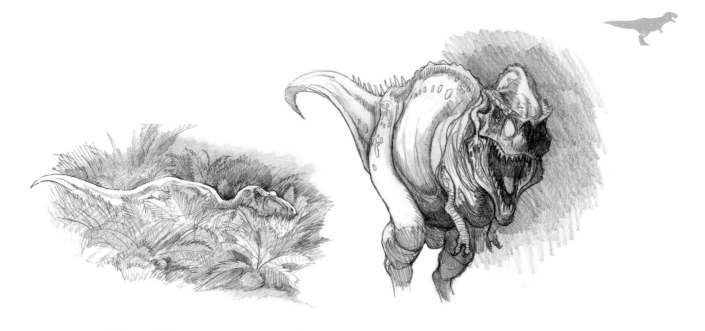

A Superb Hunter or a Scavenger?

Like today's lions and tigers, the T-rex most likely used its environment to ambush its prey. The large cycad and fern growth could hide a T-rex fairly easily despite its size. Although undoubtably a carnivore, the T-rex's mode of hunting has been widely debated. Some paleontologists suggest it was a hunter of opportunity, lying in wait, killing the weak and the lame, not chasing down its meals. T-rex's large jaws would bite into the throat of its victim and force it to the ground to suffocate or bleed out. Others suggest it was a scavenger like a hyena, chasing off the smaller predators in order to take kills for themselves.

The Largest Land Carnivore

The tyrannosaurids were huge animals, making up the largest land carnivores in history. When placed in the context of the environment, old growth redwood forests would appear much less titanic, and rather comparable in scale to the equally large T-rex.

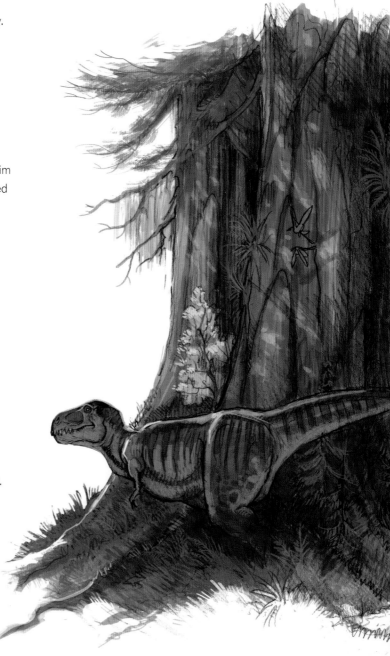

Demonstration
TYRANNOSAURUS

When approaching the T-rex I wanted to show defining aspects of the animal while demonstrating theories of its behavior. I imagined the T-rex scavenging off a beached kronosaurus (see page 60). The power of the T-rex is evident in its massive frame, and in scaled relationship to the troodons attempting to scavenge off the carcass as well. But the Tyrant Lizard is having none of it—he's king of the kill. Like modern scenes in the wild, a big kill like this would attract all kinds of animals. In addition to the small pod of troodon, I added some pterosaurs challenging the king from the surrounding cliffs.

References

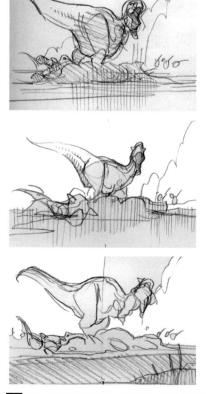

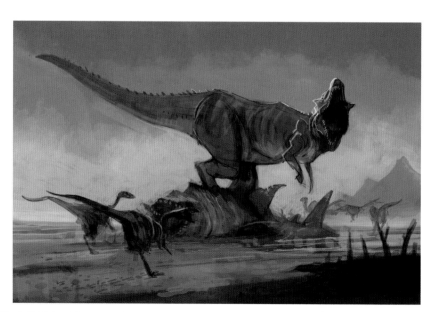

1 PRELIMINARY THUMBNAILS AND CONCEPT SKETCH

140

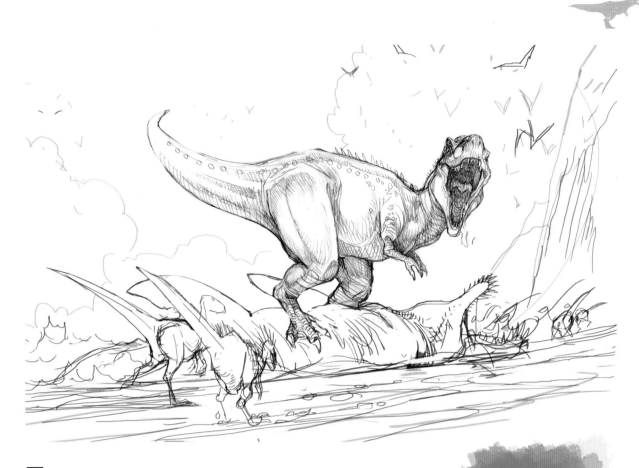

2 SKETCHING THE FINAL DRAWING

Sketch the initial drawing on 11" × 15" (28cm × 38cm) paper or on the computer. When getting started, I remind myself of the three important elements of an artwork: the background landscape, keeping the subject as the focus and adding a foreground element to create a frame for the composition (see page 7).

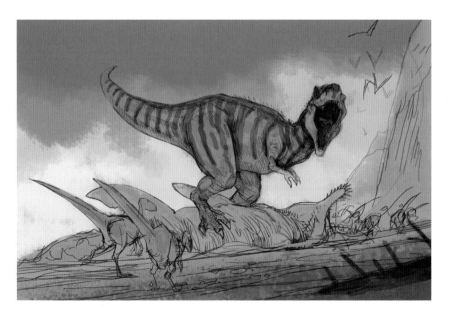

Color Palette

3 ESTABLISHING THE UNDERPAINTING

Use a variety of textured brushes to establish the main landscape forms and colors with broad stokes. Gray muted tones will help create a moody, stormy landscape for our dramatic scene. Use pale, light and cool colors in the background, and warmer colors in the foreground to create an illusion of depth of space. Keep the clouds around the T-rex light in order to help silhouette and frame the head.

Visit impact-books.com/hall-of-dinosaurs to download free bonus materials.

141

TUTORIAL | Tyrannosaurus Head

Begin drawing the tyrannosaurus head by roughly sketching out the skull's features including the eye socket, nasal cavity and mandible. The powerful bite of the T-rex comes from the thick muscles in its jaw and back of its neck. Details of skin and hide are completed last.

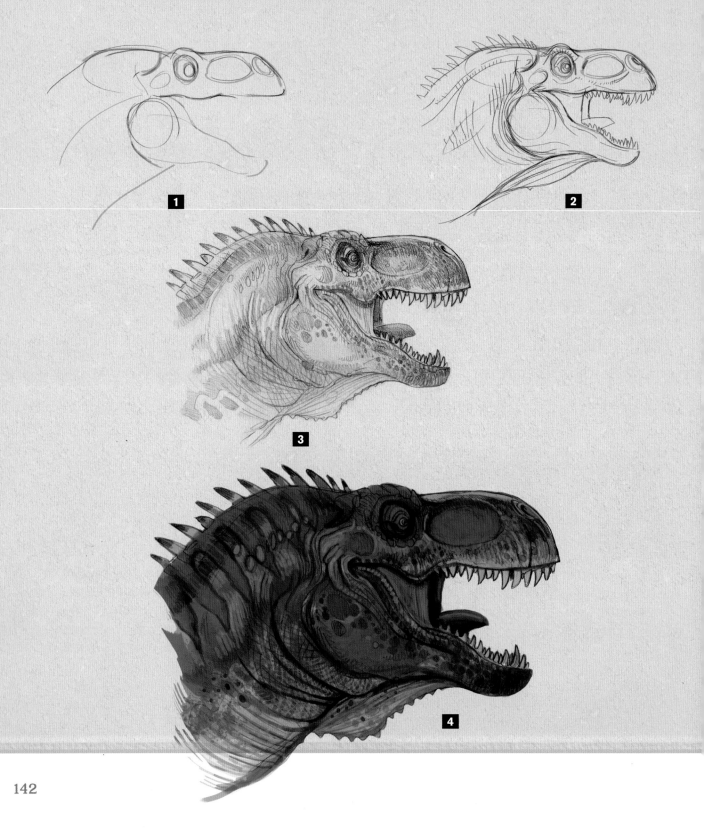

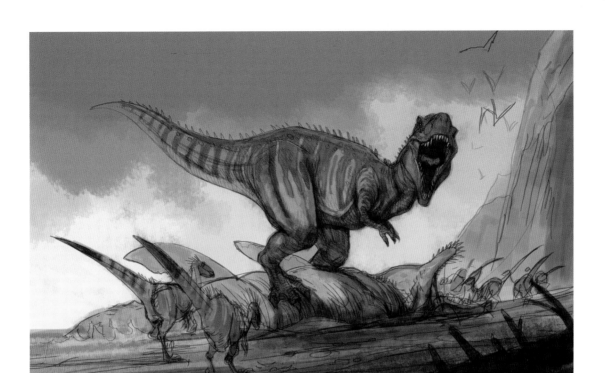

4 RENDERING THE MIDDLE GROUND AND SUBJECT

Use a variety of textured brushes to scumble some detail into the beach, T-rex and kronosaurus. Sketch a few birds or pterosaurs flying around the scene.

5 REFINING THE BACKGROUND

Complete the cliff and waterfall and add a few more birds roosting in the distance. Carry some of the colors into the kronosaurus to create cohesion between the middle ground and background.

TROODON

Troodon was a little dinosaur amongst giants. In the late Cretaceous, this swift and nimble carnivore likely hunted small mammals and lizards, as its name infers, but would not be unwilling to take a bite of a free meal. It's likely that troodon had feathers like its velociraptor cousin. I also envisioned striking markings reminiscent of a hyena pack.

Troodon formosus
Length 8 ft (2½m)

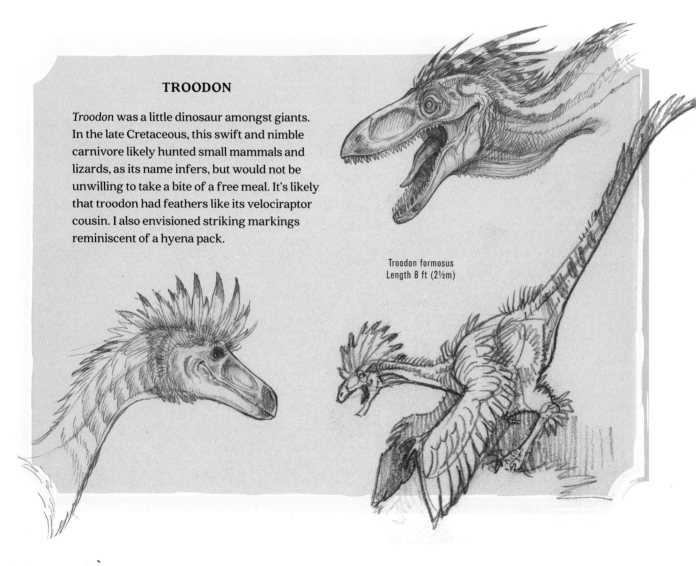

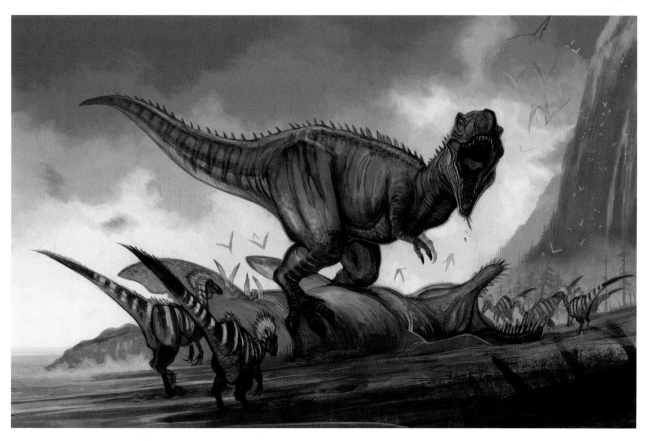

6 FOREGROUND AND FINISHING DETAILS

Bring your designs to life with details. Textured skin, feathers, birds and pterosaurs in the sky and small teeth and seashells in the foreground add to the illusion. Since troodon are depicted living at the beach I looked to shore birds like pipers, terns and cormorants for plumage inspiration. I was reminded of the gulls in *Finding Nemo*: "Mine, mine, mine." I also added trees near the cliffs, wet foot prints and some flotsam in the extreme foreground to enhance the scale and realism.

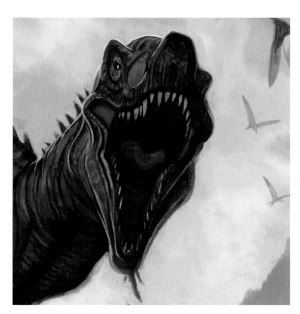

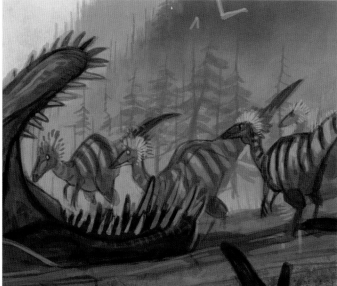

Details of Tyrannosaurus and Troodon

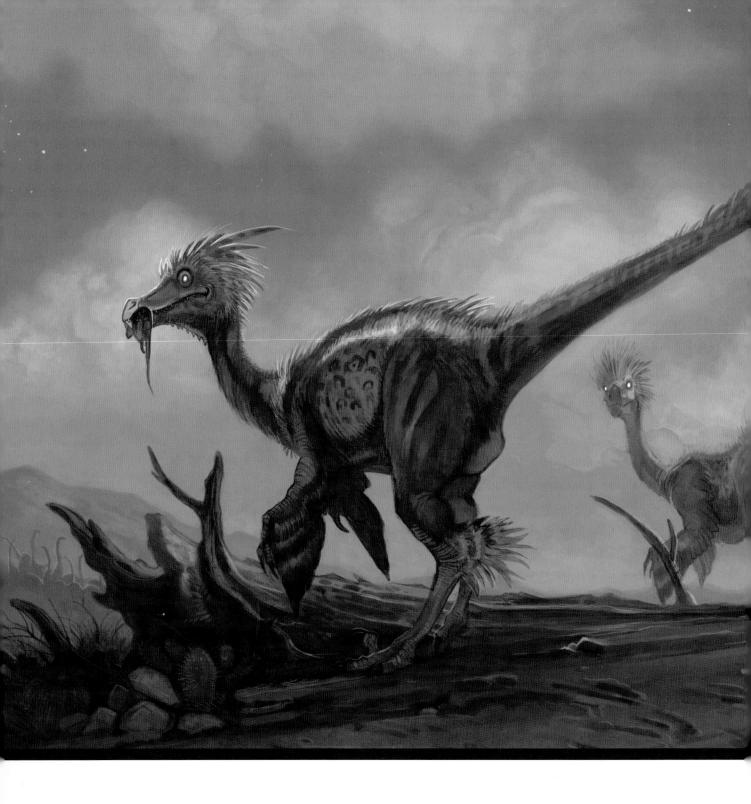

VELOCIRAPTOR

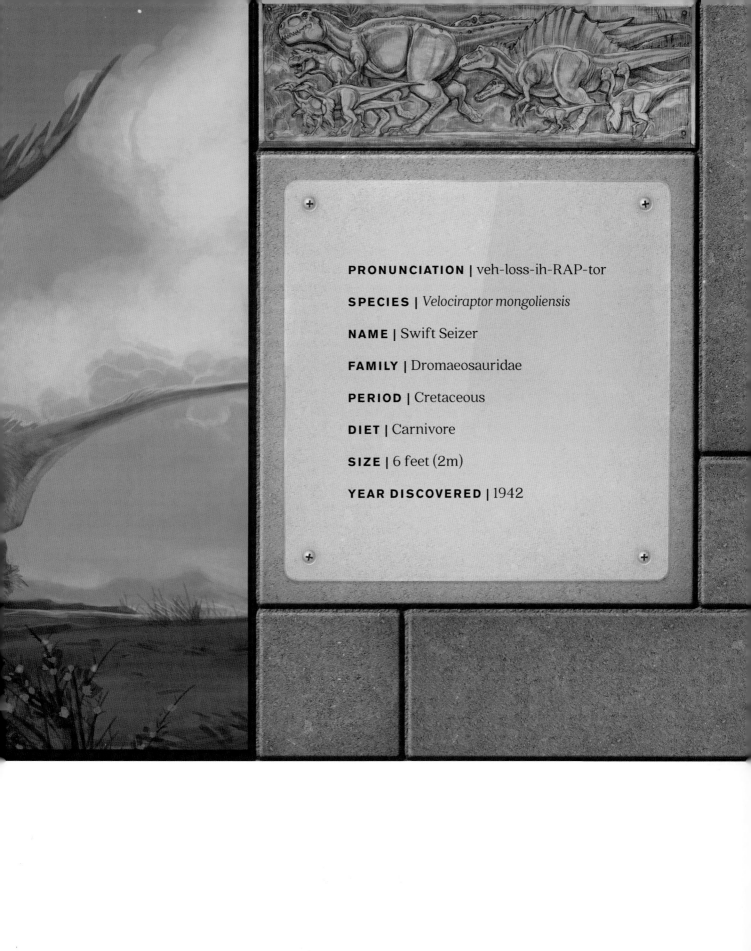

PRONUNCIATION | veh-loss-ih-RAP-tor

SPECIES | *Velociraptor mongoliensis*

NAME | Swift Seizer

FAMILY | Dromaeosauridae

PERIOD | Cretaceous

DIET | Carnivore

SIZE | 6 feet (2m)

YEAR DISCOVERED | 1942

DESCRIPTION AND BIOLOGY

Velociraptor and its cousin the deinonychus are species of the famous sickle-toed bipedal theropods known as dromaeosaurus. These feathered, fast predators have been the stars of books and films because of their deadly claws and vicious hunting skills.

Rigid tendons in the long, thin tail are thought to have acted as a counterbalancing rudder to keep the raptor upright as it made quick turns, much like a modern-day cheetah. Fossil remains of several velociraptors have been found together, leading paleontologists to surmise they were pack hunters, swarming their prey as a group with their vicious claws.

The late Cretaceous period was a time of titanic dinosaurs like T-rex, apatosaurus and hadrosaurs. The velociraptor was a fascinating hybrid that straddled the dinosaur tradition of the past and the bird designs of the future. Fast, agile and nocturnal, it had feathers for insulation and night vision. Velociraptors are thought to have hunted new species of rodents and mammals, making them one of the last of the great evolutions of the dinosauria class before extinction. Without the disappearance of dinosaurs 65 million years ago, it is possible this successful design of dinosaur may have continued into the future.

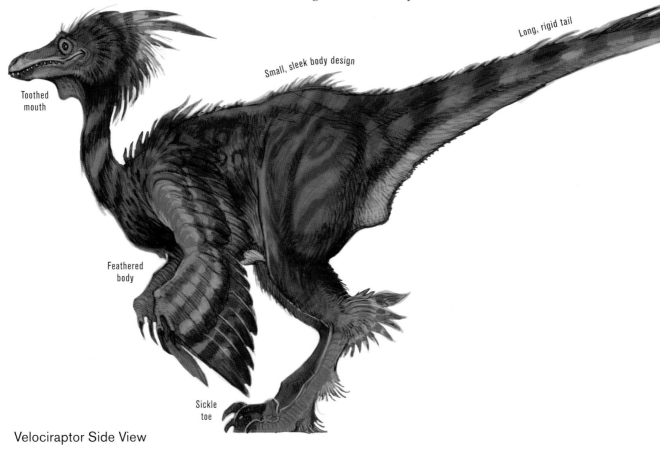

Toothed mouth

Small, sleek body design

Long, rigid tail

Feathered body

Sickle toe

Velociraptor Side View

Only reaching about 6 feet (2m) long from tip to tail, a velociraptor would have had a core not much larger than your average holiday turkey. Its long, streamlined body is understood by fossil evidence to have been covered with a variety of feathers and its large eyes and equally large brain have made some paleontologists wonder if the velociraptor was perhaps a nocturnal hunter. (See also coelophysis on page 93 and troodon on page 144.)

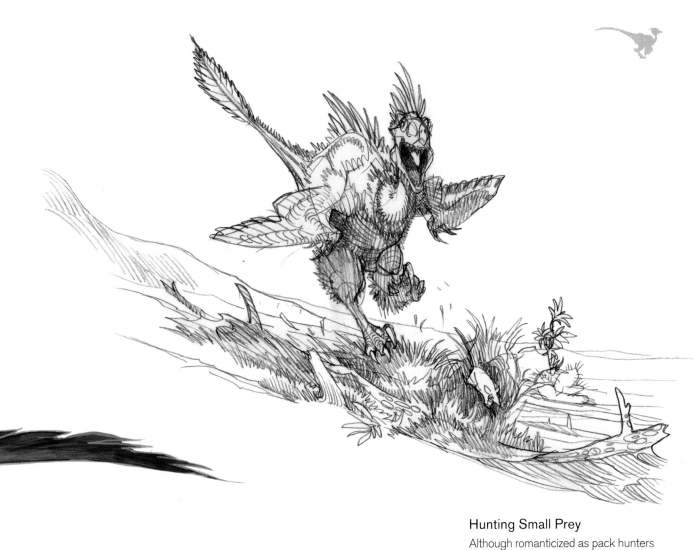

Hunting Small Prey

Although romanticized as pack hunters working in groups to bring down large prey, the velociraptor more than likely survived on lizards and small rodents. The protoceratops was probably as big a prey as it got. The feathers and tail of the velociraptor were believed to be a stabilizing element for hunting small prey in the desert.

Vocal Patterns May Have Resembled Bird Calls

Like birds, raptors were likely able to vocalize in complex patterns to communicate with other members of the flock.

Visit impact-books.com/hall-of-dinosaurs to download free bonus materials.

149

Demonstration
VELOCIRAPTOR

Since velociraptors are thought to be pack hunters and highly social, I wanted to depict a mated pair. After several different sketches I was inspired by the display of gray wolves at the American Museum of Natural History in New York City. A nocturnal hunting scene became my primary concept.

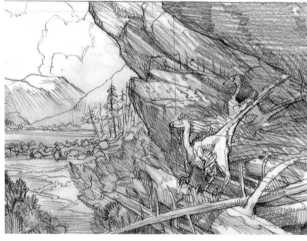

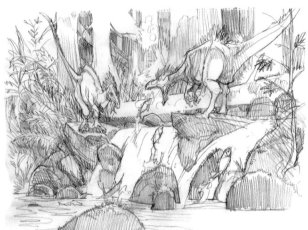

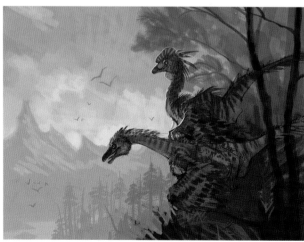

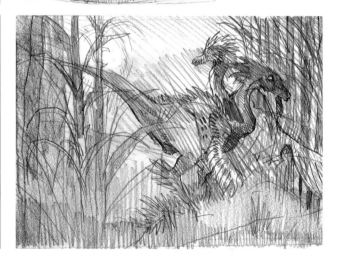

1 PRELIMINARY THUMBNAILS AND CONCEPT SKETCH

To plan the concept of my final painting, I placed one or more velociraptors in a variety of settings. From top, clockwise: in the high desert, fishing, at night in the forest, hunting and nesting.

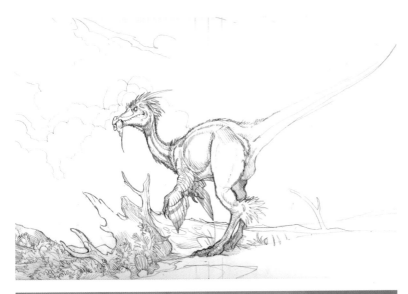

2 SKETCHING THE FINAL DRAWING

I decided on a simple night scene in the desert for my mating pair of dinos. The foreground velociraptor is the focal point, and he's just caught a small mammal scurrying near some logs and cacti. This minimal design allows the viewer to focus on the dinosaur in the dark.

Color Palette

3 ESTABLISHING THE UNDERPAINTING

Establish the basic cool color palette and lighting of this nocturnal scene. The last pink glow of the evening outlines the distant ridge line while the unseen foreground moon sculpts the silver shapes of the velociraptor out of the blue twilight. Broad, soft natural brushes quickly block in this effect.

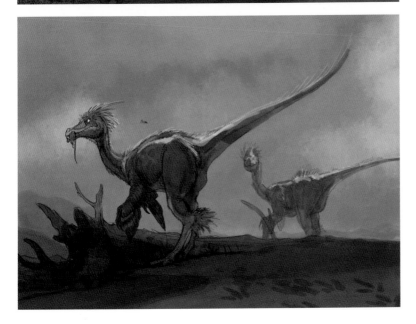

4 ADD ANOTHER VELOCIRAPTOR

If working digitally, sketch a second velociraptor, scan and scale it, then import it into the composition. If you are working in a traditional medium, simple sketch it into the drawing. Refine the localized foreground colors and details of the raptors' bodies and sickle toes. Highlight the feathers on the back and tail, and the rodent in the foreground raptor's mouth.

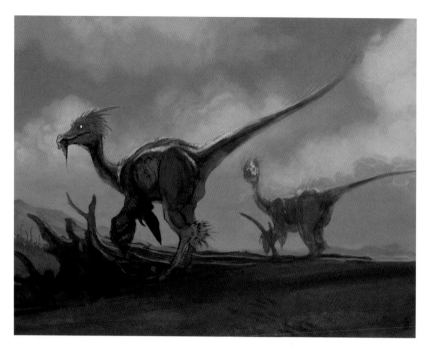

5 COMPLETING THE MIDDLE GROUND AND SUBJECT

Refine the skyscape and further develop the surrounding environment to include a herd a sauropods in the lower left corner resting or perhaps sleeping. Paleontologists are unsure whether these massive animals could have laid down.

Detail of Sauropod Herd

TUTORIAL | Velociraptor Sketch

The structure of a velociraptor is similar to a modern bird. Begin with a simple wire-frame skeleton to establish the basic proportions, placing the center of gravity over the dinosaur's knees. Flesh out the basic muscle mass and add details such as feathers last. See page 148 for the finished colored drawing.

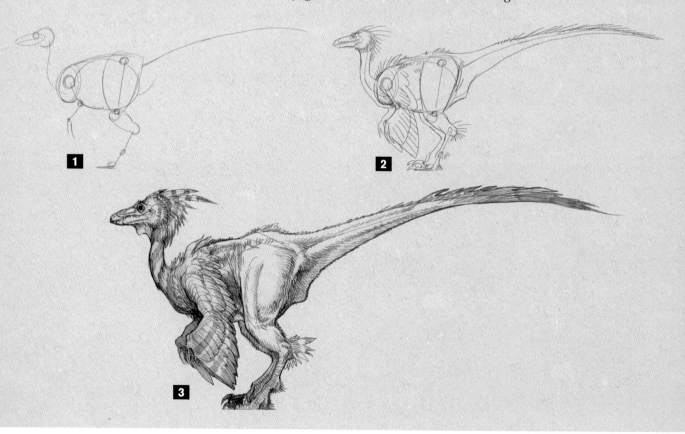

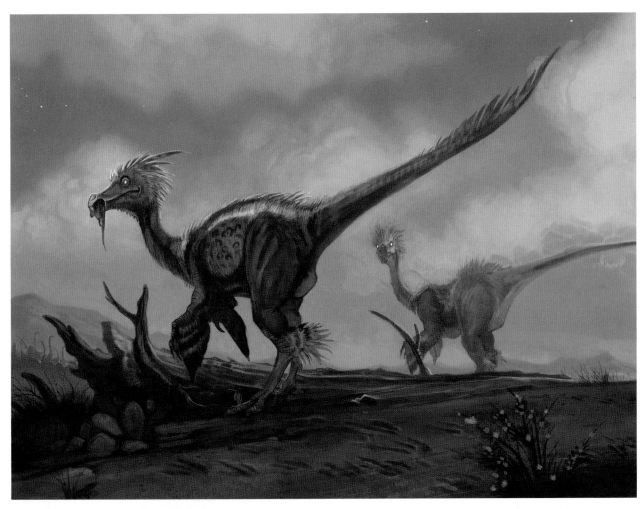

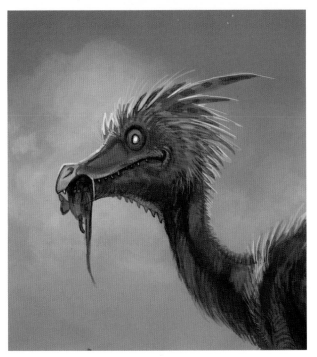

Detail of Velociraptor Head

6 FOREGROUND AND FINISHING DETAILS

Build the raptors' colors and background, adding a nice pink glow at the horizon to indicate the dusk. Use small brushes to render the closest details such as feathers, bushes, cacti and other small details that will give the image a touch of reality. The thorny shrub in the extreme foreground is detailed with subtle purple flowers to illustrate the new flowering plants of the Cretaceous period, as well as to create depth in the painting. Add a few specks of white in the upper left to indicate a starry night.

PALEONTOLOGY
AND PALEOECOLOGY

PALEONTOLOGY AND PALEOECOLOGY, or dinosaurs and dinoplants, are two important sciences in designing believable dinosaurs. Paleontology is the science of reconstructing and understanding prehistoric animals, while paleoecology is the science of understanding prehistoric environments and ecosystems. To better visualize dinosaurs, it is important to envision where they lived.

PALEOBOTANY

Studying ancient prehistoric plant life is as important as studying the dinosaurs themselves. Knowing the plants that they fed on and lived among helps to understand the habits and biomechanics of dinosaurs. Fortunately for us, there are still many different kinds of plants that existed during the Mesozoic Era around today. If you happen to live in a tropical or subtropical climate, you can virtually look out your window and see many of the ferns, cycads and palms that dominated the dinosaurs' landscape as well as early conifers, many of which still exist such as dawn redwood and Norfolk Island pine. Flowering fruit plants like ginkgo and mountain laurels also began to evolve in the age of dinosaurs.

If you live in a temperate climate that does not support these plants, there are still many places to go to observe them such as conservatories and botanical gardens. The local plant shop may carry a wide variety of specimens to use as reference. Even an ordinary pineapple is a great example of a cycad plant that dominated the Mesozoic landscape.

I recommend visiting a place where you can see reference live as opposed to just pictures in a book. It is much more educational when you can stand among the trees and smell the mulch that dinosaurs would have known.

Almost every major city in the world has a conservatory or botanic garden worth visiting. Try to find one near where you live!

DINOSAUR COLORATION AND MARKINGS

PALEONTOLOGISTS HAVE MANY DIFFERENT opinions as to the dinosaurs' appearance and all are valid. This is where paleoart can be very creative. The two reasons for any animal's markings are simple: camouflage and mating. Seeing that dinosaurs are the natural predecessors to birds, it is reasonable to imagine that they all had startling markings, crests and plumage like modern birds. While this is a tantalizing theory, one must also take into account that dinosaurs were not birds, and in fact filled many of the same environmental niches as today's mega fauna and top predators such as lions and hippos. Though it would be ludicrous to imagine a cardinal red lion or a canary yellow rhinoceros, it's not improbable to imagine colored horns or crests.

Massive sauropods were very much like today's elephants and bison. Large herd animals do not usually develop camouflage because their sheer size and numbers protect them. The striping on zebras is unique in that it is not designed to camouflage the animal into its environment, rather it is to make the herd of animals blend together so that predators get confused, known as "dazzle camouflage."

Alpha hunters usually retain a dull color to blend in with their surroundings, often with patterning to break up their silhouette. Balancing this with the fact that dinosaurs are the predecessors to birds, it is quite likely that even the largest of dinosaurs would adopt selected bright markings in the males of the species to entice mates during breeding. So the coloration question of dinosaurs most likely falls somewhere between the two extremes. Large sauropods and theropods probably resembled elephants and hippos in their local color with highlights in the face and neck like contemporary birds. Females and young were probably more muted and mottled in color to protect them during the vulnerable hatchling periods. Top predators may have evolved stripes or spots like leopards and tigers, but likely kept basic color schemes like lions or wolves.

Today dinosaur discoveries take place all over the world, and new revelations about these fossil reptiles evolve every year. Paleontologists, universities and museums continue to share information and our collective image of these animals grows. And it is with the help of artists like you and me using technology new and old that these dinosaurs are brought to life.

REFERENCES

When drawing and painting dinosaurs, using reference is crucial. The Internet, books and sculptures are the main supply of reference I used in creating the images in this book as well as some extremely accurate toy dinosaurs for creating lighting effects and understanding anatomy. I recommend taking a trip to a natural history museum and botanical garden to get a better sense of scale of the plants and animals of the Mesozoic Era.

Visit impact-books.com/hall-of-dinosaurs to download free bonus materials.

155

GLOSSARY

BIPEDAL: Walking on two legs.

CERATOPSIDS (Ceratopsidae): Family of quadrupedal herbivore dinosaurs including the triceratops and styracosaurus.

CARNIVORE: Meat-eating animal.

CARNOSAURS (Carnosauria): Group of large carnivorous theropod dinosaurs including tyrannosaurus rex, allosaurus, carnotaurus and others.

CRETACEOUS PERIOD: Time within the Mesozoic Era from 150 to 65 million years ago. The last era of the dinosaurs before the mass extinction of the K-Pg boundary.

CYCAD: Family of plants related to palms and common during the age of dinosaurs.

HADROSAURS (Hadrosauridae): Family of Cretaceous herbivore dinosaurs commonly called the duck-billed dinosaurs. Species included the parasaurolophus.

HERBIVORE: Plant-eating animal.

JURASSIC PERIOD: Epoch within the Mesozoic Era approximately 200 to 150 million years ago and dominated by many dinosaur species.

K-PG BOUNDARY: The event approximately 65 million years ago that ended the age of dinosaurs, commonly believed to have been brought about by a massive comet strike on earth and extreme climate change. Commonly referred to as the transition between the Cretaceous and Paleogene periods (or the Cretaceous-Paleogene boundary).

MESOZOIC ERA: Vast period of time from 250 to 65 million years ago. Broadly contains the era of the dinosaurs.

MORPHOLOGY: The study of the design of a living creature.

PALEOART: The art of re-creating the creatures discovered in paleontology, whether traditional, digital or sculptural.

PALEOBOTANY: A branch of paleontology studying prehistoric plant fossils.

PALEOECOLOGY: The scientific study of ancient environments through fossils and geology.

PALEONTOLOGY: The scientific study of ancient life forms through fossil remains.

PANGAEA: The name given to the super continent landmass that existed for 300 million years during the reign of dinosaurs. This super continent broke up into the modern continents we know today.

PERMIAN PERIOD: Era approximately 300 to 250 million years ago directly preceding the Mesozoic Era of the dinosaurs.

PLESIOSAURS: Group of marine dinosaurs.

PTEROSAURS: Group of flying reptiles; cousins to the dinosaurs.

QUADRUPEDAL: Walking on four legs.

SAUROPOD: Group of large four-legged herbivore dinosaurs including apatosaurus, brachiosaurus and others. Name means "Lizard Footed."

THEROPODS: Group of two-legged dinosaurs that included families such as Tyrannosauridae and Dromaeosauridae, and would later evolve into the birds. Name means "Beast Footed."

TRIASSIC PERIOD: Era existing from 250 to 200 million years ago containing the first species of dinosaurs.

KEY MUSEUMS

The Field Museum of Natural History (Chicago)
fieldmuseum.org

American Museum of Natural History (New York City)
amnh.org

Smithsonian Institution National Museum of Natural History (Washington, D.C.)
mnh.si.edu

Natural History Museum (London)
nhm.ac.uk

INDEX

Visit impact-books.com/hall-of-dinosaurs to download free bonus materials.

157

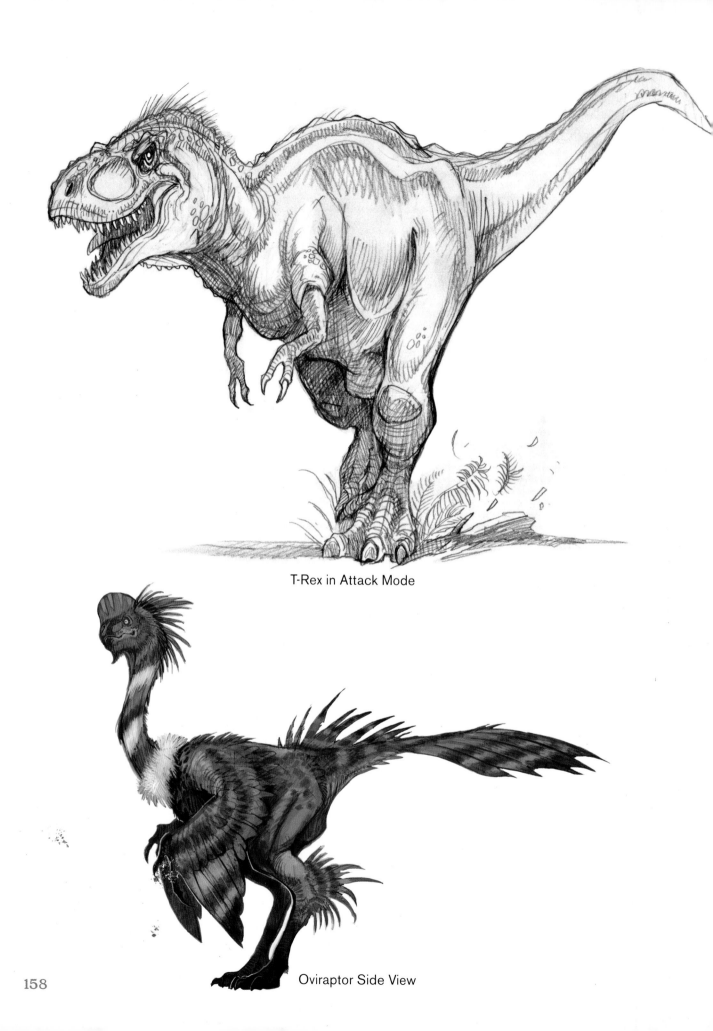

T-Rex in Attack Mode

Oviraptor Side View

Other fine IMPACT Books are available from your favorite bookstore, art supply store or online supplier. Visit our website at fwcommunity.com.

a content + ecommerce company

19 18 17 16 15 5 4 3 2 1

DISTRIBUTED IN CANADA BY FRASER DIRECT
100 Armstrong Avenue
Georgetown, ON, Canada L7G 5S4
Tel: (905) 877-4411

DISTRIBUTED IN THE U.K. AND EUROPE
BY F&W MEDIA INTERNATIONAL, LTD
Brunel House, Forde Close, Newton Abbot, TQ12 4PU, UK
Tel: (+44) 1626 323200, Fax: (+44) 1626 323319
Email: enquiries@fwmedia.com

DISTRIBUTED IN AUSTRALIA BY CAPRICORN LINK
P.O. Box 704, S. Windsor NSW, 2756 Australia
Tel: (02) 4560-1600; Fax: (02) 4577 5288
Email: books@capricornlink.com.au

ISBN 13: 978-1-4403-4072-7

Edited by Sarah Laichas
Designed by Brianna Scharstein
Production coordinated by Jennifer Bass

METRIC CONVERSION CHART

CONVERT	TO	MULTIPLY BY
Inches	Centimeters	2.54
Centimeters	Inches	0.4
Feet	Centimeters	30.5
Centimeters	Feet	0.03
Yards	Meters	0.9
Meters	Yards	1.1

ABOUT THE AUTHOR

William O'Connor is an illustrator, concept artist, fine artist and instructor with more than 25 years' experience. He has produced more than 5,000 published illustrations for the gaming, publishing and advertising industries and has won more than 30 awards for artistic excellence. He has contributed to *Spectrum: The Best in Contemporary Fantastic Art* 10 times and been nominated for several Chesley Awards for outstanding work in the field of fantasy illustration. O'Connor's bestselling *Dracopedia* series includes *Dracopedia*, *Dracopedia: The Great Dragons* and *Dracopedia: The Bestiary*. O'Connor lives and works from his studio in New York. Visit his website at **wocstudios.com**.

DEDICATION TO JEFF.

Thanks for all the great support and reference over the years.

AUTHOR'S NOTE

The information in this book is intended for entertainment and artistic purposes only and should not to be cited academically.

Visit impact-books.com/hall-of-dinosaurs to download free bonus materials.

159

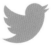 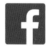

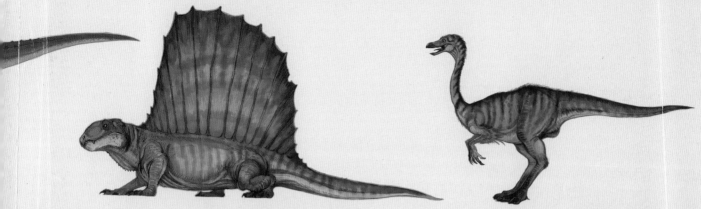

US

 DIMETRODON
SIZE | 15 feet (5m)

GALLIMIMUS
SIZE | 20 feet (6m)

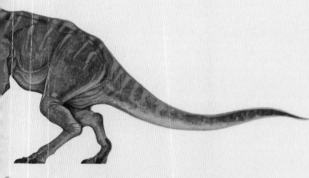

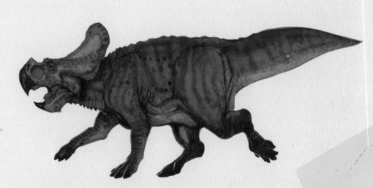

PLATEOSAURUS
SIZE | 30 feet (9m)

 PROTOCERATOPS
SIZE | 6 feet (2m)

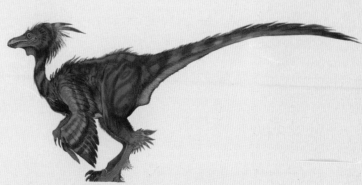

AURUS

VELOCIRAPTOR
SIZE | 6 feet (2m)

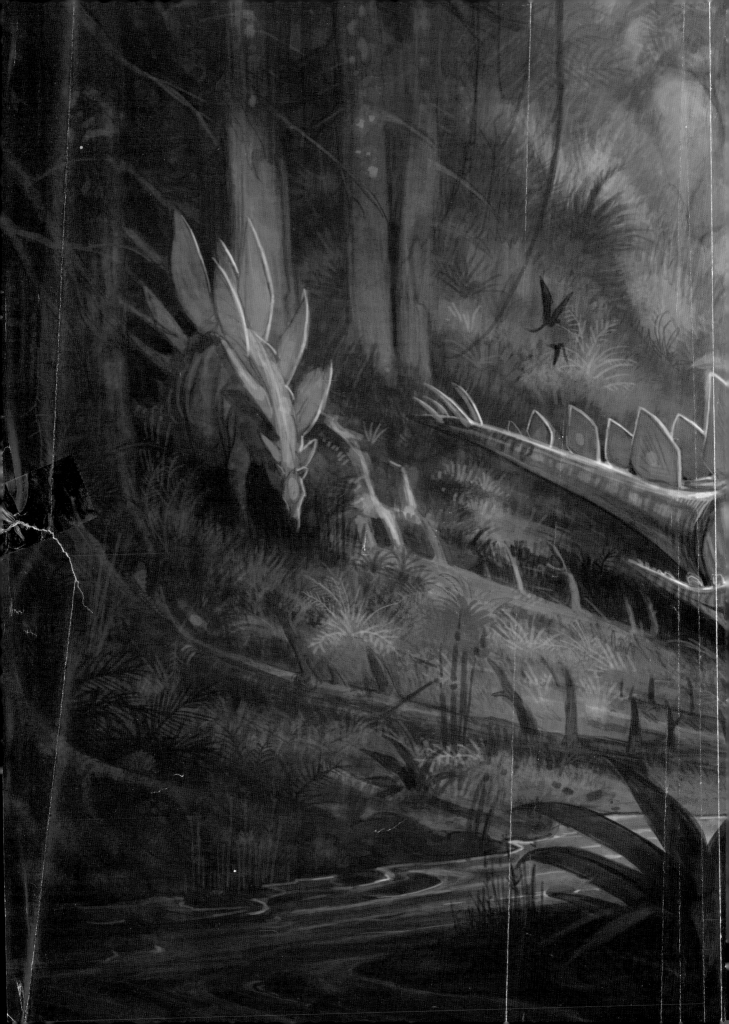

ARCHAEOPTERYX
SIZE | 2 feet (61cm)

CARNOTAUR
SIZE | 25 feet (8m)

OSAURUS

PARASAUROLOPHUS
SIZE | 30 feet (9m)

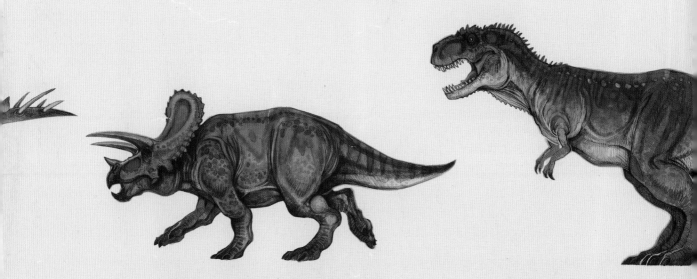

TRICERATOPS
SIZE | 20 feet (6m)

TYRANNOS

SIZE | 40 feet (12m)

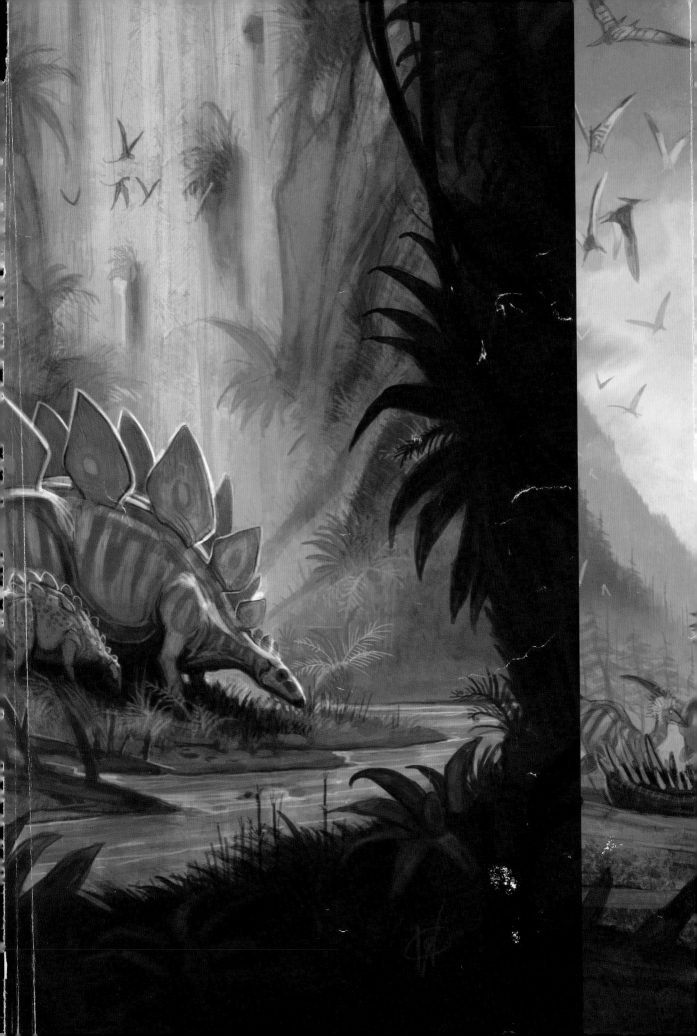

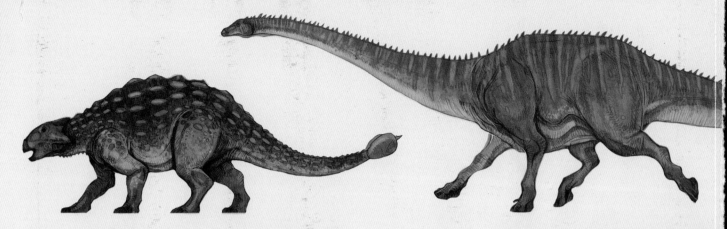

ANKYLOSAURUS

SIZE | 30 feet (9m)

APATOSAURUS

SIZE | 75 feet (23m)

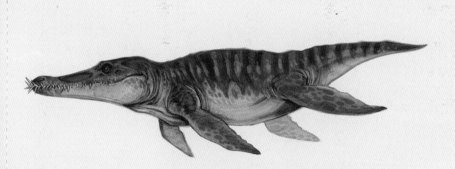

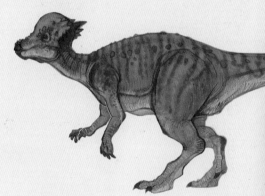

KRONOSAURUS

SIZE | 40 feet (12m)

PACHYCEPHAL

SIZE | 26 feet (8m)

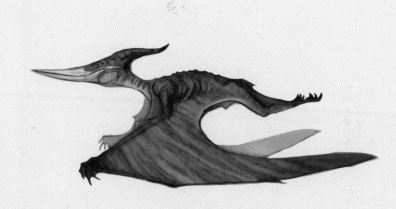

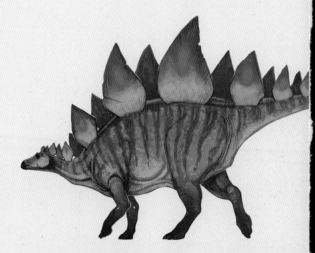

PTERANODON

SIZE | 20 feet (6m)

STEGOSAURUS

SIZE | 30 feet (9m)

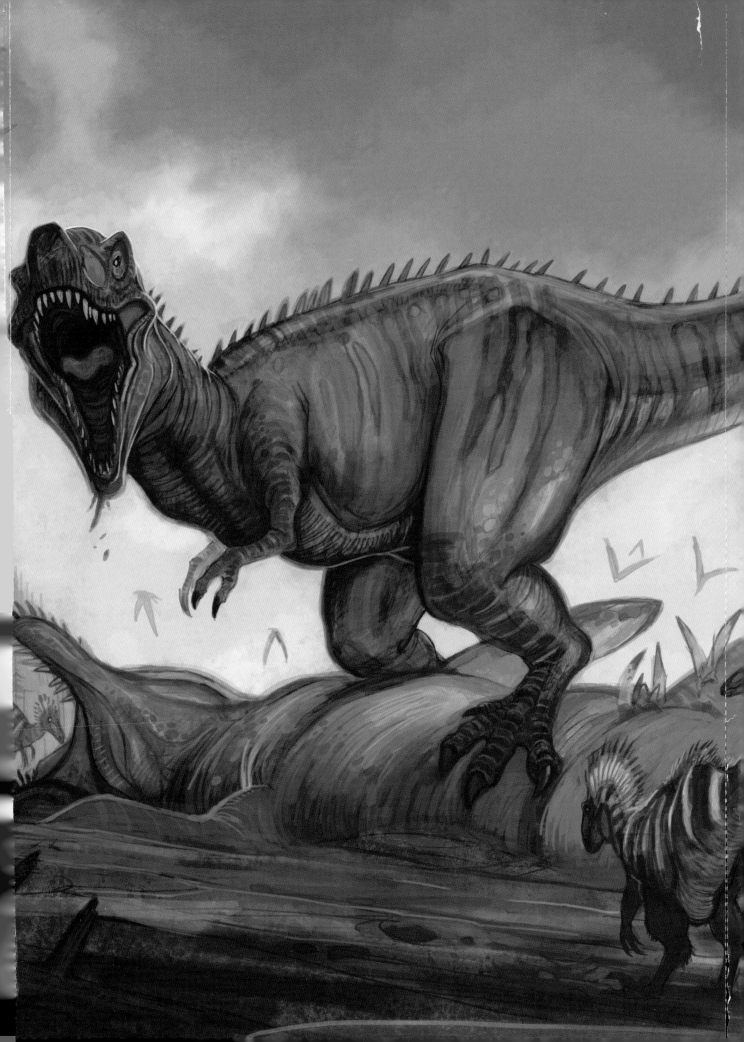